GANGES

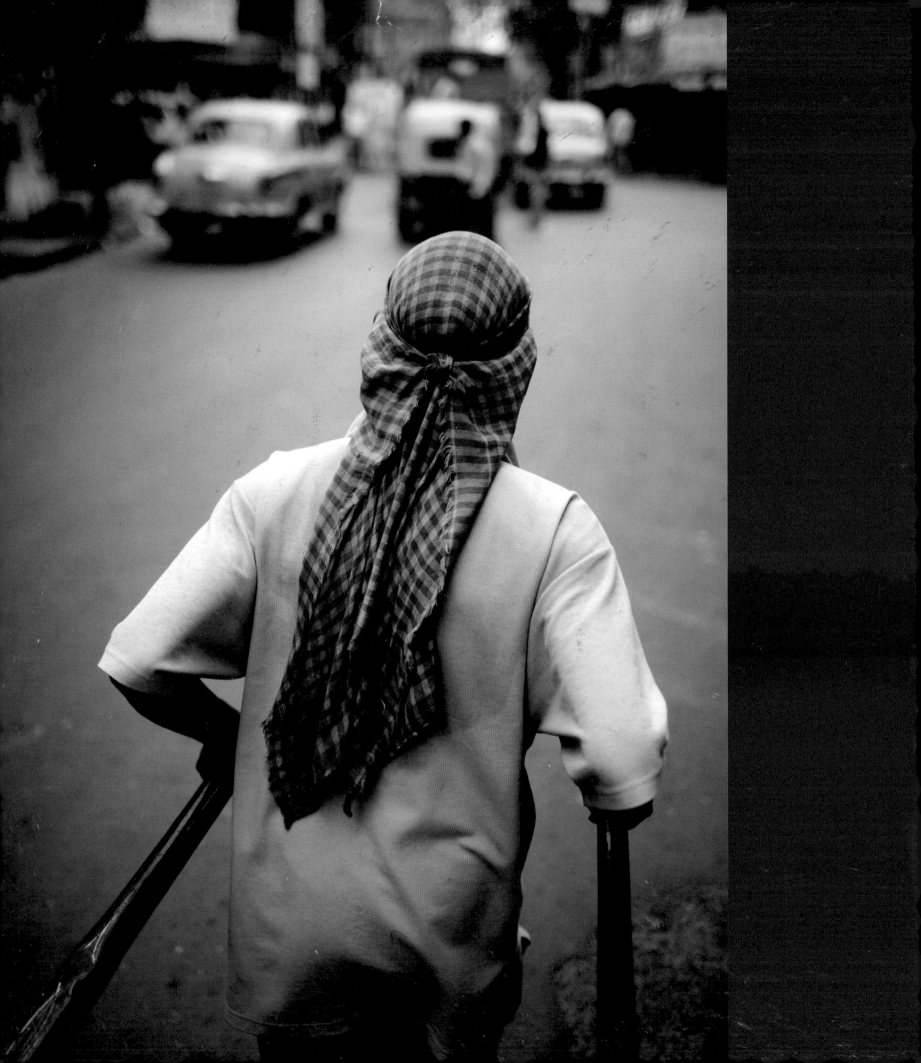

GANGES

PHOTOGRAPHY BY
JON NICHOLSON

TEXT BY
IAN GRAY, TOM HUGH-JONES AND DAN REES
WITH SHARMILA CHOUDHURY

BBC
BOOKS

10 9 8 7 6 5 4 3 2 1

Published in 2007 by BBC Books,
an imprint of Ebury Publishing.
Ebury Publishing is a division of the
Random House Group Limited.

Photographs Copyright © Jon Nicholson 2007
(except those listed on page 164)
Text Copyright © Ian Gray, Tom Hugh-Jones,
Dan Rees 2007

The right of Jon Nicholson to be identified as the
photographer and Ian Gray, Tom Hugh-Jones, Jon
Nicholson and Dan Rees to be identified as the
authors of this work has been asserted in
accordance with Sections 77 and 78 of the
Copyright, Designs and Patents Act 1988.

The Random House Group Limited
Reg. No. 954009

Addresses for companies within the Random House
Group can be found at www.randomhouse.co.uk

A CIP catalogue record for this book is available
from the British Library.

ISBN 978 0 563 49359 4

The Random House Group Limited makes every
effort to ensure that the papers used in our books
are made from trees that have been legally sourced
from well-managed and credibly certified forests.
Our paper procurement policy can be found on
www.randomhouse.co.uk

Commissioning Editor: Shirley Patton
Project Editor: Cameron Fitch
Editor: Rosamund Kidman Cox
Designer: Bobby Birchall, Bobby&Co Design
Production Controller: David Brimble
Map Design: Encompass Graphics

Set in Helvetica Neue and Trajan
Printed and bound in Italy by
Printer Trento Srl
Colour separations by GRB Editrice Ltd. London

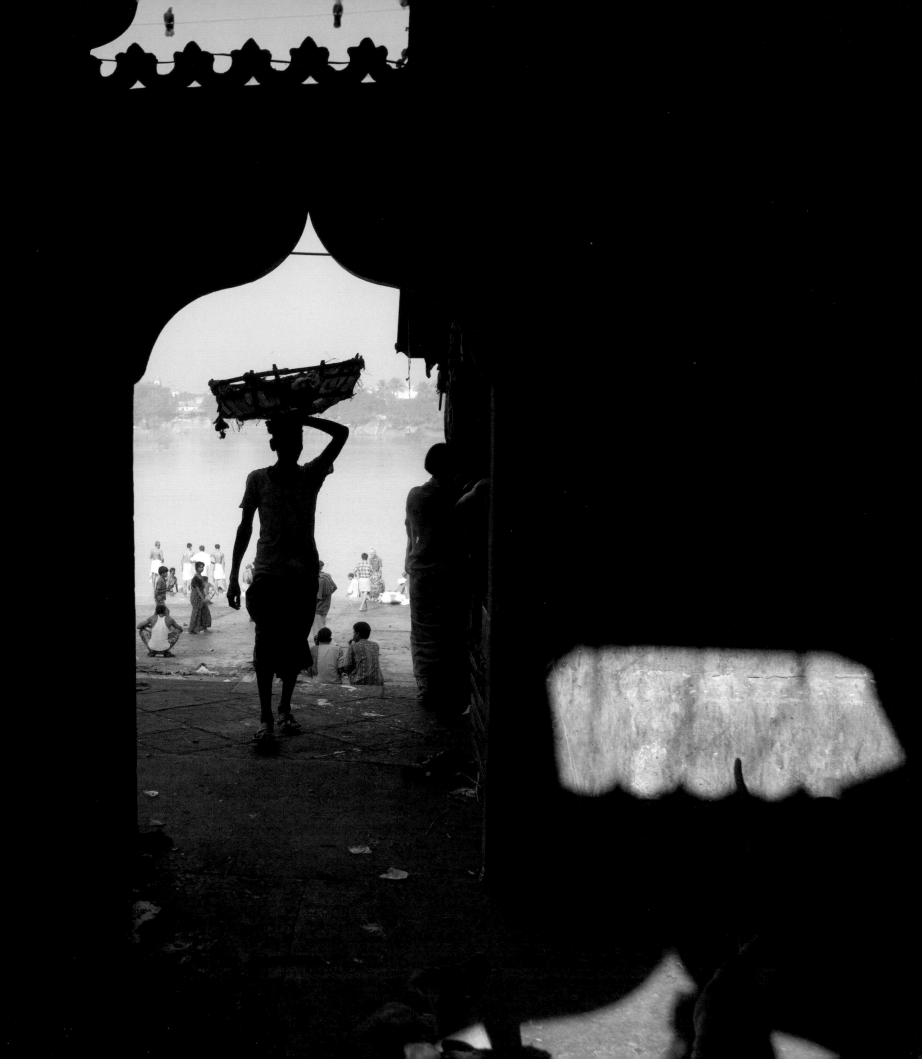

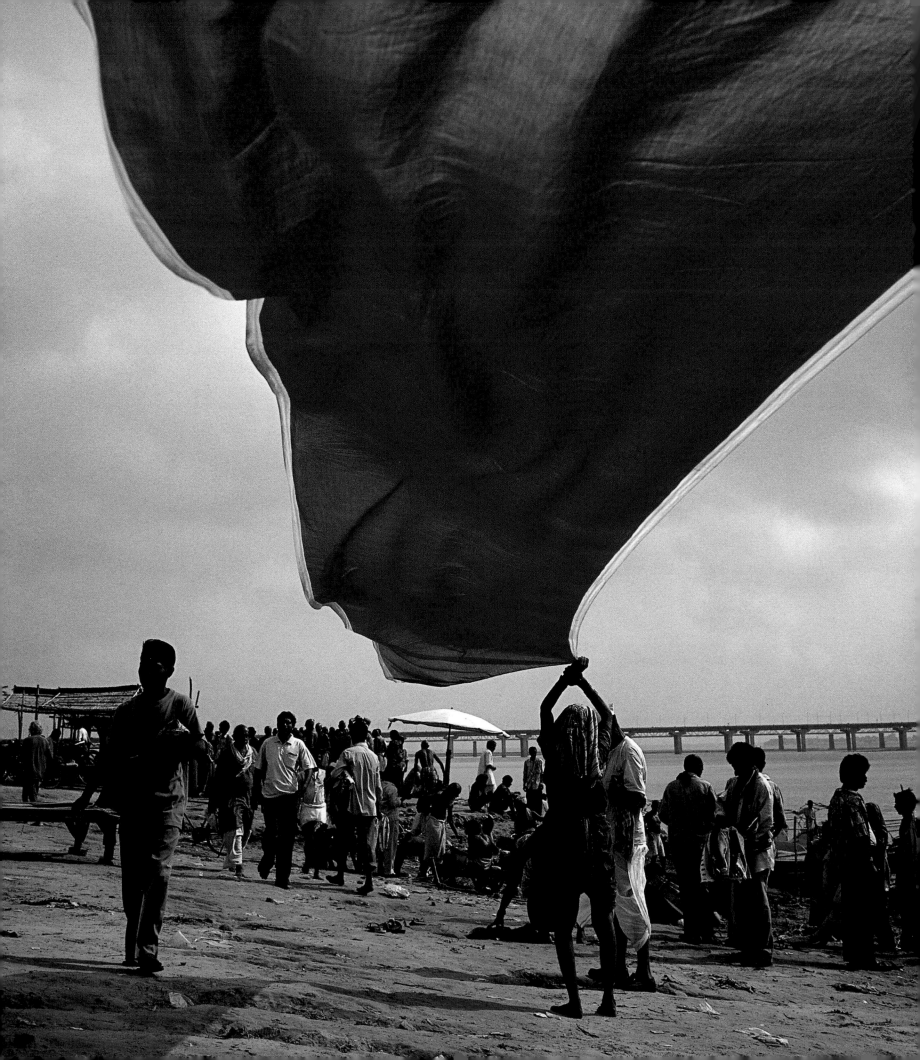

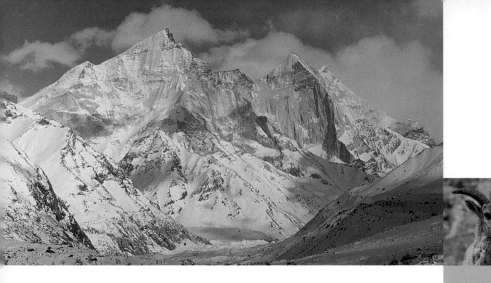

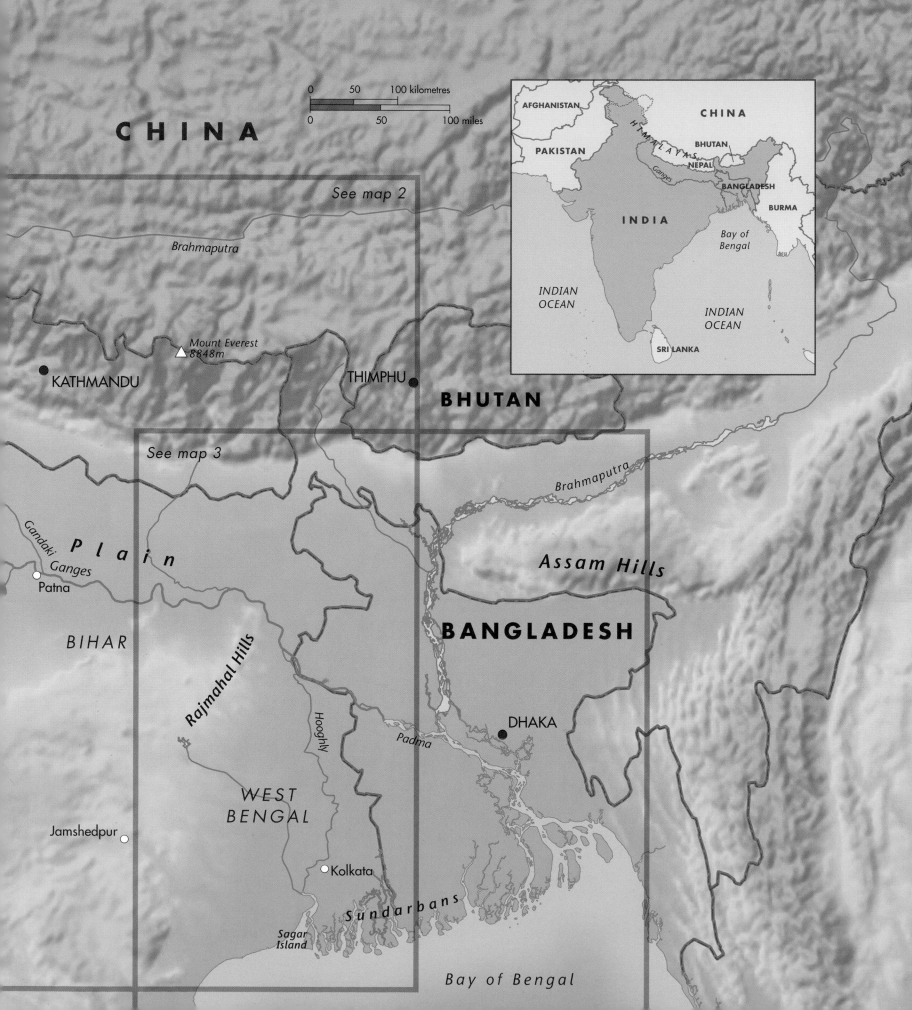

CHINA

See map 2

Brahmaputra

Mount Everest
8848m ▲

● KATHMANDU

THIMPHU ●

BHUTAN

See map 3

Brahmaputra

P l a i n

Assam Hills

Gandaki

Ganges

○ Patna

BANGLADESH

BIHAR

Rajmahal Hills

Hooghly

Padma

DHAKA ●

*WEST
BENGAL*

Jamshedpur ○

○ Kolkata

Sundarbans

*Sagar
Island*

Bay of Bengal

AFGHANISTAN

CHINA

PAKISTAN

HIMALAYAS

BHUTAN

NEPAL

Ganges

BANGLADESH

INDIA

BURMA

*Bay of
Bengal*

*INDIAN
OCEAN*

*INDIAN
OCEAN*

SRI LANKA

0 50 100 kilometres

0 50 100 miles

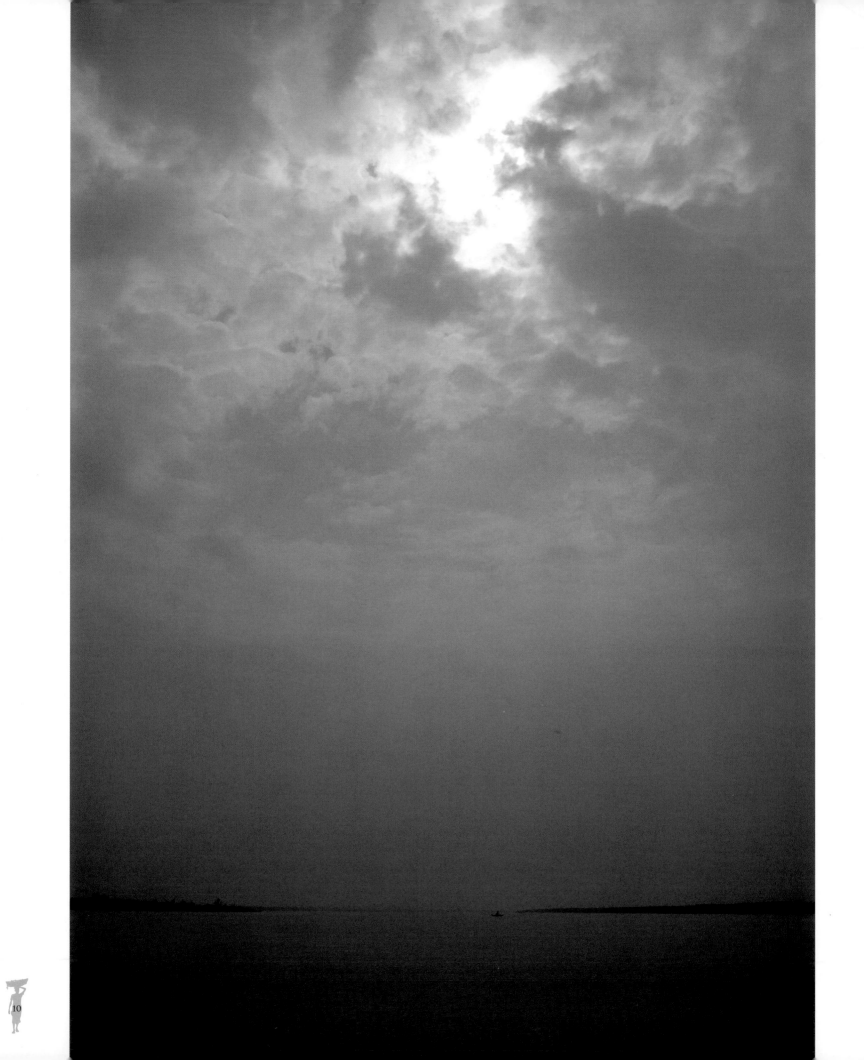

PREFACE

The River Ganges, or Ganga, to give it the Hindu name, flows 2500km (1550 miles) from the Gangotri glacier high in the Himalayas, across the vast Gangetic Plain, through cities such as Allahabad and Varanasi and into the massive delta of the Sundarbans – a 10,000-square-kilometre (3610-square-mile) mangrove forest, home to the Bengal tiger – before pouring into the Bay of Bengal. The silt from this river can be seen more than 500km (300 miles) offshore.

Ganga Ma – the mother – is not the longest or fastest-flowing river in the world, but to Hindus, it is the most sacred. Ganga is a goddess descended from the heavens who symbolizes purity, transformation and the essence of life. For the millions of pilgrims who live and die by her side, she cleanses their sins and allows their souls to pass on to nirvana. Even to exclaim 'Ganga, Ganga' from a hundred leagues away can deliver a pilgrim from the penance of sins in three previous lives. Now, as in the past, the Ganga attracts westerners to marvel at its wonders. Today, though, there are many more activities available: the thrills of white-water rafting and canoeing in the higher reaches of the river and organised treks to the peaks that surround the source.

But all along the mighty Ganga, the modern world is taking its toll. At its source, Gangotri, the winters are getting warmer and reducing the amount of snow needed to regenerate the glacier, which is retreating at an alarming rate. Further down, the water flow has been severely reduced by major dams, one near Haridwar and one at Tehri, diverting the Himalayan snowmelt waters into the upper Ganges irrigation canal built by the British in 1854.

THE BEGINNING

My journey started at the age of 11, when I took the number 12 bus from Dulwich to Oxford Street in London to visit Carnaby Street. There a man in saffron robes handed me a book full of amazing pictures of the Hindu gods – Shiva, Krishna and many more. Thereafter, my fascination with India and this river grew and grew, and it became my desire to travel from its source to its end.

I finally took the decision to start my pilgrimage in 2001, after finishing a major project in the US and feeling ready for more of a challenge. India and the Ganga certainly proved to be that challenge. It may not be the longest river in the world, but following its route can be tough. Days can be spent working out the correct route, and when the monsoon floods arrive, it can be

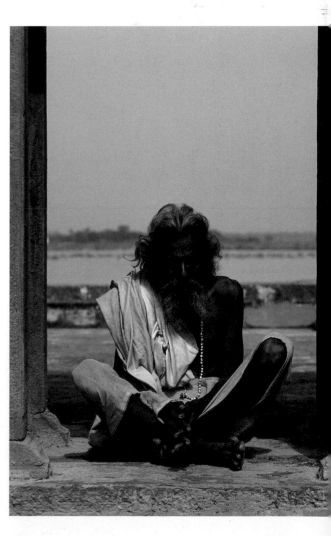

Opposite: Mother Ganga near the end of her journey, carrying with her the greatest fertility of any river in the world.

Below: Holy man in the holy city of Varanasi.

Overleaf: The flower market under Howrah Bridge, Kolkata.

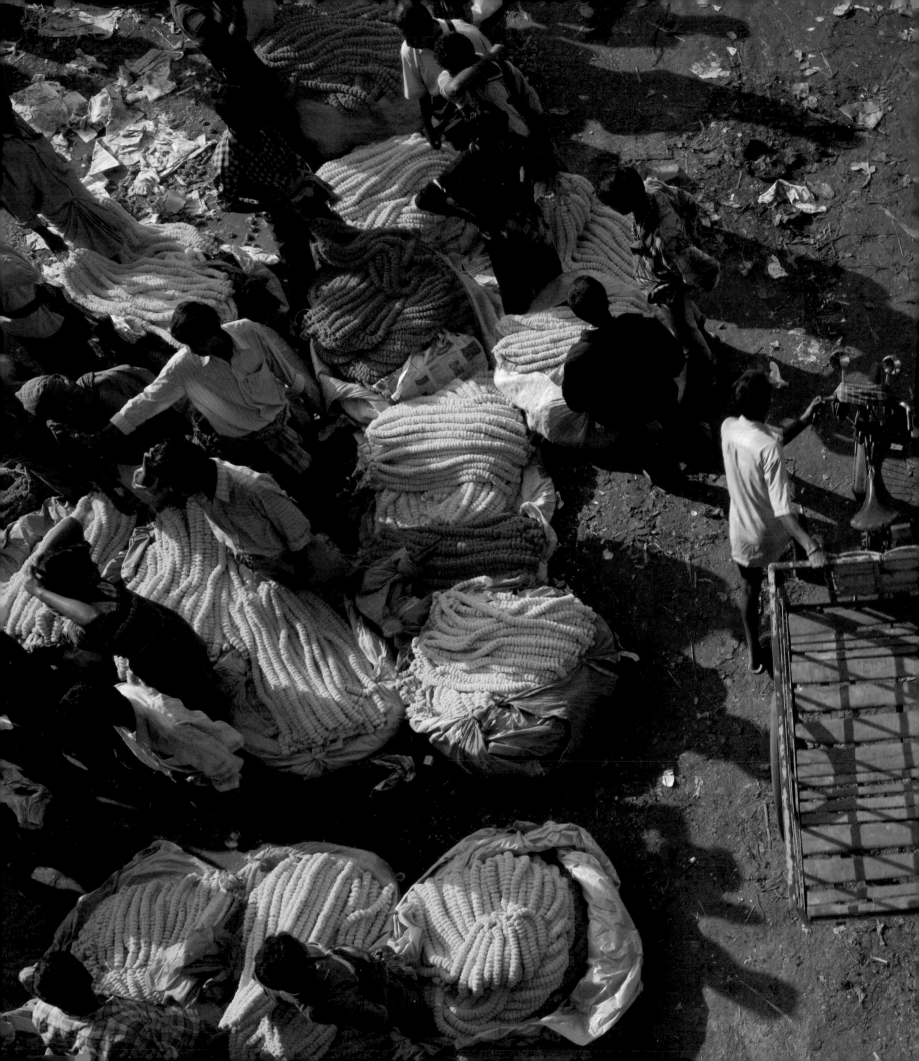

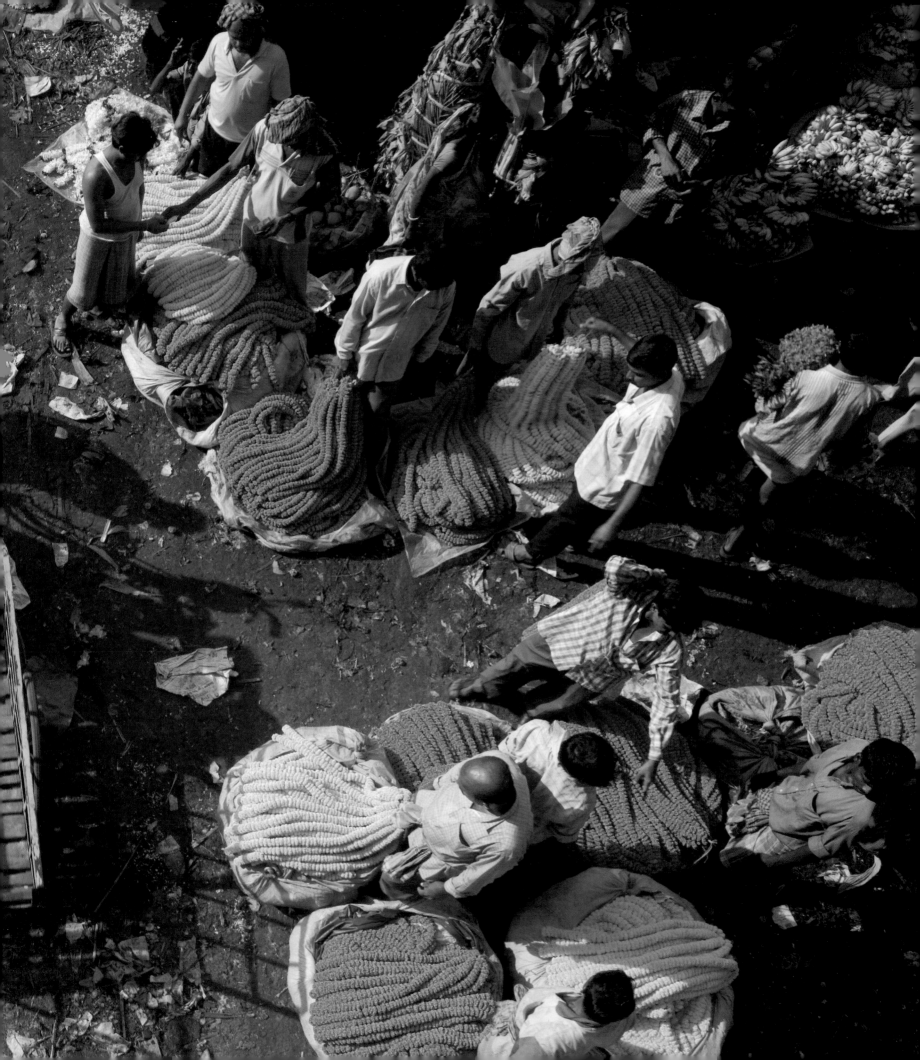

almost impossible to find the actual river. Poor roads and towns that you can never seem to find your way out of can turn 5-hour journeys into 14-hour ones.

My first foray was flying straight into the holy city of Kashi, also known as Benares or Varanasi. Eight million people live here in a city about the area of Cambridge in the middle of nowhere. The ride into the city to my hotel was pleasant. But once out in the streets, it hit me: the noise, the hooters, the smells, the colour, the fact that there were so many people. It's hard to find your way because one view looks like another, but there are plenty of people willing to help – for a rupee or two.

Below: Street colour, Varanasi – a city with 8 million inhabitants.

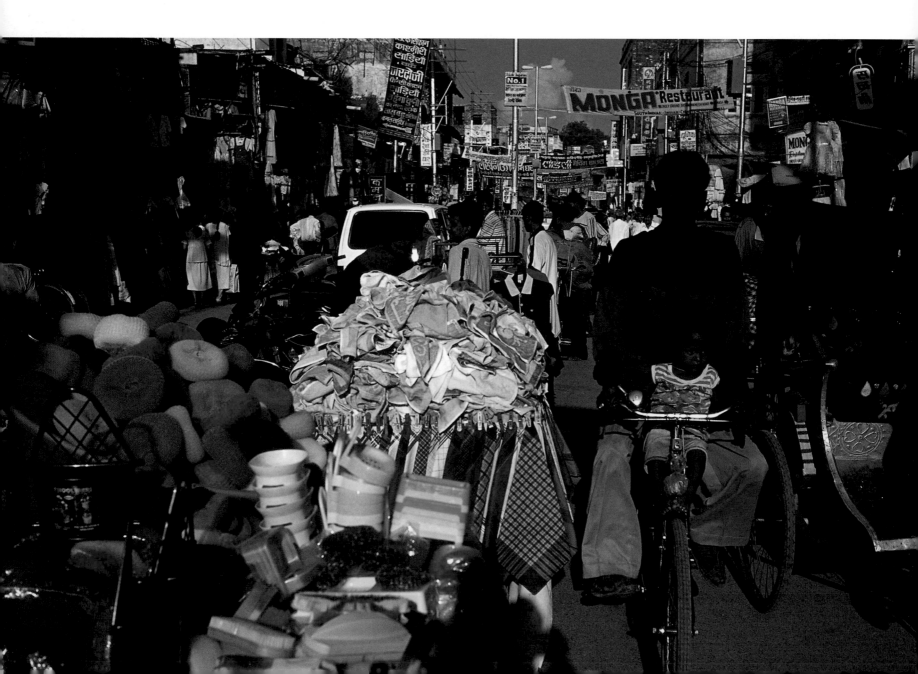

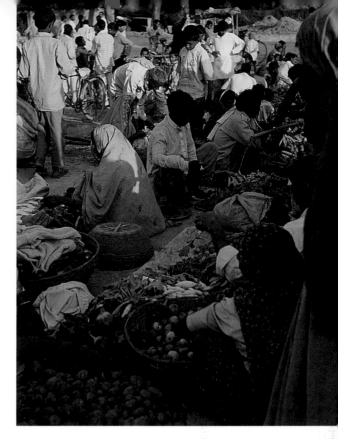

Above: Village market on the great Gangetic Plain – one of the most fertile areas in the world, supporting one of the densest human populations.

As I searched for the river, I became a little frustrated – surely it was just down the road or around the next bend. But, no, it took half an hour in a taxi to get me close. On foot, I headed in the direction the driver had sent me, full of excitement. But there were yet more crowds and even a market to press through. Then, abruptly, I was brought to a standstill. Open sky and, below me, as far as I could see in both directions was the reason for my journey – the Ganga, dwarfing all. A gentle, warm breeze and the smell of incense created a sense of total calm.

I sat on the ghats (the steps) and just watched. People were everywhere, running around doing this and that, and boats were gently drifting downstream. I had begun my journey.

After two weeks in Varanasi, I returned home to plan and research. With other commitments, this project was to take years, because even when I managed three trips a year, doing a different section each time, there were always some trips when I made little headway along the river.

I started travelling with a friend of mine, who brought two of his staff with him. It made a huge difference, as we would camp in total isolation, build a stove in the earth, eat well and drink warm beer.

A man who gave me a great sense of purpose and visual companionship on the journey was the photographer Raghubir Singh, a pioneer of colour photo-journalism, who died in 1999 but whose pictures of India from 20 or more years ago were an inspiration.

He got his first glimpse of the great river from the heights of the Granary in Patna, which is where I went in the summer of 2006. But the view of the river is now totally eclipsed by new buildings. The exact course of the river also changes. One town, Kanuj, used to be a fishing port but is now about 8 km (5 miles) away from the river, and quaysides are now streets. Fishing has been replaced by perfume-making.

A project like this does not come without other hurdles: camera gear packing up, getting robbed – though, surprisingly, not getting ill or bitten. Scary moments came in the higher reaches while hiking to the Gangotri glacier and the Cow's Mouth (where the meltwaters appear from the ice wall). We travelled early in the spring, when snow was still falling. Avalanches had blasted several sections of the track clean away, and rocks would whistle past, smashing into the river below. As we crossed one section, which was basically a mudslide, I watched in horror as a huge boulder came hurtling towards my friend Rajawat, who froze for a second but moved in time to escape being hit. (A week later, on our descent, we heard that a French climber had been hit by a rock.)

THE END OF THE JOURNEY

My vision of Kolkata (Calcutta) was a city of dirt, poverty and crumbling buildings. Arriving for the first time at night did not help. I had hoped for a glimpse of the river cutting a path through the night lights of the city, but fog on the approach to the airport prevented any view.

On the first afternooon, though, all my misconceptions disappeared when I ventured out to walk along the riverbank and see the two great bridges, the Howrah and the Hooghly. The Howrah is the oldest bridge in Kolkata, renowned for its traffic: trucks, taxis, rickshaws and coolies dragging wagons with incredible loads, being pushed on by the ever-present sound of hooters. Beneath the bridge, flower markets throng to buzz of bees. I did not once get hassled to buy something or take a taxi. People here don't have time to worry about foreigners.

Kolkata is a great city, with the third highest wages after Delhi and Bombay. In the past, it has been a haven for many thousands of people fleeing floods, war and crop failure, and the old factory buildings speak of good times. It also has great beauty, and many buildings hark back to when the British were here and the East India Company occupied the river frontage. Of course there is still the dirt, but Kolkata is cleaning itself up. There are waste-management programmes, and the people are taking pride in their city.

Above: Postbox —
remnant of the days of
the British Raj, Kolkata.

To many, the most famous name to emerge from Kolkata is that of Mother Teresa of the Sisters of Mercy and the house at Kalighat. Though Mother Teresa is gone, the work she and her sisters started many years ago continues, and the beds are still full of the sick. The sisters venture out in pairs to visit people who need help, and donations of food and money, however small, are all gratefully received. I was granted permission to enter and take pictures here after six years of asking and feel honoured to have seen this great humanitarian place at work.

Downstream is a rich and fertile area, the beginning of the world's biggest delta. When the monsoon rains stop, work gets under way to rebuild the mud walls that prevent crops being washed away and villages being cut off by the huge tidal surges.

In January, the beach of Sagar Island is full of pilgrims bathing to heal their illnesses and pay respect to the Ganga as she enters the vast tidal basin. What I tried to do was visit this and the other holy places when the melas (festivals) were not in progress, to see day-to-day pilgrims making their pujas (ceremonies). So though you may see some festivals illustrated in this book, the big melas are not present. Sadly, I only had time for one visit to the Sundarbans, the largest

mangrove swamp on the planet. More mud passes through here than anywhere else in the world. It is home to the Bengal tiger, an animal feared by the villagers. A friend of my guide was recently admitted to hospital after being mauled, the right side of his body so badly damaged that the doctors were not sure he would survive.

I stood on the beach at Sagar Island, among millions of red crabs, and looked out to sea, knowing that I had ended my journey. Looking down at the water, I remembered the day I had stood watching the meltwater tumbling out of the Cow's Mouth high in the Himalayas, rushing away to start its own journey. How much of that water runs out into the sea? Who knows?

I thank all those who helped me get to this open beach, all those who let me photograph them – who let me into their lives for a small glimpse of life on the banks of this mighty river. Also thanks to my late wife (who has now reached nirvana) for letting me start this journey, and to Molly, Maisy and Sam for allowing me to finish it. This is for you with love.

JON NICHOLSON

Below: The joy of life. Swimming games in the delta of the great Ganga.

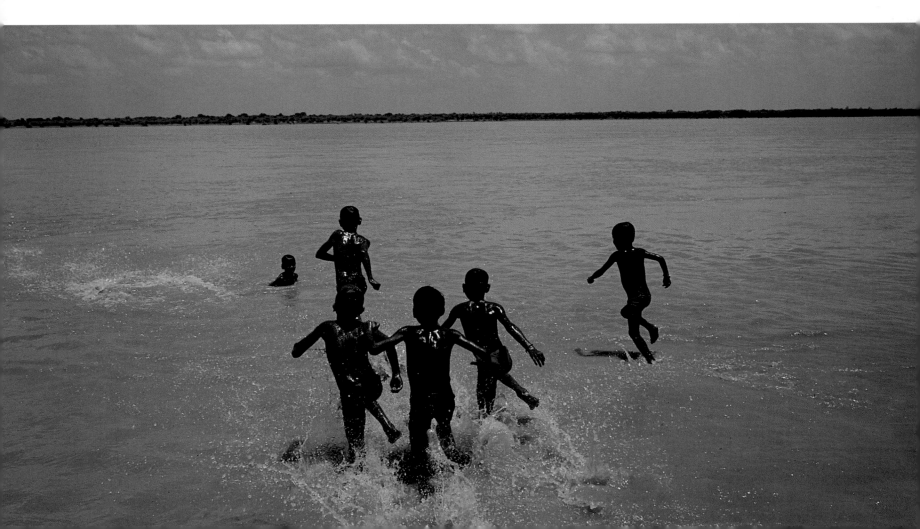

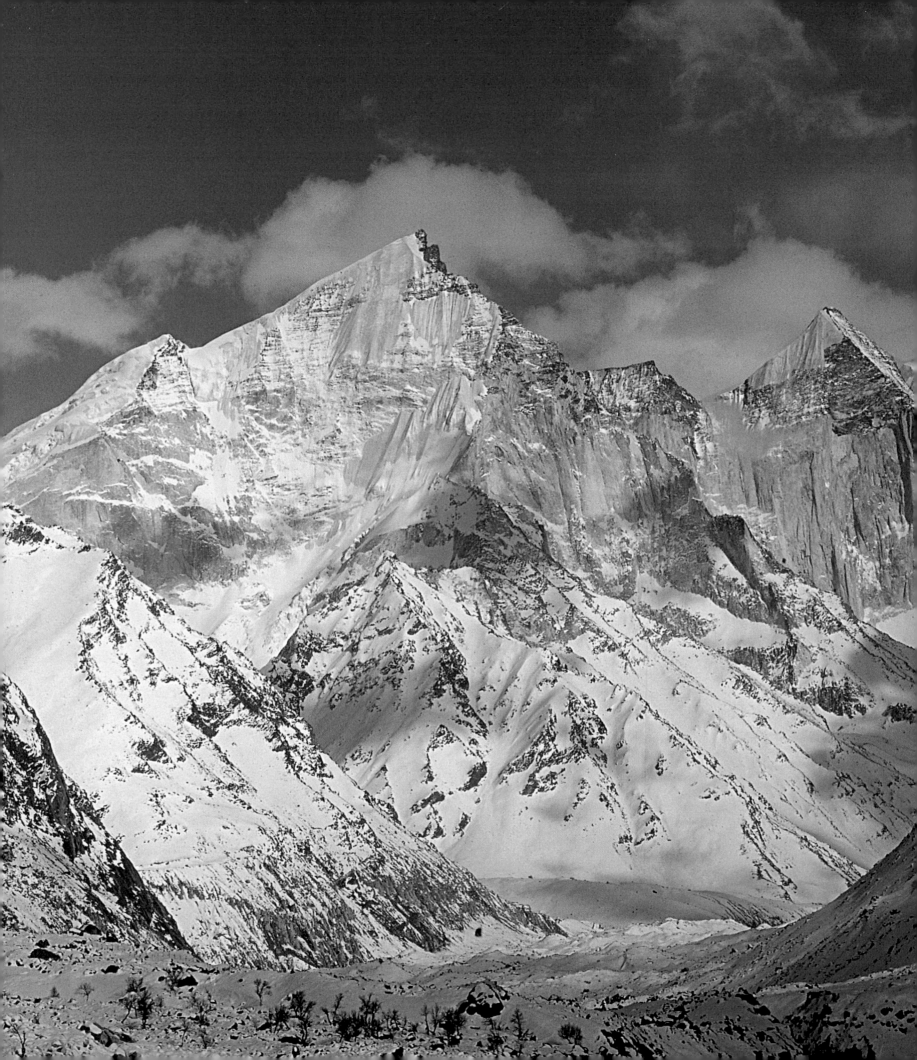

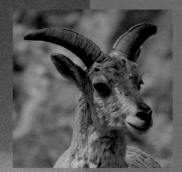

CHAPTER 1

DAUGHTER
OF THE
MOUNTAINS

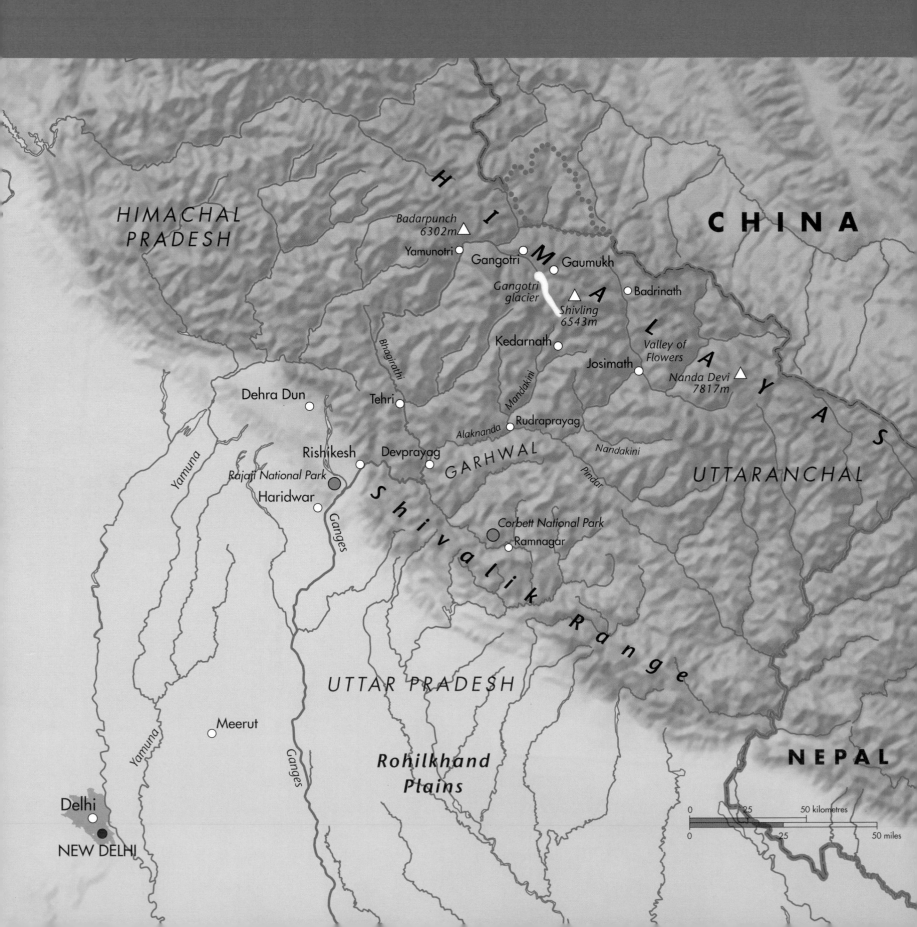

HIMACHAL
PRADESH

CHINA

H I M A L A Y A S

Badarpunch
6302m

Yamunotri Gangotri Gaumukh

Gangotri
glacier Shivling
6543m Badrinath

Kedarnath Valley of
Flowers

Mandakini Josimath Nanda Devi
7817m

Dehra Dun

Bhagirathi Tehri

Alaknanda Rudraprayag Nandakini

Devprayag GARHWAL UTTARANCHAL

Rishikesh

Rajaji National Park Pindar

Haridwar

Corbett National Park

Ramnagar

S h i v a l i k R a n g e

Yamuna

UTTAR PRADESH

Ganges

Meerut

Yamuna Rohilkhand
Plains NEPAL

Ganges

Delhi

NEW DELHI

0 25 50 kilometres

0 25 50 miles

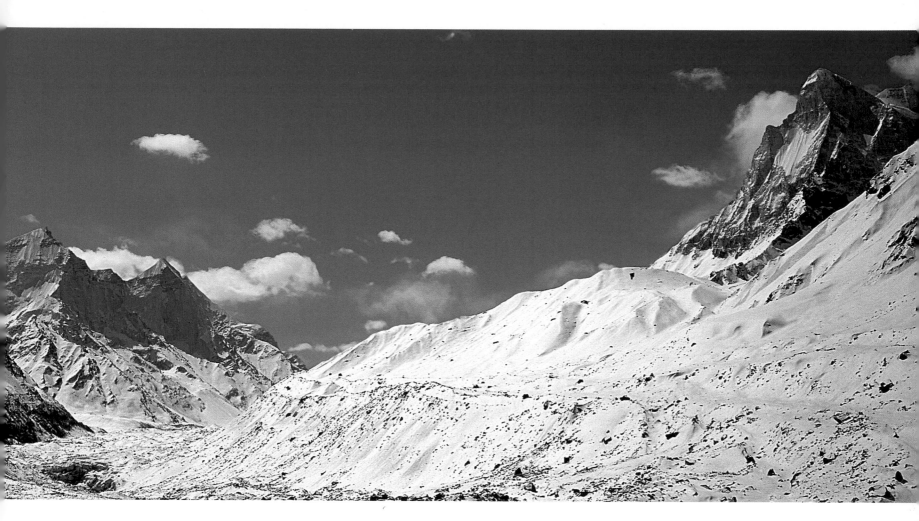

In India, the Himalayas have another name: Dev Bhoomi, Land of the Gods. Every feature is deeply symbolic for Hindus. The mountains are manifestations of all-powerful gods, and the innumerable streams and rivers fed by Himalayan glaciers are flowing forms of benevolent goddesses. The most exalted of these is Ganga, the Daughter of the Mountains.

Portrayed as voluptuous and beautiful, Ganga carries an overflowing pot that represents abundant life and fertility, because she nourishes and sustains the universe. She has become one of the most venerated deities in Hinduism, and the Ganges is the most sacred of all rivers. Bathing in the river's waters brings deliverance from sins committed in the present and in all lives past. The water is used for purification in Hindu ceremonies, and in the final hours of life, gangajal, or 'Ganga water', is administered to the dying for deliverance of the soul. Even immersing the ashes of the dead in the waters of the Ganga can guarantee them salvation.

Above: Manifestations of the gods. To the left, the sacred Bhagirathi sisters. To the right, Mount Shivling, where Lord Shiva came to Earth – a granite pyramid rising 6543 metres (21,460 feet) above the snout of the Gangotri glacier.

Previous page: The Bhagirathi peaks, all over 6000 metres (20,000 feet). The Bhagirathi glacier is formed from their snow.

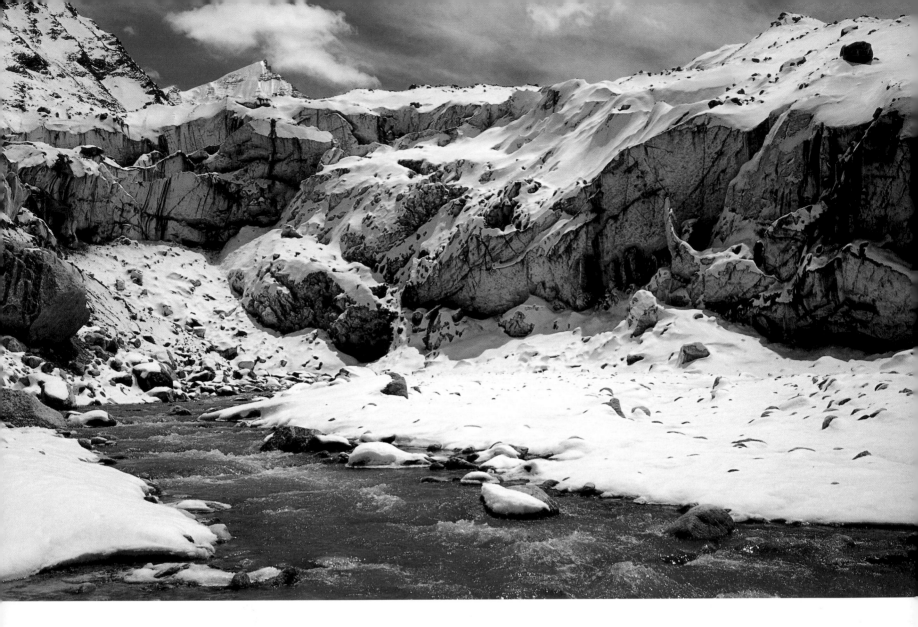

The source of the Ganges is therefore a place of great significance for millions of Hindus, and the mountain ranges where she has her beginnings are littered with shrines and temples and crisscrossed with pilgrimage routes followed by those seeking enlightenment. But where in the Himalayas does the river really begin?

Above: Sacred water running from Gaumukh, the Cows Mouth of the Gangotri glacier, to form the Bhagirathi river. The ice is now retreating at a staggering 34 metres (110 feet) a year.

THE BIRTH OF GANGA

Some answers can be found at the mountain village of Gangotri, high in the Garhwal region. Nestling in a deep gorge surrounded by pine forest, Gangotri is where the heavenly Ganga touched the Earth for the first time and is one of the most sacred places in all India. Ganga was brought to Earth by the appeals of King Bhagirathi, one of the great heroes of Hindu mythology. The sons of the king's great-great grandfather, King Sagar, had been reduced to ashes by the wrath of the sage Kapil Muni, whose meditations they had interrupted. Only Ganga could ensure the salvation of their souls by cleansing their ashes with her pure waters.

Persuaded by Bhagirathi's pleadings, Ganga plunged to Earth as a raging torrent, one that would have crushed the Earth but for the timely intervention of Lord Shiva, who absorbed the power of the falling waters with his head, gathering the cascades in his long matted locks and then releasing them as gentle streams across the mountains.

The rock where Shiva stood to perform this feat is said to lie in the stream running through Gangotri but is only visible in early winter, when the water levels are low. Up here, the stream is not yet called the Ganga but the Bhagirathi. Nearby is a spectacular 30-metre-high (100-foot) waterfall, which is venerated as an earthly reminder of the Ganges' tumultuous descent and marks out Gangotri as a place where Heaven and Earth come together.

On the banks of the stream is an eighteenth-century white granite temple dedicated to Ganga, where pilgrims perform their puja, or act of worship, before a ritual dip in the freezing water. This simple building once stood close to the snout of the Gangotri glacier, from which the Bhagirathi originates, but today the glacier ends 20km (12 miles) further up the valley and is still shrinking as the climate warms.

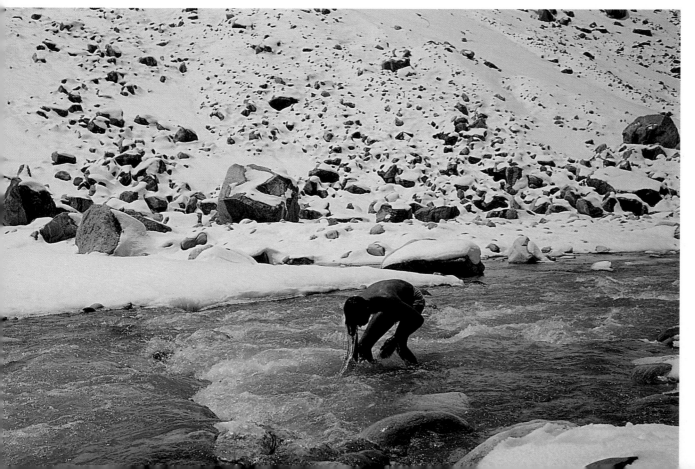

Left: A pilgrim washing away his sins in the icy meltwater. Lord Shiva used his matted locks to absorb the power of the raging torrent of Ganga as she fell to Earth.

Overleaf: Pilgrims descending from the Gangotri glacier in spring. They risk rock-slides and avalanches.

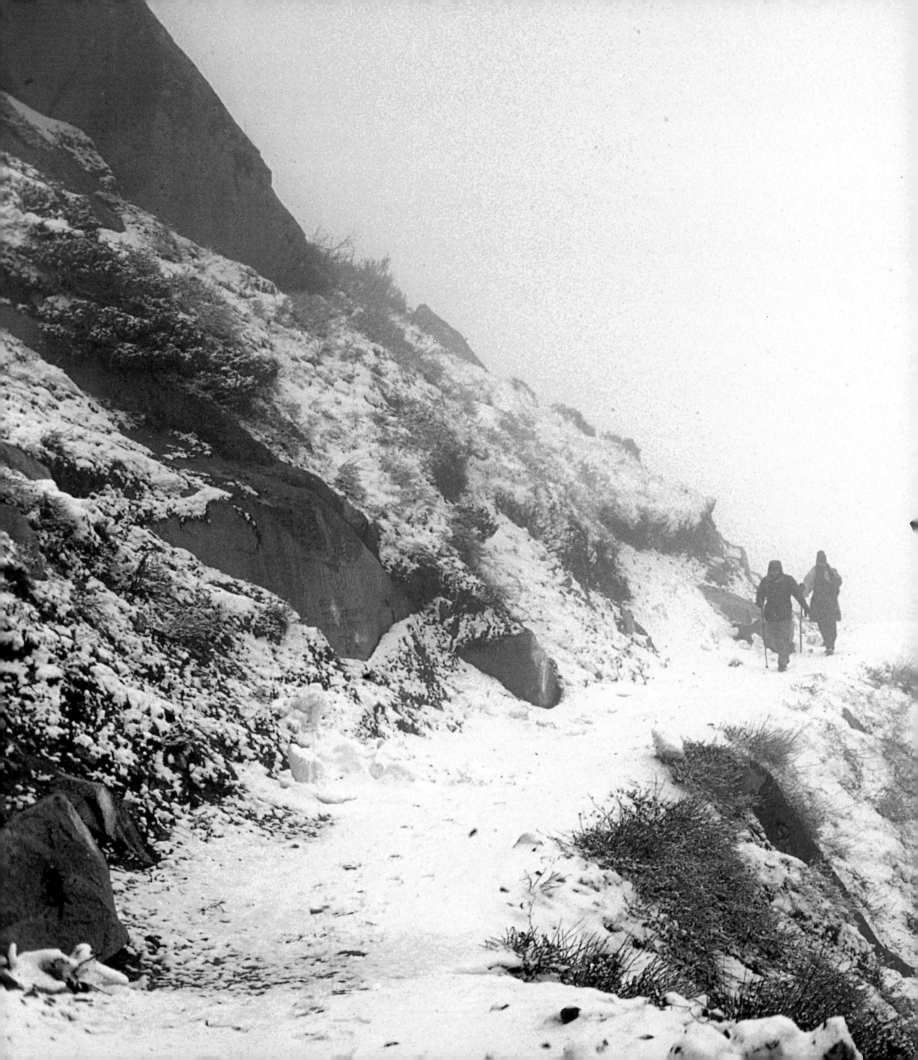

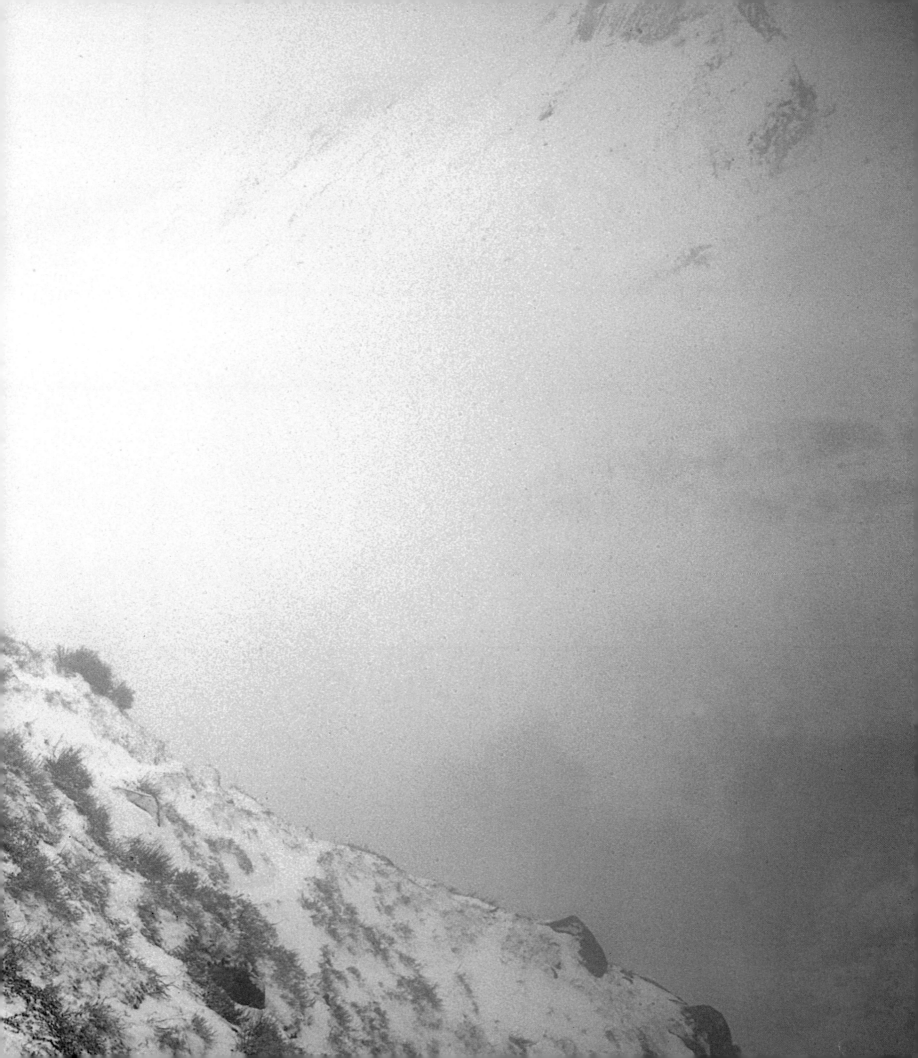

The retreat of the Gangotri glacier – 850 metres (2790 feet) between 1971 and 1996 alone – is one of the most dramatic signs of global warming anywhere, and it has huge implications for the future of the Ganges. Another 1000 or more glaciers drain into the Ganges, and all these great ice fields are shrinking faster than glaciers in any other part of the world. If the present rate continues, it's predicted that they will vanish within 40 years, reducing the flow of Himalayan rivers such as the Ganges by as much as two thirds. The result will be widespread water shortages for the 500 million people on the plains below and a dramatic reduction in the area of India's irrigated farmland.

Below: The waterfall at Gangotri – the spot where the goddess Ganga landed when she fell from Heaven.

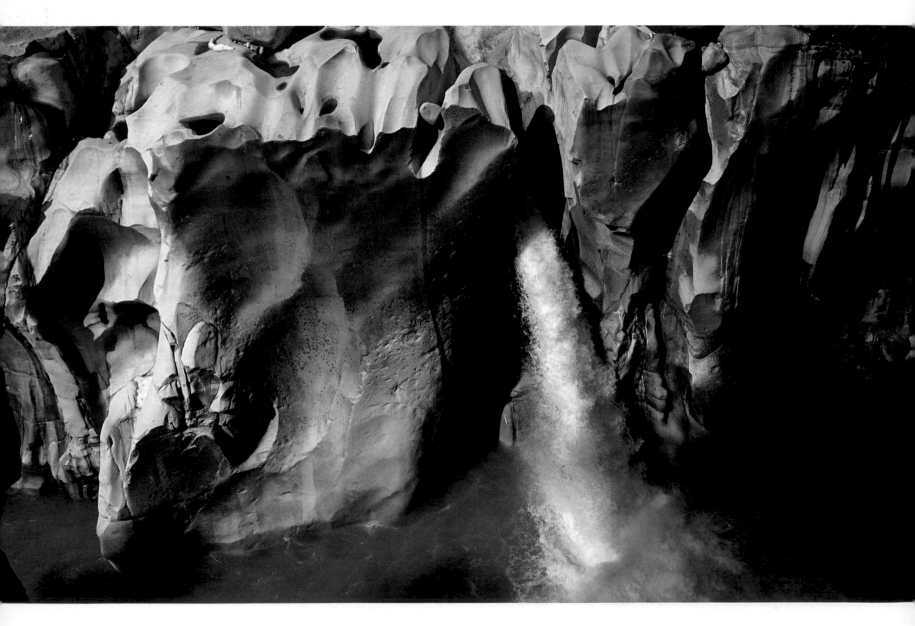

The temple at Gangotri may mark the spiritual source of the river, but for the true source, dedicated pilgrims must now march for two more days up into the mountains. It is said that the journey is so dangerous and demanding that you should undertake the pilgrimage only after the fulfilment of all family responsibilities.

After two days' hard walking, devotees come face to face with the shattered snout of the Gangotri glacier – a huge ice wall with an ice cave 30 metres (100 feet) across at its base, from which flows a milky meltwater stream. This is Gaumukh, the Cow's Mouth' – the source of the Ganges.

Apparently oblivious to the cold, the most devout pilgrims and sadhus, or holy men, plunge into the freezing water for their ritual baths – dipping three times, washing and offering the water in cupped hands towards the sun. But this is not a place to linger. More dangerous than the intense cold is the unstable ice wall, great chunks of which regularly fall into the stream below, occasionally killing people.

The actual source of the Ganges, however, exists up above the glacier in the meadows of Tapovan, surrounded by some of the region's highest peaks – Shivling, Bhagirathi, Srikailash and Meru. In summer, the meadows are criss-crossed with meltwater streams pouring down from the peaks. And since these streams feed into the Ganges, they could be considered the true fountain of life.

HIGH LIFE

These glacial valleys and wild peaks are bleak and barren places. But they are not devoid of life. The creatures that survive here are among the most striking in the Himalayas. One of the biggest predators is the snow leopard, with grey and white fur that camouflages it among the blasted landscape of rock and ice and protects it from the extreme cold. Snow leopards have been seen crossing ridges as high as 5500 metres (18,000 feet), and with their short, powerful legs and large paws, they can move over the most rugged terrains, using their long tails for balance.

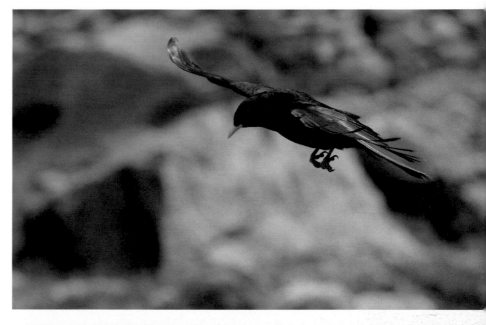

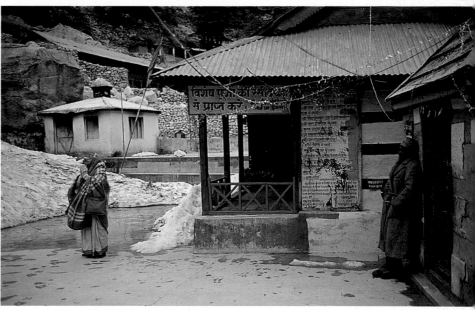

Above: A woman prays outside the temple in Gangotri. Bad weather has prevented the return of the statue of Ma Ganga to the temple.

Top: Yellow-billed chough, high-altitude survivor.

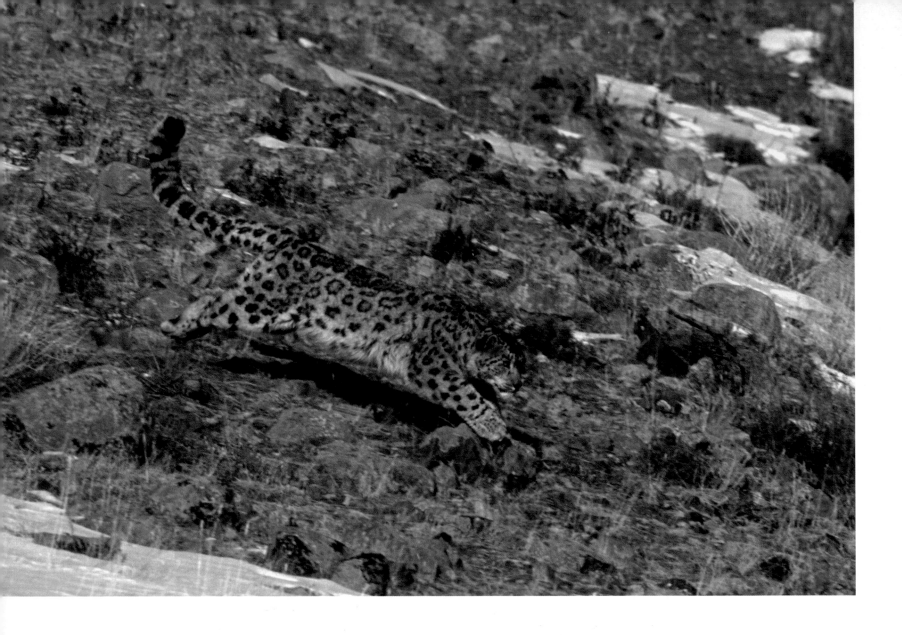

The snow leopard's main prey is the horned bharal, or blue sheep (a 'goat antelope' rather than a true sheep), which is abundant around Gaumukh, grazing on the thin cover of grasses. With an absence of cover, the bharal's defence is to freeze when approached, relying on its colour to blend into the rocks. Once spotted, it will race away up the precipitous cliffs and then freeze again, melting into the rock-face. The snow leopard's hunting strategy is to use the cover of dusk and dawn to stalk the bharal, approaching as close as possible before a final sprint. Since its prey is often heavier than itself, the snow leopard may remain close to its kill, returning over a period of three to four days to feed.

The bharal move up and down the mountains with the seasons, leaving the snow leopard no option but to follow them below the tree line. Yellow-billed choughs, though, survive at high altitudes all year round and have even been recorded at heights of 8330 metres (27,300 feet). Most of the year, they are insectivorous, probing the earth with their bills and digging holes in search of insect larvae, but in winter they survive by scavenging on anything they can find – including the offerings left by pilgrims at the shrines around Gaumukh.

Above: Snow leopard – endangered through loss of habitat and prey. It is also still persecuted by sheep and goat farmers and is hunted for both its fur and bones – used in Chinese medicine.

Opposite: Bharal, or blue sheep – staple prey of the snow leopard. Like its predator, it blends in well with the rocky mountain terrain.

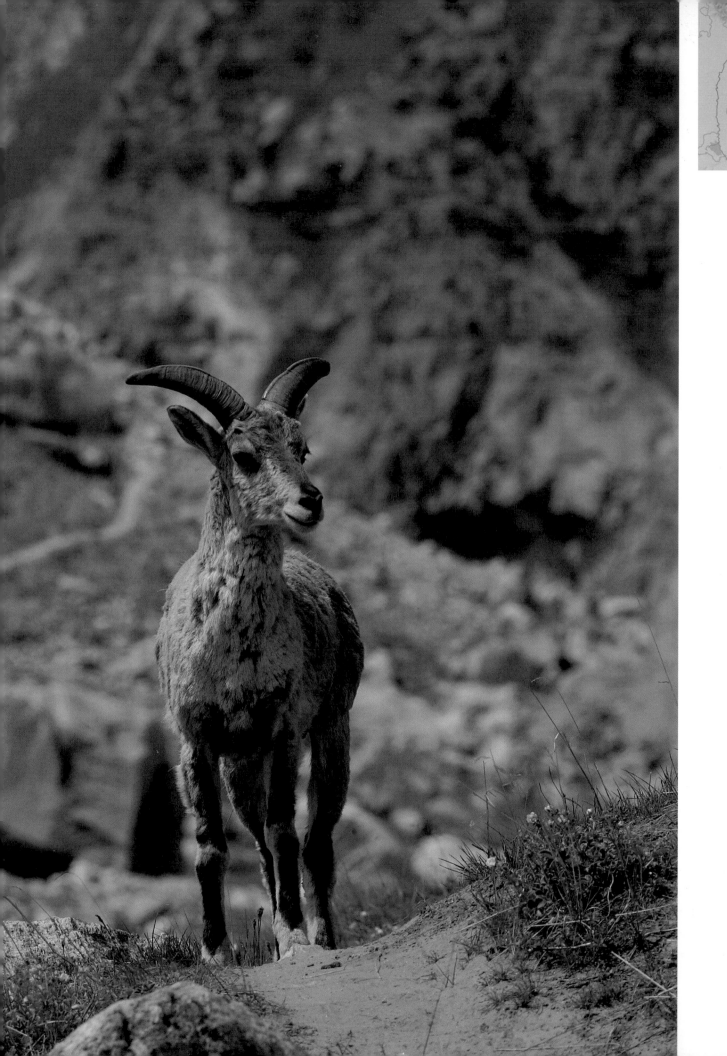

THE CHAR DHAMS

Gaumukh is the ultimate destination for the most devout, and to visit the headwaters of the sacred river brings great prestige. Not many of India's 900 million Hindus are able to make the tough trek to this remote spot, but each summer, many hundreds of thousands head into the Garhwal Himalayas on a pilgrimage known as the Char Dham Yatra.

The route takes in four of the most hallowed shrines in the Himalayas. Each temple sits on one of the main streams that ultimately form the Ganges. The first is the Bhagirathi at Gangotri, but pilgrims must also visit Yamunotri on the Yamuna, Kedarnath at the headwaters of the Mandakini, and Badrinath on the banks of the Alaknanda. But the timing of this pilgrimage is crucial.

The harsh conditions in the Himalayas mean the temples can stay open only for the short summer season. In the autumn, the deities are carried from their temple homes to their winter quarters in the lower valleys, and the shrines are closed down and barred against the ferocious winter weather. Only in the late spring, as the snow melts, do the gods re-emerge and, with great ceremony, are carried back up into the mountains to mark the reopening of the temples.

KEDARNATH

One of the most spectacular of these processions is the one that brings the god Shiva from his winter quarters in the village of Okimath up to his summer residence in the temple at Kedarnath, the second of the char dhams. He's carried on a doli, a chair mounted on four poles. After blessings, the doli is shouldered by barefoot devotees and is taken on the long trek back up to Kedarnath. It takes four days to cover the 60km (37 miles) and a climb of more than 2000 metres (6560 feet). The procession involves the rawal, or head priest responsible for Kedarnath, along with his temple assistants and the Garhwal Rifles bagpipe band. As the pilgrimage enters towns and villages along the route, people come out to throw rice and flowers over the doli, and the group stops to worship at each local temple.

Above: Himalayan pika watching for danger.
It is eaten by almost every predator, from weasels and foxes to bears and hawks.

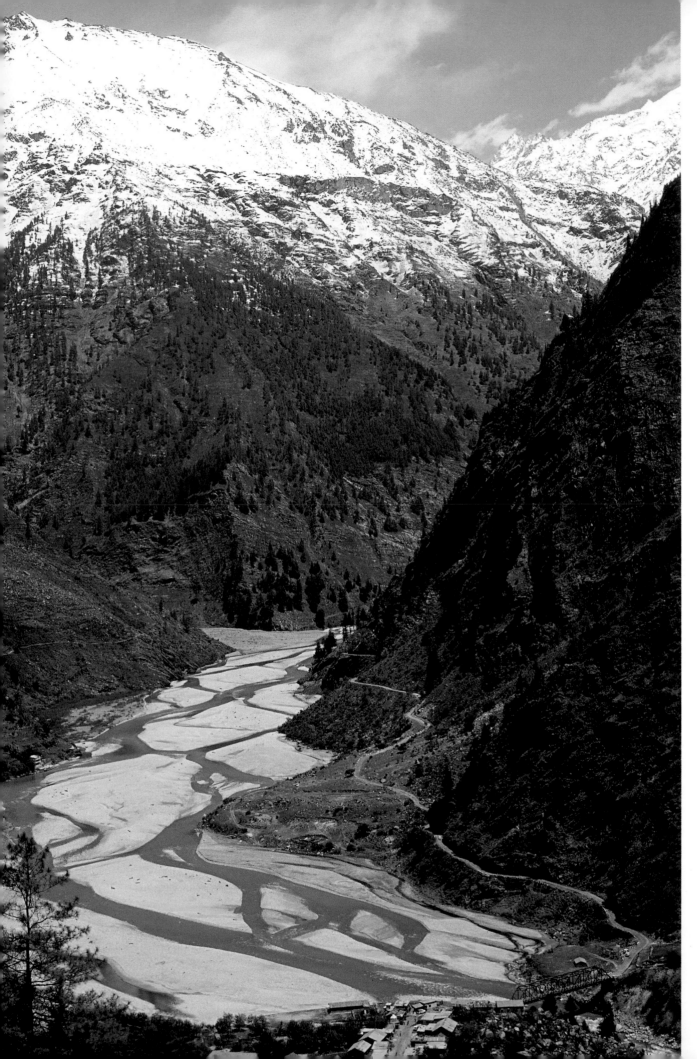

Left: The Bhagirathi river, late spring. Once it reaches Devprayag, it is officially the Ganges.

Overleaf: The town of Tehri – site of one of the most controversial of hydroelectric dam projects. Built on a major fault zone at the confluence of the Bhagirathi and Bhilangana rivers, the Tehri dam has greatly reduced the flow of water from the Bhagirathi into the Ganges.

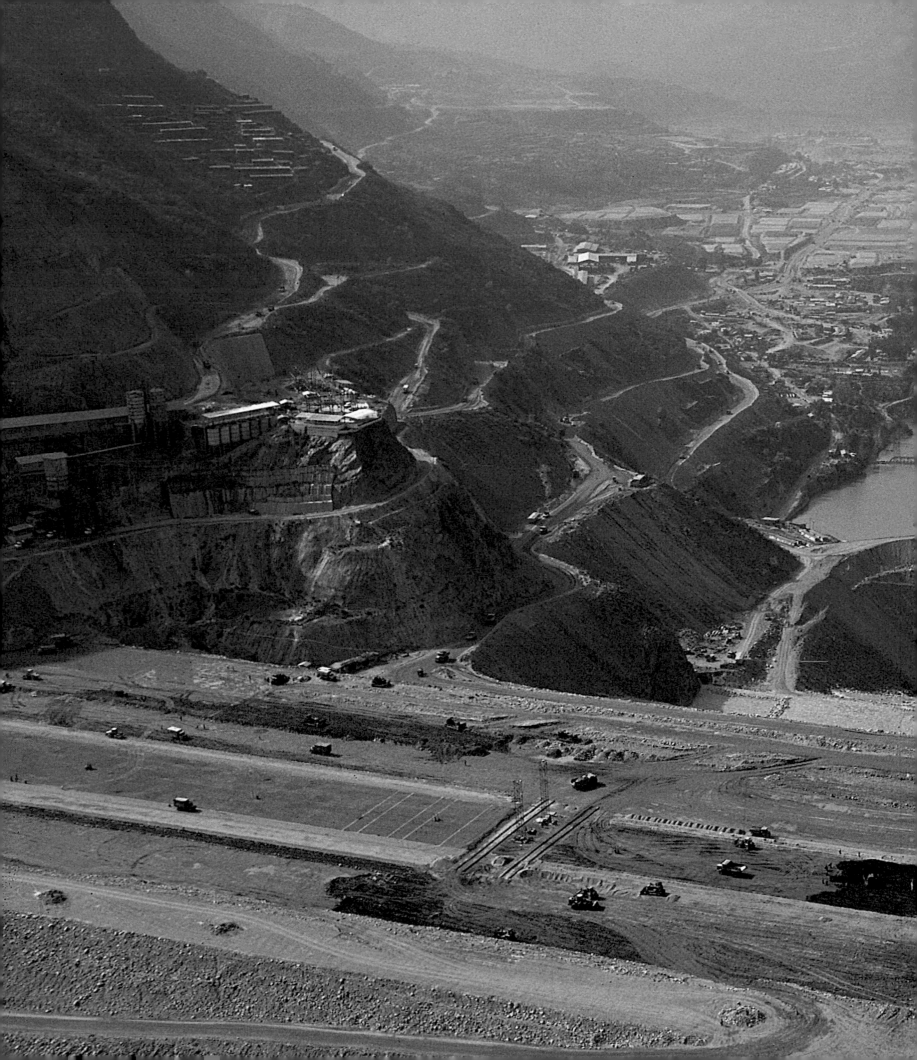

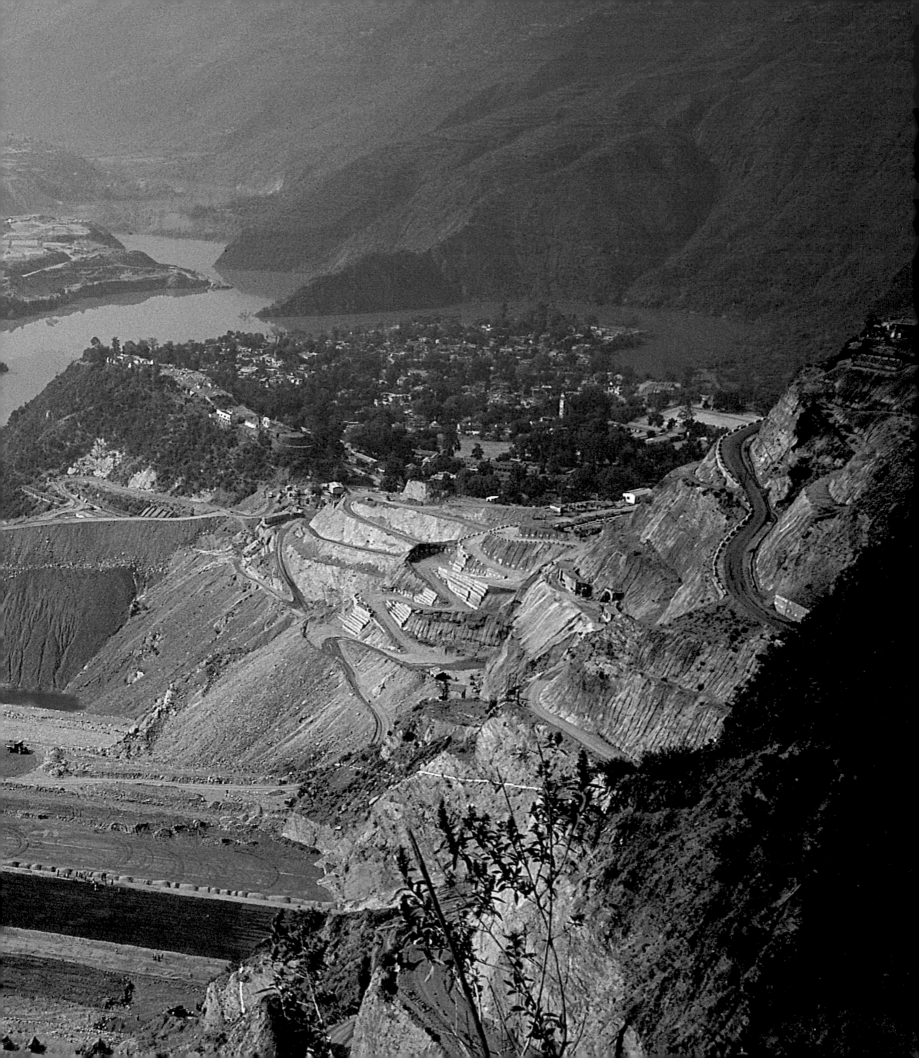

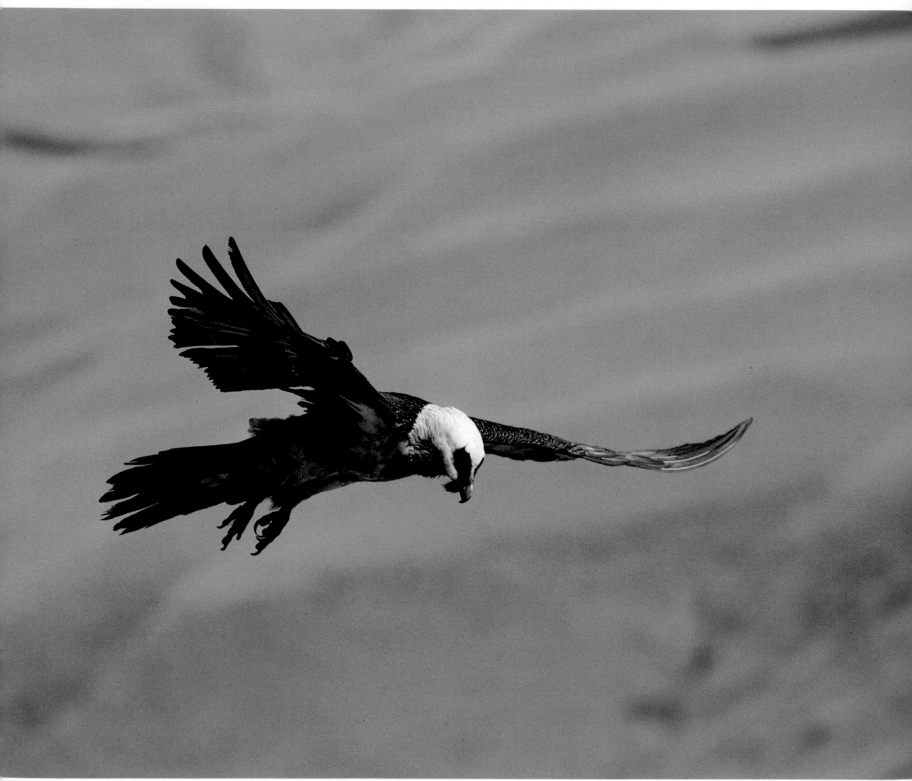

At 3800 metres (12,500 feet), Kedarnath is the highest and most remote of the char dhams, sitting in a wide valley on the banks of the fast-flowing Mandakini river and surrounded by towering peaks, including Kedarnath itself, at 6940 metres (22,760 feet). The temple here is thought to be at least 1000 years old and is built of extremely large, evenly cut granite slabs – an impressive feat of construction, given the building's location and age.

Opposite: Bearded vulture – bone-breaker and scavenger soaring over the high valleys.

Once the idol is installed, the temple is declared open. Almost overnight, Kedarnath is transformed from a ghost town, as thousands of pilgrims pour in from the lower valleys. The last 14km (9 miles) is up a steep, narrow track, and to reach the temple, many pilgrims will have walked barefoot, often through drifts of late snow. After performing their puja (worship), they turn around and descend again to the more welcoming valleys.

Above: Awaiting submergence. The massive Tehri reservoir, created to supply power and water for irrigation, has now drowned the town of Tehri and the villages around it, displacing an estimated 100,000 people.

All year round, the Kedarnath region is home to bearded vultures, which weigh up to 8kg (18 pounds). They soar effortlessly across the valleys and over ridges on their 3-metre-wide (10-foot) wingspans, catching wind currents and thermals, staying aloft for hours at a time with hardly a flap. If food is scarce, bearded vultures may fly 30–40km (19–25 miles) a day. Most of their diet is made up of carrion, small mammals, other birds and the marrow from large bones. Sometimes the bones themselves are eaten, digested by the birds' strong stomach acid, but more often they are picked up and dropped onto the rocks below. The bearded vultures' superb eyesight enables them to see the shards of broken bones, and it is then a simple matter of swooping down and eating the marrow.

BADRINATH AND THE SACRED MOUNTAIN

The third char dham, Badrinath, at 3122 metres (10,240 feet), is lower than Kedarnath but lies only a few kilometres from the Tibetan border. A forest of badri (berry) trees, known as the mythical Badrivan, once covered the area, giving the place its name. Dedicated to Lord Vishnu, the temple at Badrinath, on the banks of the Alaknanda, is very different from the austere grey granite of Kedarnath. The original shrine, built by the ninth-century saint Shankara, has been rebuilt several times because of damage from avalanches and snowfall. Made of wood, it stands 15 metres (50 feet) high and is topped with a gilded cupola. The highly decorative exterior is painted in bright reds, yellows and blues every year before the temple gates open.

Below: Hill predator. Leopards still survive in the hill country, but where normal prey has been reduced by habitat loss or overhunting, they are often forced to feed on livestock and dogs.

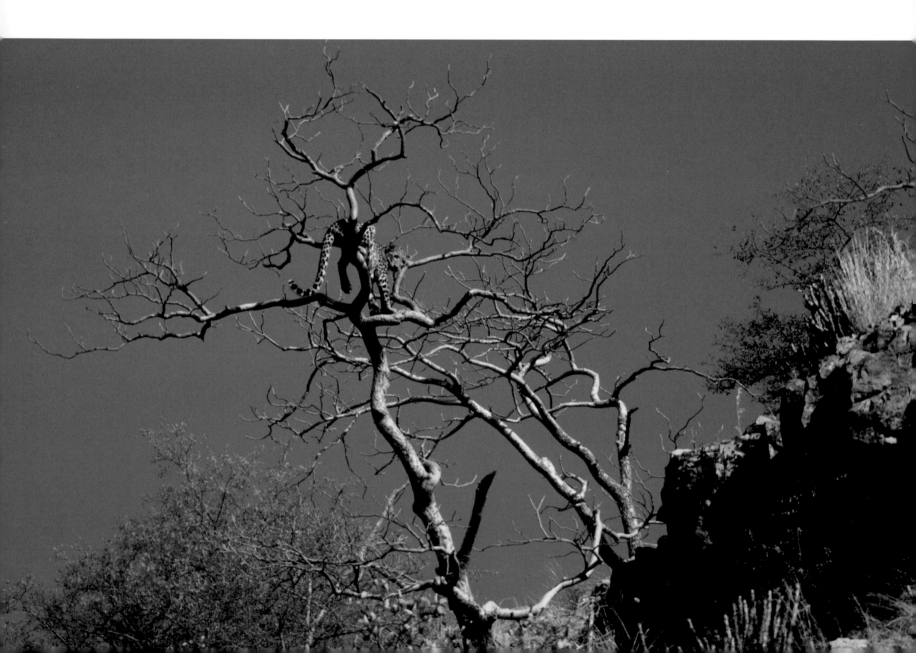

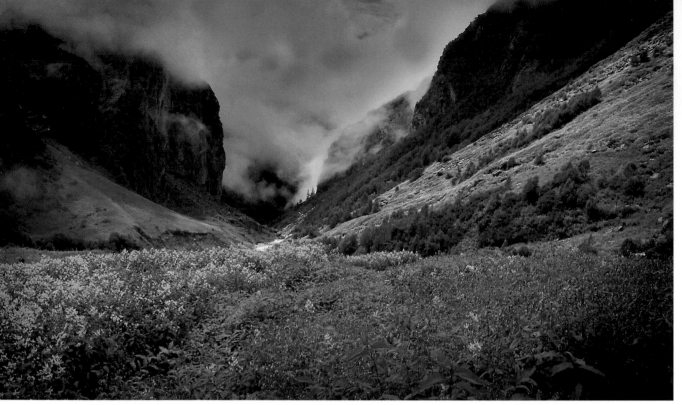

Left: The spring blooming of the alpine pastures of the Valley of Flowers. Here, Himalayan balsam carpets a bank of the river, but earlier in the summer and spring, a succession of flowers, including many rarities, provides a kaleidoscope of colour.

Nearby is the highest of all the Himalayan peaks in this region, Nanda Devi, at 7816 metres (25,636 feet). The name means bliss-giving goddess, and the peak is regarded as the patron goddess of the Garhwal Himalayas. The sacred mountain is guarded by a seemingly impenetrable ring of peaks, themselves among the highest mountains in the Indian Himalayas – 12 of them exceed 6400 metres (21,000 feet). These form the Nanda Devi Sanctuary, which has kept the region all but untouched, making it a wonderful place to see wildlife. Today, Nanda Devi sits at the core of the Nanda Devi and Valley of Flowers National Parks – a Natural World Heritage Site – and the main summit has been off-limits to climbing expeditions since 1982. But even when it was open, few mountaineers reached its summit. It took 50 years of arduous exploration just to find a passage into the interior of the almost insurmountable ring of protective peaks.

In 1934, the British explorers Eric Shipton and H.W. Tilman, with three Sherpa companions, Angtharkay, Pasang and Kusang, finally discovered a route by working their way along the walls of the deep gorge cut by the Rishi Ganga. When the mountain was later climbed in 1936 by a British-American expedition, including Tilman and Noel Odell, it became the highest peak ever climbed until the ascent of the 8091-metre (26,539-foot) Annapurna in 1950.

THE VALLEY OF FLOWERS

In the Nanda Devi World Heritage Site is one of Garhwal's most spectacular areas. In 1931, the English mountaineer Frank Smythe, on his way back from an expedition to Mount Kamet, was forced by bad weather to descend into a remote glacial valley. Here he stumbled across a botanist's dream – 8km (5 miles) of wild flowers. He christened it the 'Valley of Flowers'.

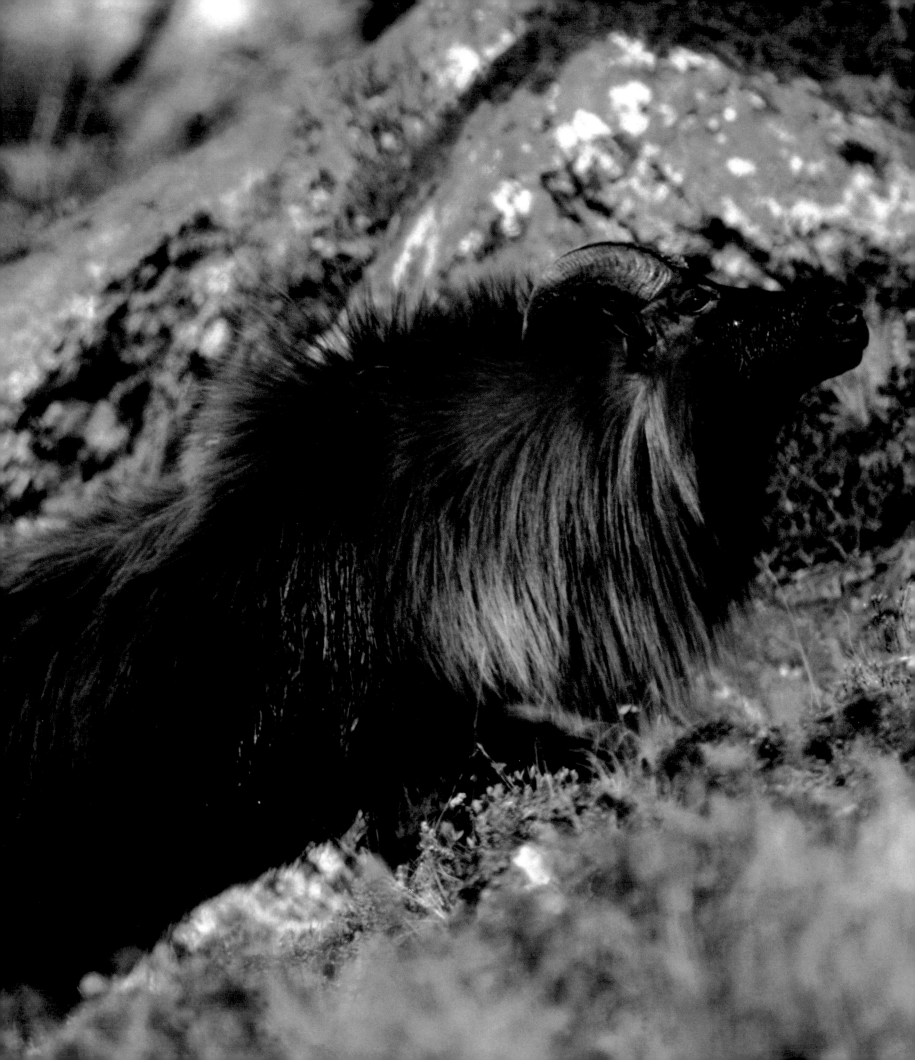

The Pushpawati river, a tributary of the Alaknanda and therefore the Ganges, waters the Bhyundar valley, as it is known locally. For much of the year, the valley is buried in snow, but the spring thaw brings about a transformation. Each week, different flowers come into bloom, creating an ever-changing kaleidoscope of colours. Some 600 species have been recorded, including orchids, primulas, calendulas and anemones. Some of the rarities include the elusive brahma kamal, the cobra lily, the Himalayan edelweiss and the Himalayan blue poppy. The locals say that the valley is inhabited by fairies, who will carry off anyone who ventures too far into their domain, and that there are flowers growing there with a fragrance so potent it can make you faint.

When the government declared the Valley of Flowers a national park in 1981 and banned visitors, it also banned local shepherds and their sheep, on the assumption that sheep would destroy the ecological balance of the system. Over the past decade, a very aggressive polygonum, a kind of knotweed, which was previously eaten by the sheep, has invaded and swamped the more delicate alpine plants. Now a belated eradication programme is attempting to redress the balance and restore the meadows to their full glory.

The Valley of Flowers is just one of a number of spectacular alpine pastures that can be found all across the headwaters of the Ganges. These meadows, or bugyals, and their surrounding grassy slopes are magnets for wildlife. These are the haunt of goat-like mammals, such as the tahr and the smaller goral, and are also visited by Asiatic brown and Asiatic black bears.

SISTER OF THE GANGES

The Yamuna river starts as an icy, crystal-clear stream from the high lakes of Saptarishi Kund on the flanks of the 6302-metre (20,670-foot) peak of Bandarpunch. Considered the sister river of the Ganges, it follows a parallel course down through the mountains, often flowing only a few kilometres from it but uniting with the Ganges far out on the plains at the holy city of Allahabad.

The fourth of the char dhams is near the Yamuna's source, in the village of Yamunotri. The temple dedicated to the goddess Yamuna found here was built about 80 years ago, but there have been temples on this site for hundreds of years – continual rebuilding is needed because of the region's regular earthquakes. Surrounding the temple are sulphurous hot-springs, another sign of the intense tectonic activity in the Himalayas. Pilgrims bathe in these springs before visiting the temple and also prepare offerings of potatoes and rice for the gods, wrapping them in muslin and lowering them into one of the hotter springs to cook.

MOUNTAIN POWER

The story of the Himalayas begins around 100 million years ago, when the chunk of crust that was to become India broke away from Africa somewhere near the South Pole and began to drift northwards. Moving at about 5cm (2 inches) a year (the speed human fingernails grow), the land mass was carried towards the great continental block of Asia to the north.

As the two continents approached each other about 70 million years ago, the seabed between them was forced upwards as if squeezed between the jaws of a vice. Thrown into great folds and ridges, these seabed rocks began to create the Himalayas. Today, India is still drifting northwards into Asia, squeezing the summits ever higher. Evidence of their seabed origins can be seen in the many fossilized sea-creatures that have been found throughout the Himalayas, even high up on Mount Everest.

The Ganges and its many tributaries have been carving their spectacular course through these growing mountains for millions of years. The vertical-sided canyons, gravel-strewn floodplains, heavily eroded ravines and spectacular waterfalls all attest to the erosive power of this great river. Though the Ganges flows throughout the year, it has a very variable rate, slowing in winter as the Himalayas freeze up and then surging down the valleys as it fills with spring meltwater. But it is the torrential monsoon rains that really turn the Ganges into a river capable of devastation.

The full power of the monsoon hits in the summer, as warm, moist air from the distant oceans finally meets the south-facing slopes of the Himalayas. Forced upwards, the clouds shed their moisture. Of the 2 metres (nearly 7 feet) of rain that falls in the lower Himalayas, 90 per cent falls in the short monsoon season, often as torrential downpours. River levels can rise by tens of metres in a few hours, only to subside just as quickly.

The early-season rains often cause the most damage. The earth is usually parched and rock-hard, and when the rain falls, it causes landslides that pour into the rivers, washing away roads and villages. Sometimes whole mountainsides disappear, sliding into the river, to be carried away to the plains. But such destruction results in some of the most fertile soils in the world, as the mud and silt end up being spread far and wide.

Recently, though, the level of destruction caused by the rains has increased alarmingly as the growing demand for wood for construction and fuel has stripped the precipitous slopes of their forests and left the land extremely vulnerable to erosion.

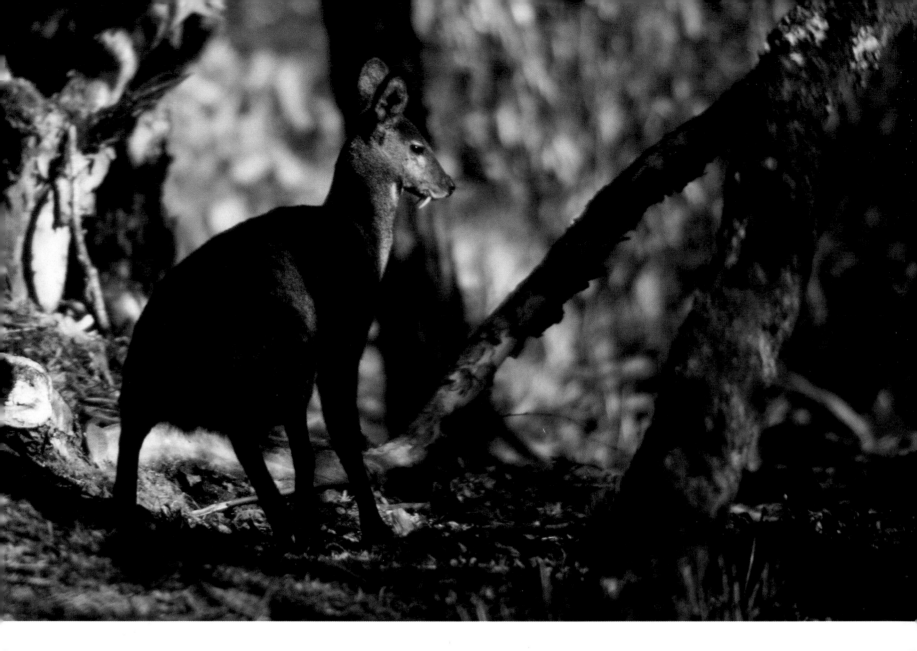

FOREST HAVENS

The great forests that once cloaked the Ganges watershed are disappearing fast. By 2000, the region had lost 15 per cent of them compared with the early 1970s. But one place where it is still possible to find rich natural forest is in the Kedarnath Sanctuary in Uttar Pradesh. It comprises almost 1000 square kilometres (390 square miles) of snow-covered mountains and a spectacular mix of towering conifers such as pine, deodar and cypress growing alongside oak and chestnut, with bamboo and rhododendron beneath. In spring, it is a riot of colour as the pink, red and white flowers of the rhododendrons contrast with the new growth of the conifers. In some years, when the rhododendrons flower in unison, whole hillsides turn every shade of red.

Such forests are the haunt of the Himalayan musk deer. Standing just 50cm (20 inches) at the shoulder and weighing only 15kg (33 pounds), this diminutive deer spends the day in deep

Above: A secretive male musk deer, displaying its distinctive canines. Lying close to its testicles is its musk pouch, producing a powerful scent to attract females. The musk is also sought after for traditional East-Asian medicine, with the result that the species is now endangered throughout the Himalayas.

shade, emerging only at dawn and dusk to feed. Its most distinctive feature is a pair of elongated canines, which in a male can measure up to 10cm (4 inches) and protrude well below the upper lip. The word 'musk' derives from the ancient Indian word for testicles, which alludes to the fact that the musk sac of the male is close to the genitals. Musk plays a role in attracting females during the breeding season. It is also highly prized in traditional East-Asian medicine and is used in more than 400 pharmaceutical preparations to treat everything from the heart to the nervous system. As a result, musk deer have been hunted for centuries. The price of a kilo of musk can reach $50,000, and so even though the deer are protected, it is estimated that many thousands are killed annually in the Himalayas.

More surprising residents of these high-altitude forests are Hanuman langurs. These 'mountain monkeys' are much larger than their lowland relatives and have thick coats to keep out the cold

Below: The Devprayag ghats. Chains give pilgrims an element of safety if they choose to immerse themselves in the swirling Ganges.

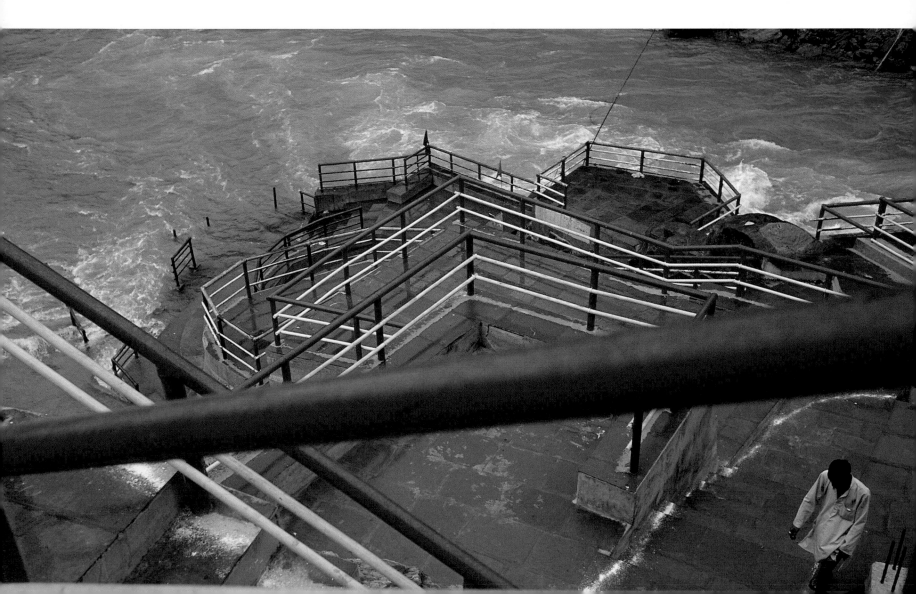

and damp. They even venture above the treeline and have been spotted as high as 4500 metres (14,760 feet) and on snowfields, which may have given rise to the stories of the fabled yeti.

Langurs have special stomachs that are extremely efficient at breaking down leaves, unripe fruit, seeds and bark. But to survive at high altitudes where there is little food, they also need to be very adaptable. In the monsoon season, they gorge on fruits and young leaves and may supplement their largely herbivorous diet with protein-rich caterpillars. In winter, they are forced to subsist for long periods on bark and leaves that have lost most of their nutrition. Come spring, the hungry monkeys will devour just about any plant they can get hold of, which is when they run into trouble. In the hill country, many slopes are terraced for growing staple crops: wheat, barley and potatoes in the spring, rice in the autumn. Though langurs are sacred to Hindus, when a crop-raiding party of monkeys descends, the villagers retaliate with sticks and torches, and by lighting fires and banging pots and pans.

GOD'S CONFLUENCE

The name Ganges does not appear on maps for some 200km (124 miles) downstream from Gangotri, at the town of Devprayag. Here, the silty waters of the Bhagirathi flowing down from Gangotri are united with those of the Ganges's other main tributary, the Alaknanda, flowing south from Badrinath. The meeting point, known as 'God's confluence', is marked with the inevitable temple and bathing ghats, which have been cut into the riverside rocks to lead pilgrims down to the swirling river. Heavy chains anchored in the rocky promontory give the bathers some safety as they plunge into the raging torrent.

These confluences, or prayags, are found all along the river and are considered holy places. In a very real way, they are points where the tumbling waters once dispersed by the locks of Shiva are reunited to form the Ganga. The five that are especially revered are Devprayag, Vishnuprayag, Nandprayag, Karnaprayag and Rudraprayag.

Rudraprayag's other claim to fame is that it was here, in 1926, that Jim Corbett – naturalist, writer, photographer and hunter – famously tracked down and killed the 'man-eating leopard of Rudraprayag'. Over 8 years, this male killed at least 126 people, many of them pilgrims en route to shrines in the higher Himalayas. The leopard was finally shot by Corbett on the banks of the Ganges after almost a year of intense effort and several close calls that nearly resulted in Corbett himself becoming a victim.

Overleaf: The holy confluence. Devprayag is where the Bhagirathi (left) meets the Alaknanda (right) to form the mighty Ganga.

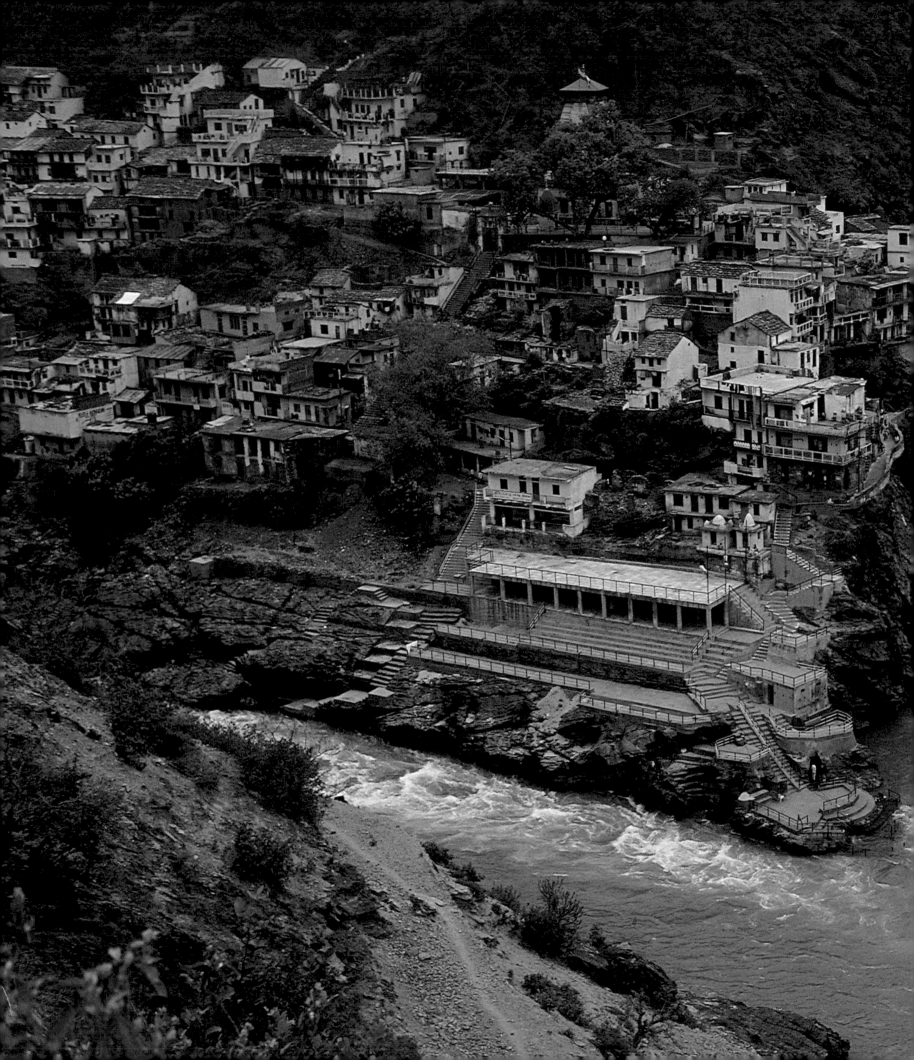

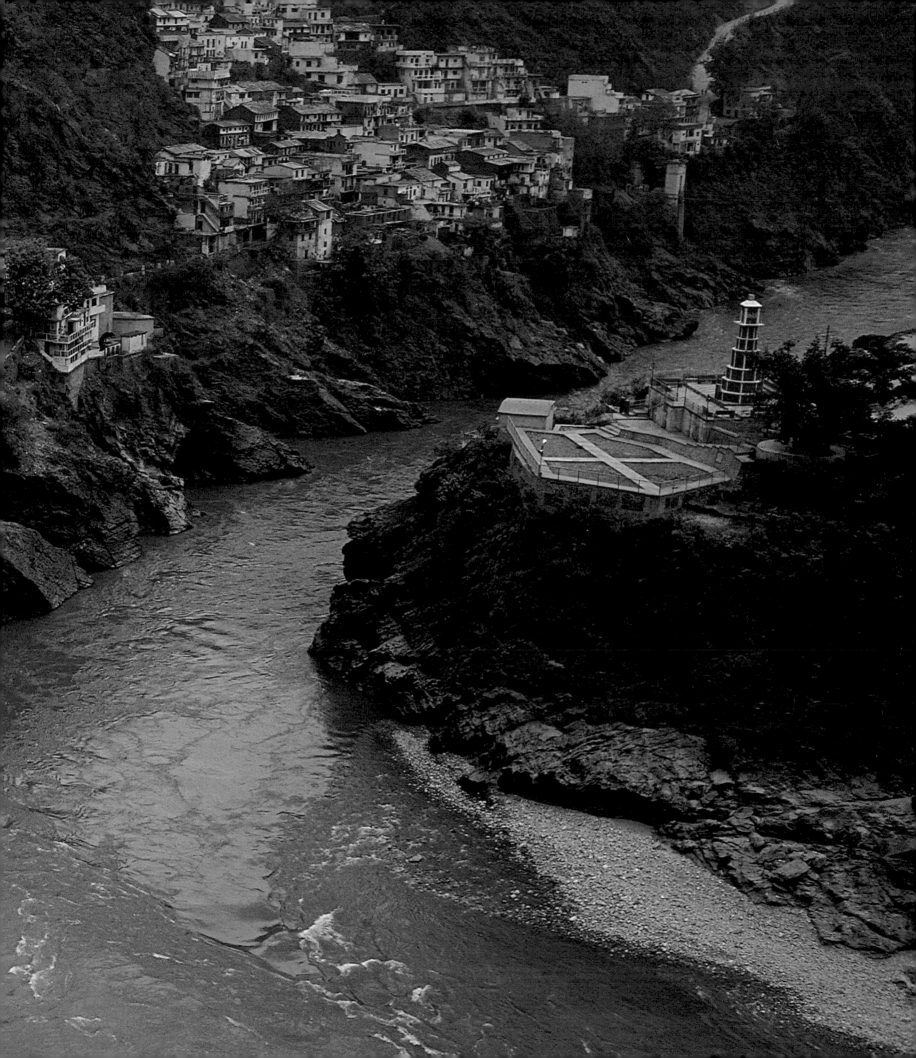

Leopards are still one of the dominant predators in the hills, though they have been very much marginalized, surviving by killing livestock and seeking cover on the edge of human habitation. Dogs are a particular favourite, though leopards also still kill the occasional small child.

FORESTS OF THE FOOTHILLS

Beyond Devprayag, the Ganges carves its way through several deep gorges before its valley broadens and the river becomes more sedate. This more forgiving landscape is known as the Shivalik – the southernmost folds of the Himalayan foothills, running in a roughly east-west direction with an average height of about 1000 metres (3280 feet) from the plains beyond. Typically, the rolling hills are bisected by gullies with seasonal streams, known as choes.

The monsoon rains nurture thick forests of tropical species such as sal, teak and bamboo. The spread of agriculture and settlements since the twentieth century, though, has put these woods

Below: A tigress and her cub with a meal of chital, Corbett National Park. The grasslands near the river are where the park's last few tigers have a good chance of catching chital and other deer. The park forms the catchment of the Ramganga, a tributary of the Ganges.

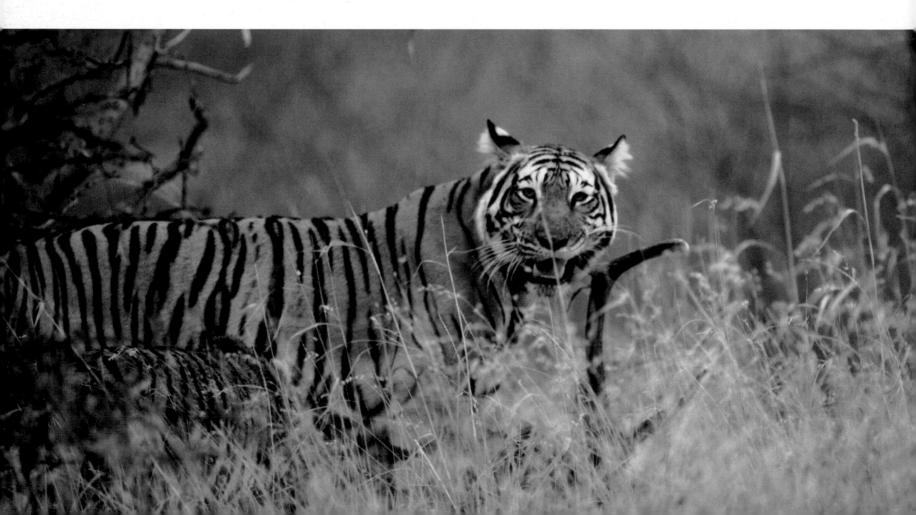

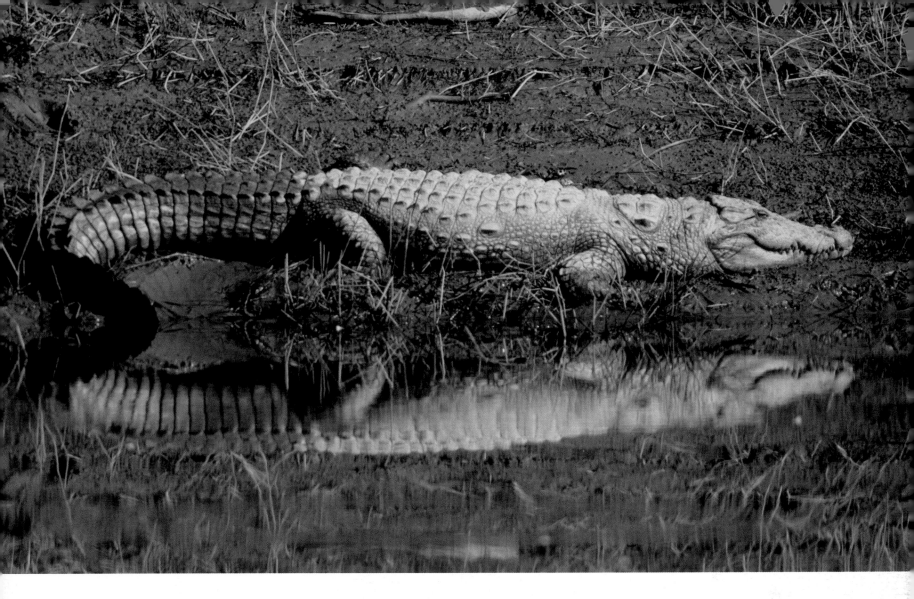

under intense pressure, and in summer, the monsoon floods play havoc with the denuded landscape. But in some protected areas, such as Corbett National Park and Rajaji National Park near Haridwar, the forests remain, together with some of India's most charismatic wild animals – tigers, elephants, peacocks and sloth bears.

Corbett was India's first national park, established in 1936 and covering more than 1000 square kilometres (390 square miles). It lies on one of the main mountain tributaries of the Ganges, the Ramganga, and is best known for its tigers, of which fewer than 50 are believed to be left. But even in this well-protected national park, poaching continues to be a problem, with tiger skins and bones being smuggled out, mainly to supply Chinese medicine.

On the open grasslands near the river are herds of chital, or spotted deer, hog deer and sambar. This is also the place to see Indian elephants, especially in the late spring, when the search for water brings them out of the forest and down to the river. The long-snouted gharial, a specialist fish-eating.crocodile, and the much larger mugger crocodile can be seen on the banks of the Ramganga. For fishermen, though, the king of the Ganges in this region is the mahseer.

Above: The great mugger, to be found on the banks of the Ramganga and other Ganges tributaries. It is capable of taking almost any animal that risks a drink.

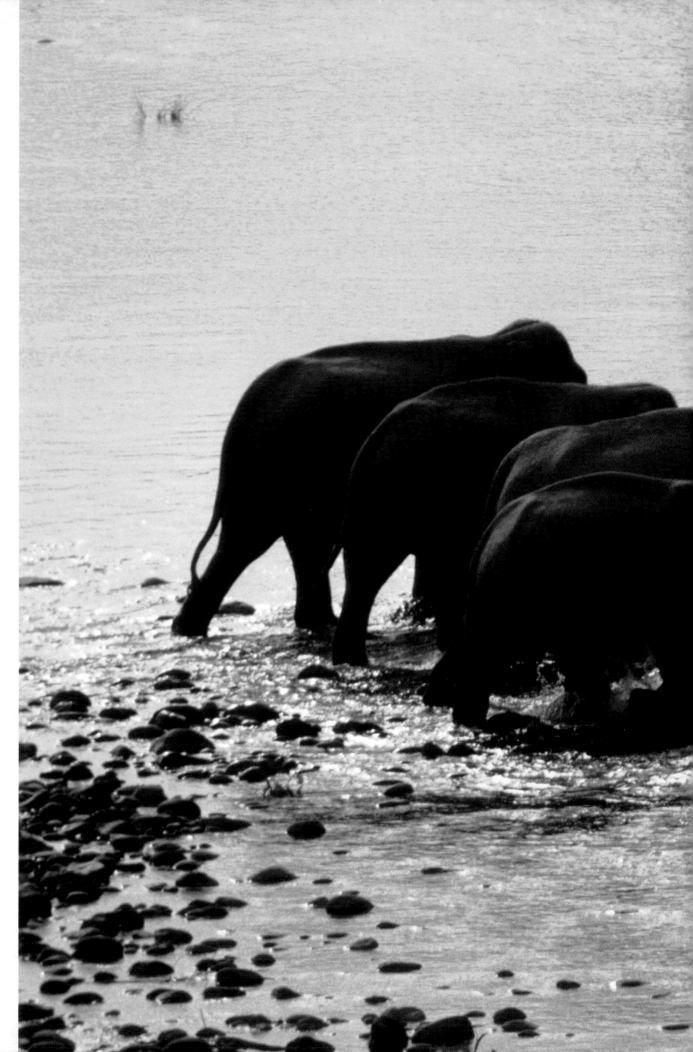

Right: River crossing, Corbett National Park. These elephants are part of a migratory population that moves between Corbett and Rajaji National Park. They face many obstructions along their traditional routes, including settlements, roads and railway lines.

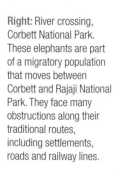

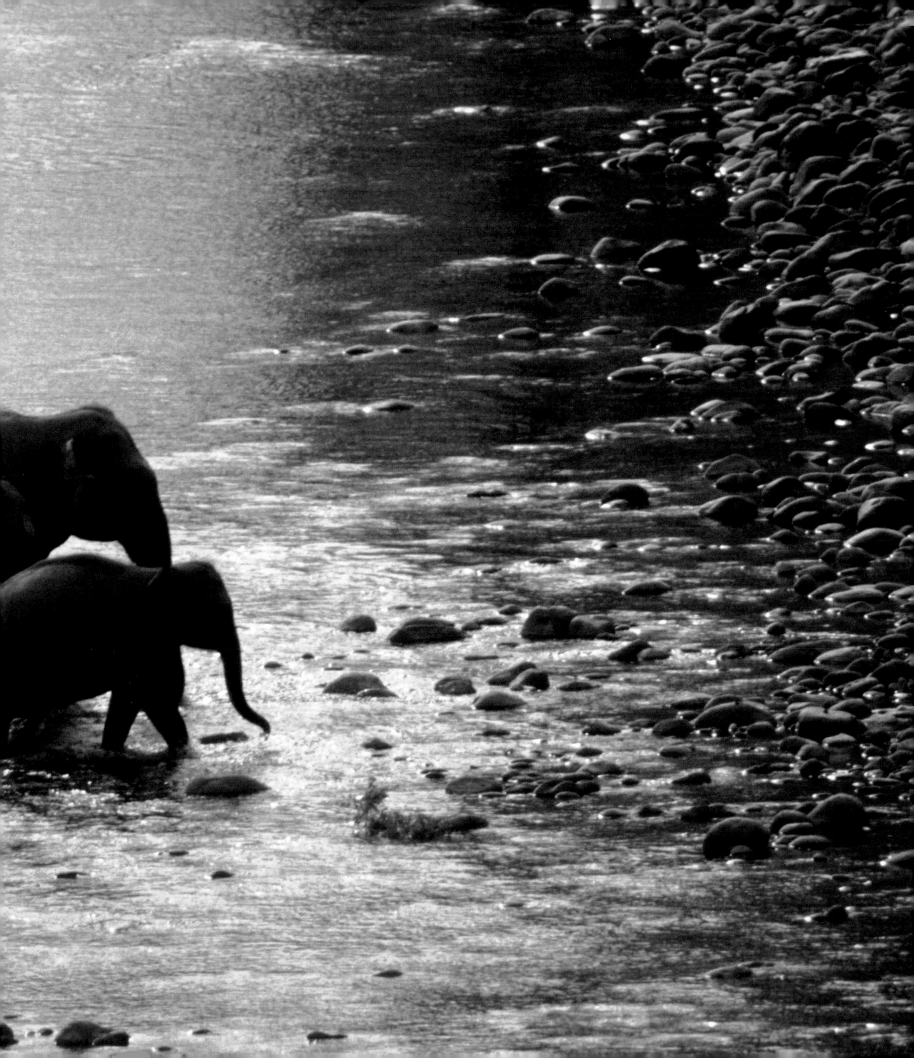

The mahseer is the largest member of the carp family and a beautiful, powerful fish, but it stands little chance against the local fishing device – a stick of dynamite. Fishing is a pursuit mainly of road-labour gangs and consists of tying explosives to a stone and throwing it into the water, which kills all the fish, bringing them belly-up to the surface. As a result the mahseer is in decline, but it can still be found in large numbers around riverside temples such as Haridwar and Rishikesh and some of the smaller temple complexes such as those at Baijnath, where the fish are protected.

In the past, the temple priests would put gold rings through the lips of the larger mahseer, and today, priests and devotees still feed them chickpeas and rice. The fish can grow huge on this diet – up to a metre (more than 3 feet) long and weighing in at more than 50kg (110 pounds). But every year they must leave the safety of the temple waters to migrate upstream, using the monsoon floods to enable them to reach the shallow streams and tributaries where they spawn. The eggs are laid and fertilized on the gravel beds, and then the mahseer run the gauntlet back down the river to the sanctuary of the temple ghats.

Wild elephants can still be seen in Rajaji National Park, which encompasses both banks of the Ganges as it nears the plains at Haridwar. An elephant must eat something like 200kg (440 pounds) of vegetation every day and needs a large amount of water to wash it all down and so can never stray too far from the river. And in the hot summer months, Rajaji's elephants converge

Above: A shoal of mahseer in the water below the temple at Baijnath. Fed on chickpeas and rice, the fish grow huge in the protected waters.

on the Ganges to drink, bathe and beat the intense heat. Around 500 make their home in the park and surrounding forest reserves, and regular movement between the two sections involves the animals crossing a railway line, as well as roads and expanding human settlements. In the past few years, at least 20 cows and young elephants have been killed by trains.

GATEWAY TO THE PLAINS

Some 300km (190 miles) from its source, the Ganges passes through a gorge and finally breaks out of the hill country. After dropping 3500 metres (11,480 feet) in those first 300km, it now spends the next 2000km (1240 miles) losing a trifling 300 metres (984 feet) of elevation as it sets its course south and east across the seemingly endless plains of northern India to reach the sea.

The town of Haridwar occupies the dramatic transition point – known as 'the gateway to the abode of the gods', guarding as it does the routes into the high country. It is the place where a drop of Amrita, the elixir of immortality, fell, which makes it one of the seven great holy cities of Hinduism and the scene every 12 years of a huge religious gathering, the Kumbh mela, when millions descend on the town to bathe and pray in the river.

Below: Haridwar – one of the seven holy cities for Hindus – where the Ganges, now wide, spills onto the plains . Pilgrims gather here throughout the year to make offerings to Ganga and to bathe in her waters.

But the human traffic through this town is constant, as pilgrims from across India make their way here throughout the year. The highlight of any visit comes every evening, when thousands of devotees gather at the ghats at Har-ki-Pauri at the northern end of the town. This is the site of the Ganga aarti, when devotees make offerings to Ganga, seeking her blessing. Pilgrims chant the Ganga stotra, the 108 names of the goddess, bathe in the chilly waters and fill copper vessels with Ganga jal to take back to their villages. At the culmination of the ceremony, priests parade large flaming torches around the ghats, and the assembled pilgrims launch thousands of flowers and put lighted earthen lamps onto the river to be carried away with the current.

By the time the Ganges reaches Haridwar, it has already travelled nearly 300km (190 miles) and has dramatically shaped the land, wildlife and culture of the Garhwal hill country. But it now takes on a very different character – wide, sluggish and muddy – and begins to have a much wider influence on Indian life both physically and spiritually. No longer is the Ganges just the Daughter of the Mountains. She has become Ganga Ma – Mother Ganges.

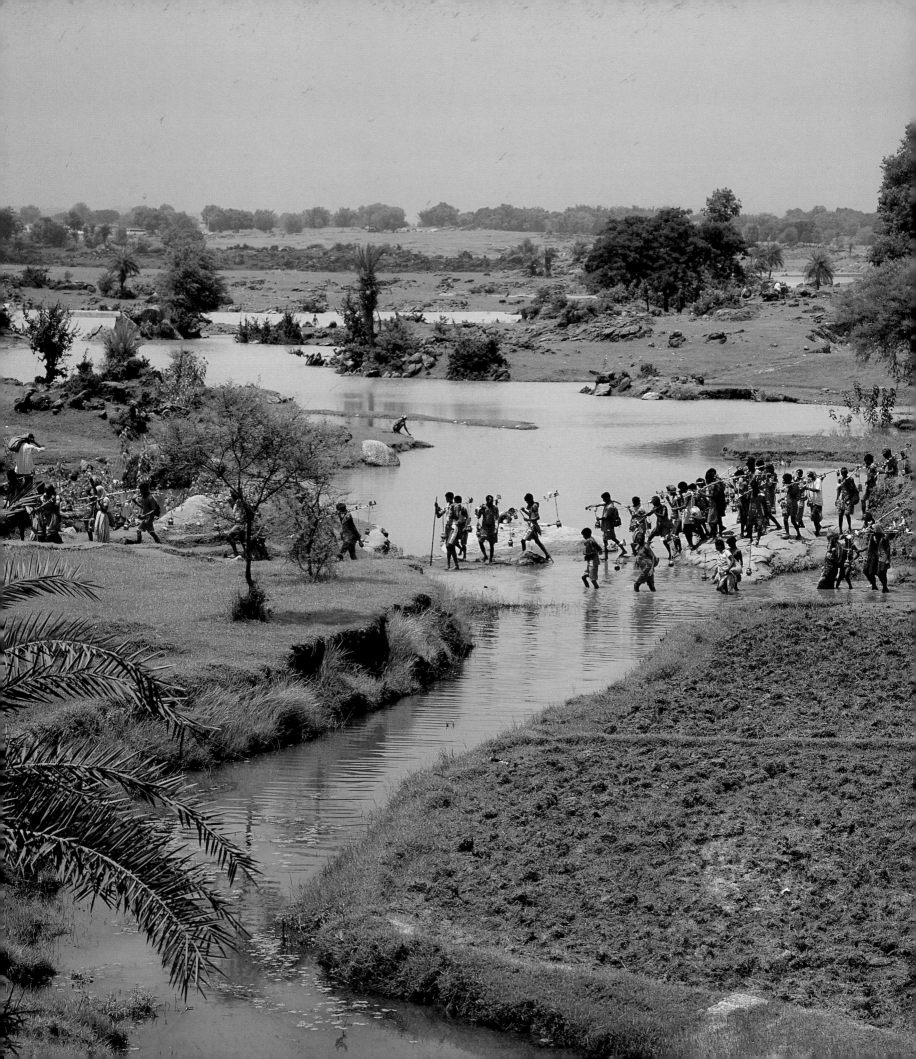

THE GREAT GANGETIC PLAIN

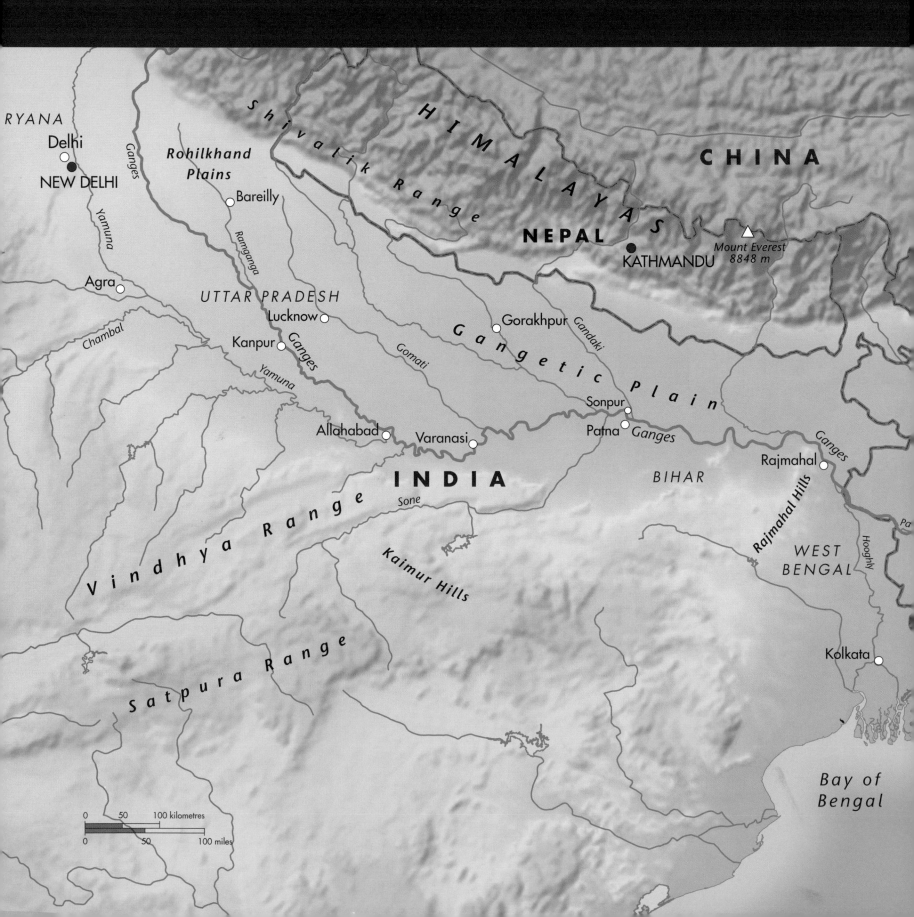

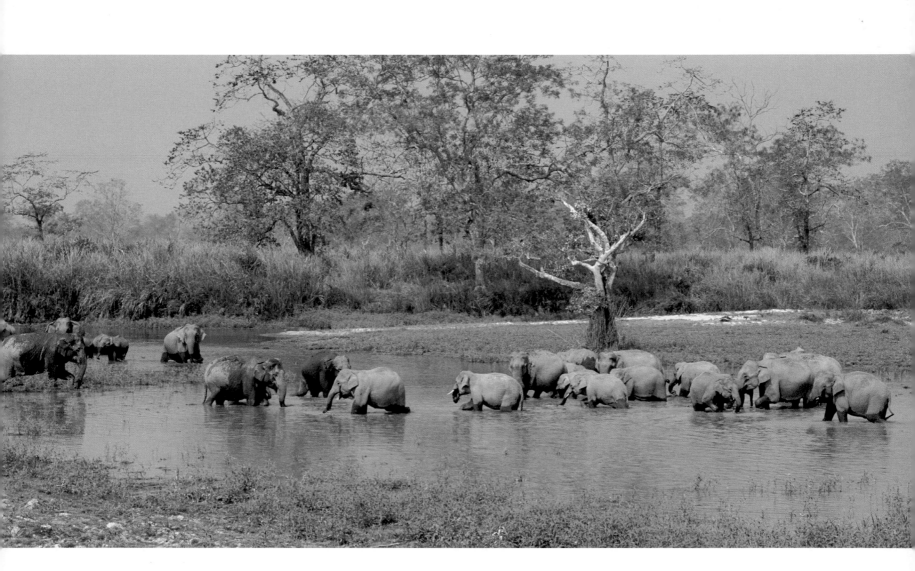

One of the most lasting impressions of India's Gangetic Plain is the sheer quantity of people who live here. Crowds are ubiquitous, not just in the cities but also in the furthest corners of the countryside. The region supports the greatest density of humans on Earth – one twelfth of the world's population – and they all depend on the river system for their survival.

It wasn't always this way. Before humans arrived, the plains were a vast wildlife paradise teeming with a diversity of creatures that would rival anything on the African savannahs. But since then, the region has endured the rise and fall of civilisations, the birth of religions and colonisation by Europeans, resulting in a complete transformation of the landscape. Yet despite the tumultuous changes, the waters of the Ganges have continued to flow and nourish the bodies and souls of all who inhabit her banks.

Above: Kaziranga's Eden. This national park, with some of the highest densities of wildlife in the country, is still very much a wilderness and gives an idea of what the Terai must have looked like before the spread of agriculture.

Previous page: Pilgrims carrying the first monsoon waters from the Ganges near Patna to the Shiva temple in Deogarh.

THE GREAT GANGETIC PLAIN

As the Ganges leaves the Himalayas and spills onto the plains, fast-flowing rapids transform into a wide, meandering, muddy brown waterway that slowly winds its way 2000km (1240 miles) eastward through northern India along the Himalayan barrier. Eroded minerals from the mountains make the Ganges the most sediment-laden river in the world – the key to its life-giving powers.

To consider the Ganges as a single river is misleading, as along her course she is joined by countless tributaries. Irrigation and industry demand so much water from the Ganges that she would very quickly run dry were it not for the water bodies that replenish her flow, not only the mountain torrents but also huge rivers.

Below: Mother and newborn calf. Half the world's population of greater one-horned rhinos survive in Kaziranga National Park in northeast India. Rhinos also once roamed the Gangetic Plain, but like other big mammals, they have been hunted out and have lost their habitat to agriculture.

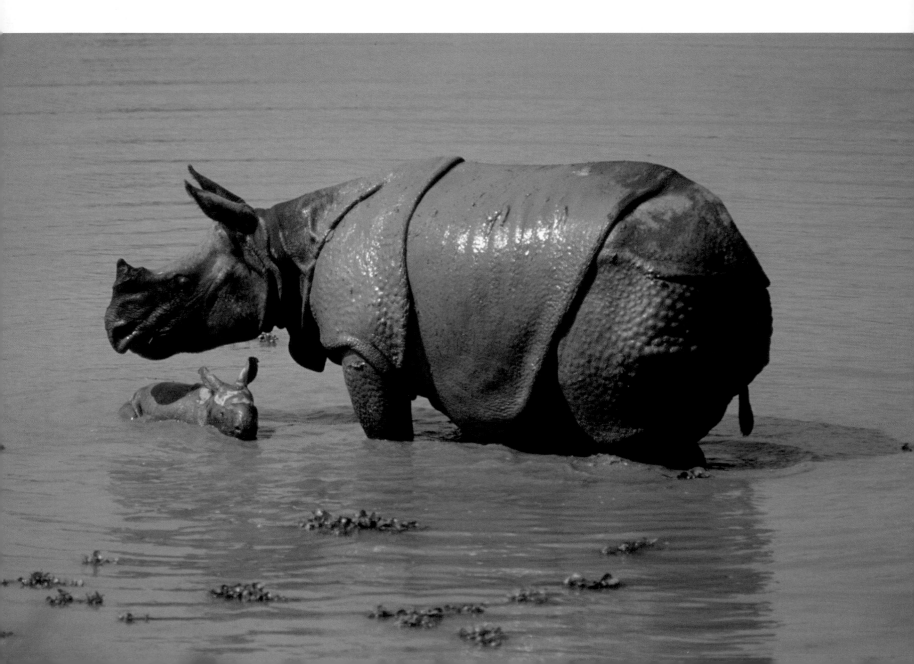

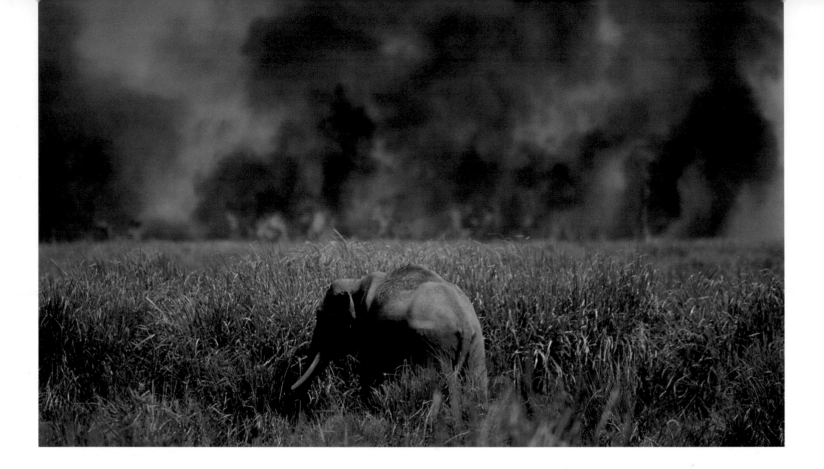

THE GREAT TERAI

The Ganges and her tributaries spread out into a vast area of marshy grassland and riverine forest known as the Terai, which forms a 50km-wide (30-mile) belt stretching for 1600km (990 miles) along the base of the Himalayas. The combination of strong sun, plentiful water and a never-ending supply of nutrients from the Himalayan rocks makes the Terai among the most productive habitats on Earth. Today, much of it is now under the plough or has been turned into sugar-cane plantations, but in the northeast of India, Kaziranga National Park acts as a reminder of what an extraordinarily rich wilderness this stretch of the Ganges once was.

In Kaziranga, the grasses can grow 4 metres (13 feet) high each year, tall enough to conceal the largest of animals. Controlled burning of the giant grasses is undertaken to prevent large-scale wildfires – an annual cycle that has been going on for thousands of years and to which the park has largely adapted. The burning allows for new grass growth, and the ashes help nourish the soil.

The park is a stronghold for many impressive mammals that once roamed the Gangetic Plain, including elephants, buffaloes and tigers, and was created specifically to protect the greater one-horned rhino from hunting. Now about 1200 rhinos live here – half the total world population. Kaziranga also boasts the highest density of tigers in India. The towering grasses provide superb ambush-cover for them, and the mixture of grassland, forest and wetland supports good numbers of prey. In fact, the park gives an impression of what the land must have looked like when the first humans arrived in the Ganges basin some 40,000 years ago.

Above: Fire – a natural part of regeneration in the grasslands of Kaziranga. Controlled burning is used to prevent large-scale wildfires, but more serious threats to the rhinos and elephants are flooding and poaching.

Overleaf: Tribesmen on a hunt. These people, from the Bihar region near the Son river – a tributary of the Ganges – use traditional hunting methods that go back to a time before agriculture covered the plains.

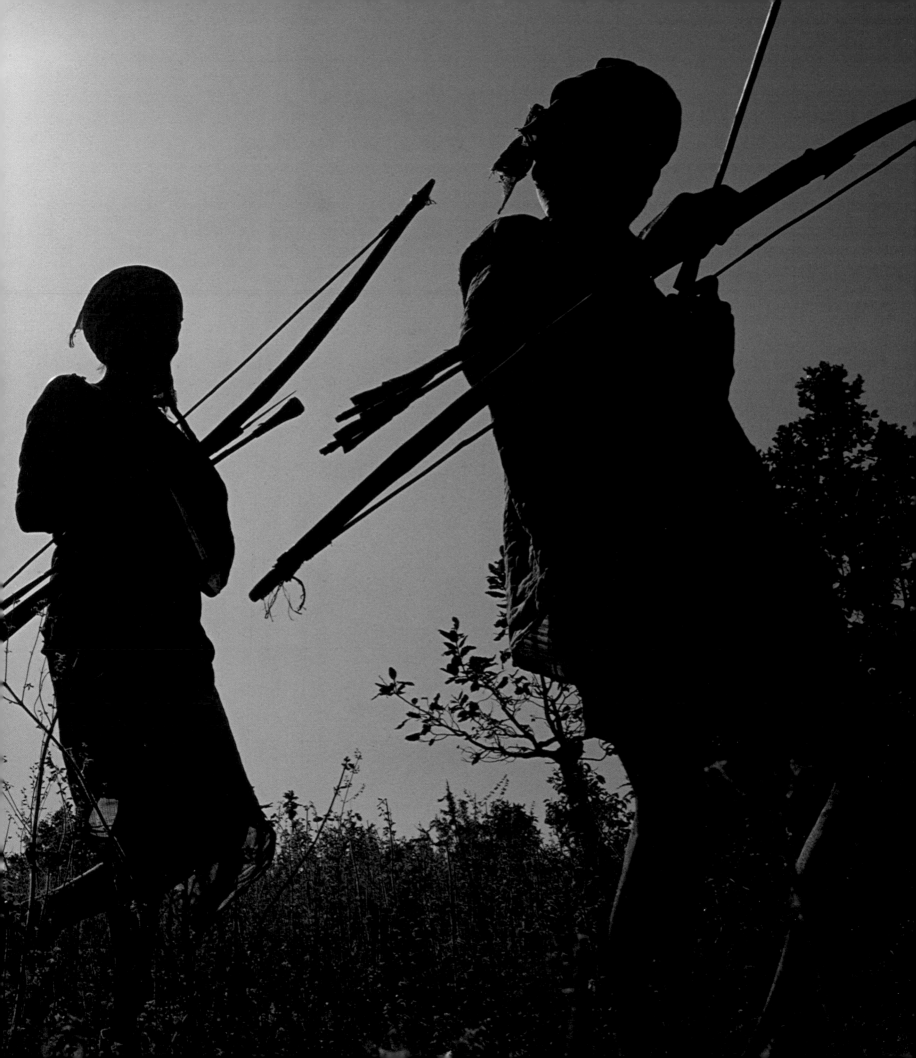

Nomads spread east into India from the Indus valley, navigating through the densely vegetated wilderness along river channels that eventually led them to the Ganges itself. With such an abundance of wildlife both in and around the river, the area proved an ideal place to settle. As these hunter-gatherer communities prospered and multiplied, their settlements began to grow, but they still remained dependent on the wilderness for all their needs. Today it is hard to find anywhere on the main Ganges channel that resembles the landscape as it would have been when people and animals shared the wilderness. But the banks of some of the rivers that feed into the Ganges are less settled.

The Chambal river, which feeds into Yamuna river and then into the Ganges, has an unlikely source in the desert of Rajasthan, and since much of its banks are desert or scrub, they are less suitable for cultivation, leaving more space for the natural inhabitants. The area also has a reputation as being wild bandit country, which has played its part in keeping human activity on the river to a minimum.

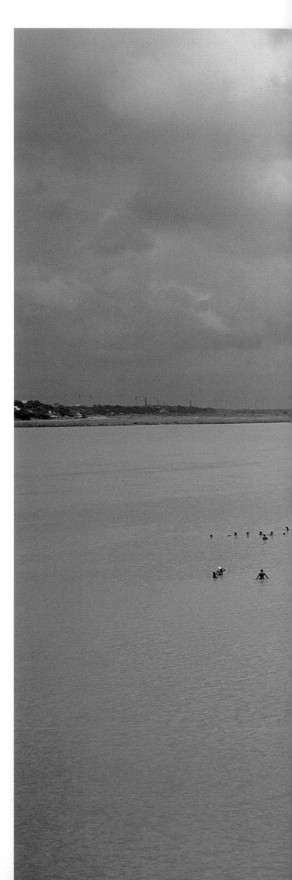

The Chambal – one of India's least polluted rivers – is a haven for all sorts of waterbirds, both resident and on migration south for the winter, including Indian skimmers, spoonbills and a variety of ducks, and is one of the few rivers where the rare Ganges dolphin can still be found. It is also a last stronghold of the strange-looking gharial. The bizarre snout of this crocodilian is an adaptation for catching fish: its thin profile reduces drag, allowing the jaws to snap shut. The name gharial comes from 'ghara', which means earthen pot and refers to the bulbous growth that males have at the end of their long, thin snouts. This acts as a resonance chamber, amplifying the hissing sound they make when courting.

Gharials are social reptiles and live in hierarchies – only the largest, most dominant males have access to the females. Once a female has mated, she pulls herself onto a sandy bank of the river, digs a hole and lays her eggs in it. For the next two months, she guards them from jackals and other predators. By May, the young are ready to hatch. Still in their eggs, they call to their mother, summoning her to help dig them out. When the hatchlings have emerged, they are vulnerable to many predators, including larger gharials. So the females combine to operate a crèche system, which allows the mothers time off to feed.

Habitat loss, hunting and collection of their eggs mean that gharials are now found only at a handful of locations along tributaries of the Ganges. Captive-breeding-and-release programmes have saved the gharial from extinction, but recent estimates suggest there could be as few as 200 in the wild, which leaves its future still hanging in the balance.

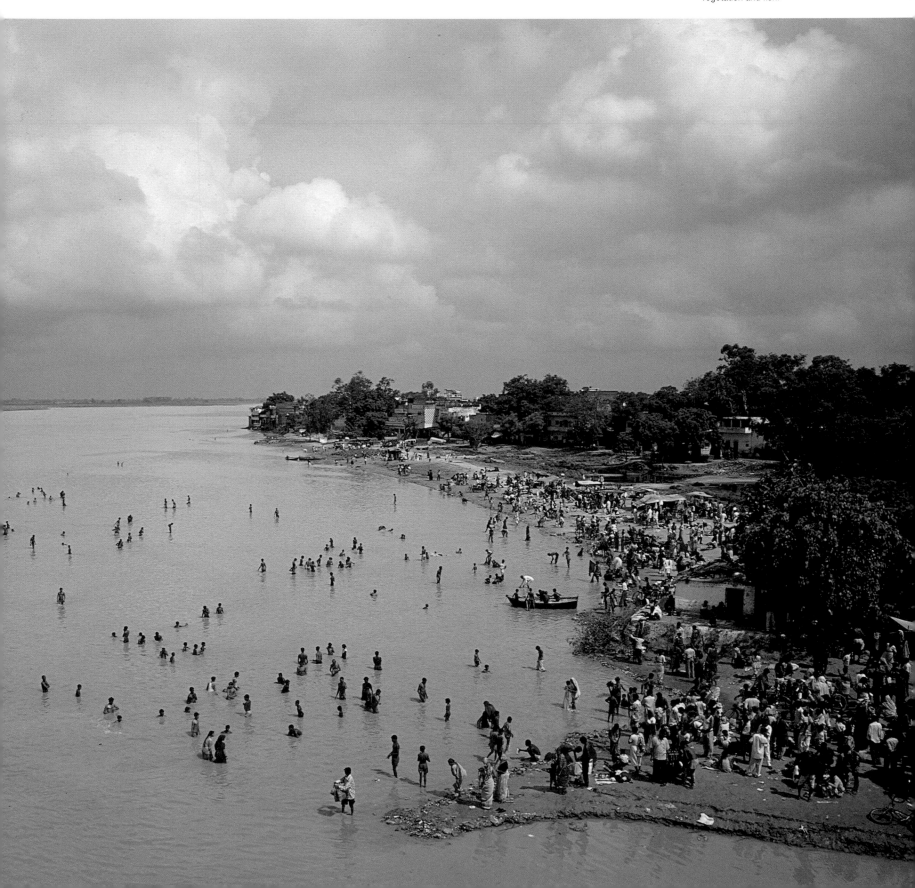

Below: Pilgrims and bathers on the swollen Ganges at Kanpur – an industrial city. Waste chemicals from Kanpur's leather works discharged into the river have, in the past, killed bankside vegetation and fish.

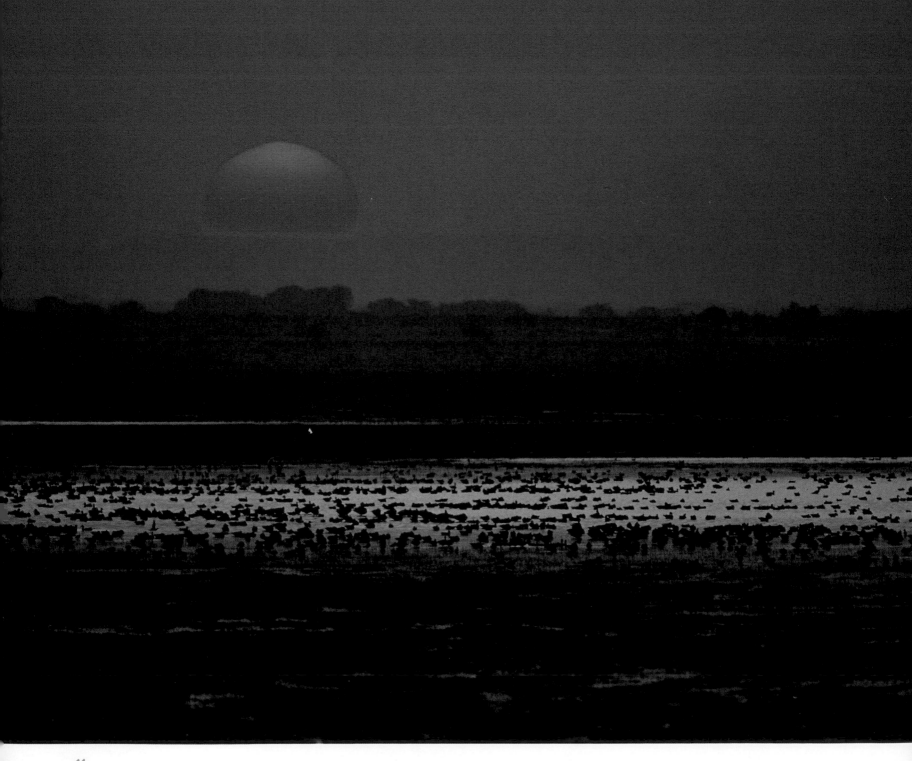

THE GIFT OF THE MONSOON

The human inhabitants of the Ganges began experimenting with agriculture around 7000 BC and were soon growing a variety of crops. Harnessing the power of fire and creating iron tools, they were able to clear areas of jungle for cultivation, albeit on a very small scale. The agricultural revolution of the Gangetic Plain was born, and from this moment, the natural history of the plains became inextricably linked with human activity.

Below: A gharial basking. It holds its jaws open to regulate its heat.

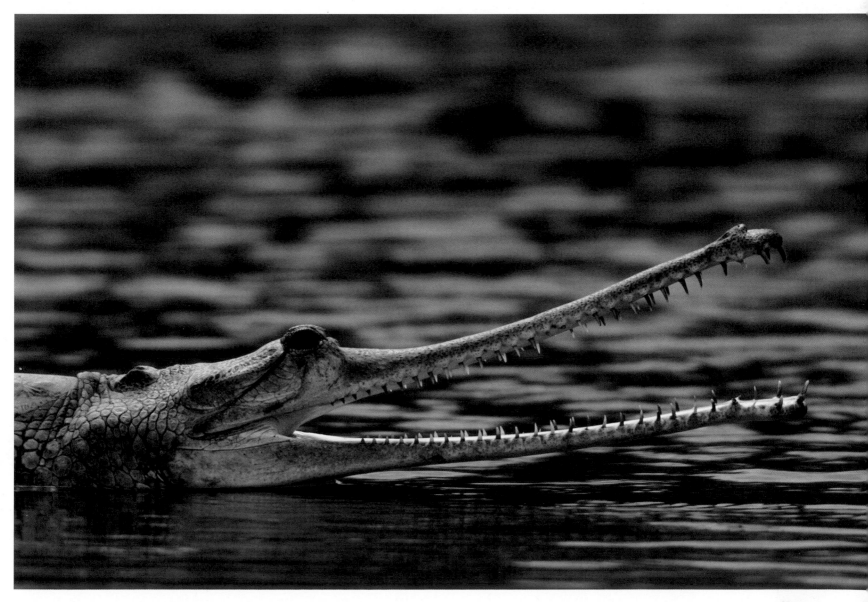

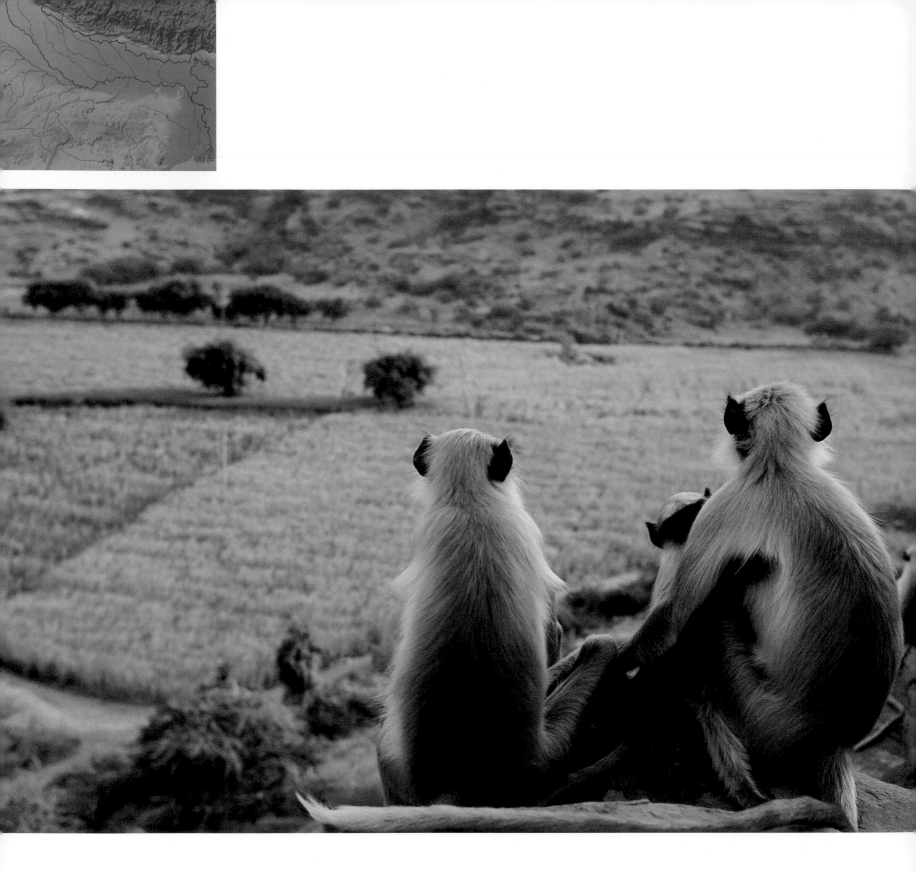

The Ganges basin is ideally suited to cultivation. The warm climate provides perfect growing conditions, and the Ganges' snowfed northern tributaries supply year-round water. But the crucial ingredient is the extraordinary fertility, the secret of which lies in the interplay between the monsoon and the river itself.

Above: Hanuman langurs. When natural food is scarce, crop-raiding and damage by hungry langurs can be a serious problem.

In April temperatures on the plains regularly reach 43°C (110°F) in the shade, and by June they can rise to 48°F (120°F). As midsummer approaches, the overhead sun turns the earth to dust and bakes the inhabitants. The only escape from the oppressive heat is to do as little as possible. Time seems to stand still as the region waits for relief.

Above: Laying out grass to dry. Harvested stems are used for anything from roofing and rope to brushes and baskets.

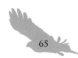

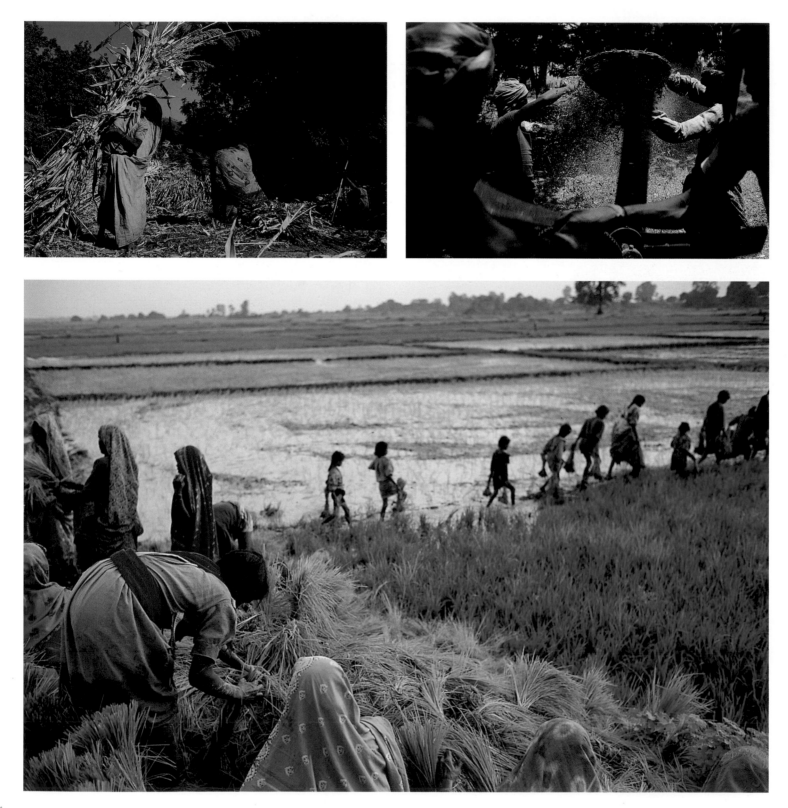

THE GREAT GANGETIC PLAIN

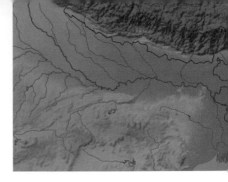

Towards the end of June, the humidity increases, large cumulous clouds fill the sky, the water level of the Ganges begins to rise and a palpable sense of expectancy builds among the people. The swollen river is a sign that the rains have already fallen in the mountains and the monsoon is on its way. Finally the heavens open.

The monsoon takes many forms, from torrential downpours to insipid drizzle that sets in for days, and for the next two to three months, the region will receive more than two thirds of its annual precipitation. Eventually, the swollen Ganges can hold no more and bursts her banks, flooding thousands of square kilometres.

Opposite, clockwise from top left: Harvesting the first millet crop of the year.

Villagers winnowing a crop, the resulting chaff forming clouds of dust.

Women undertaking the backbreaking task of planting out young rice plants in the paddy fields during the monsoon rains.

Left: Boys using banana leaves to shelter from the rain during the monsoon.

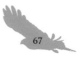

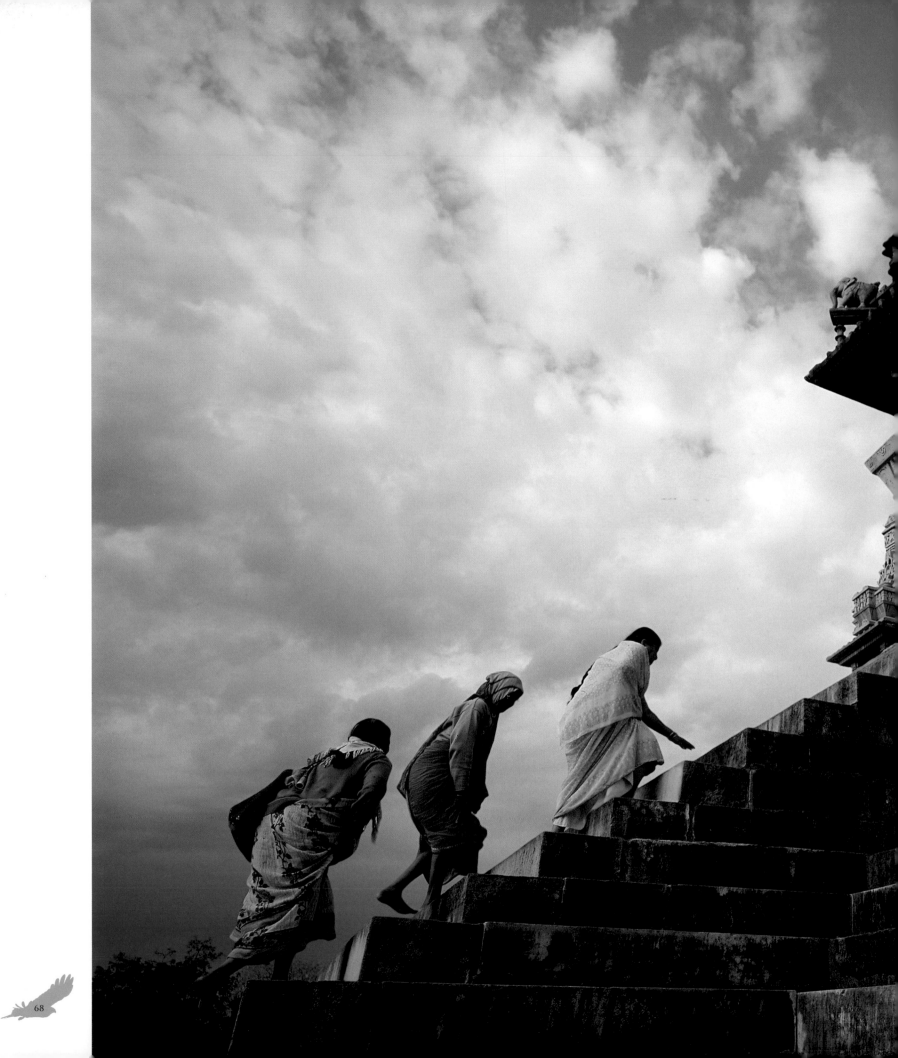

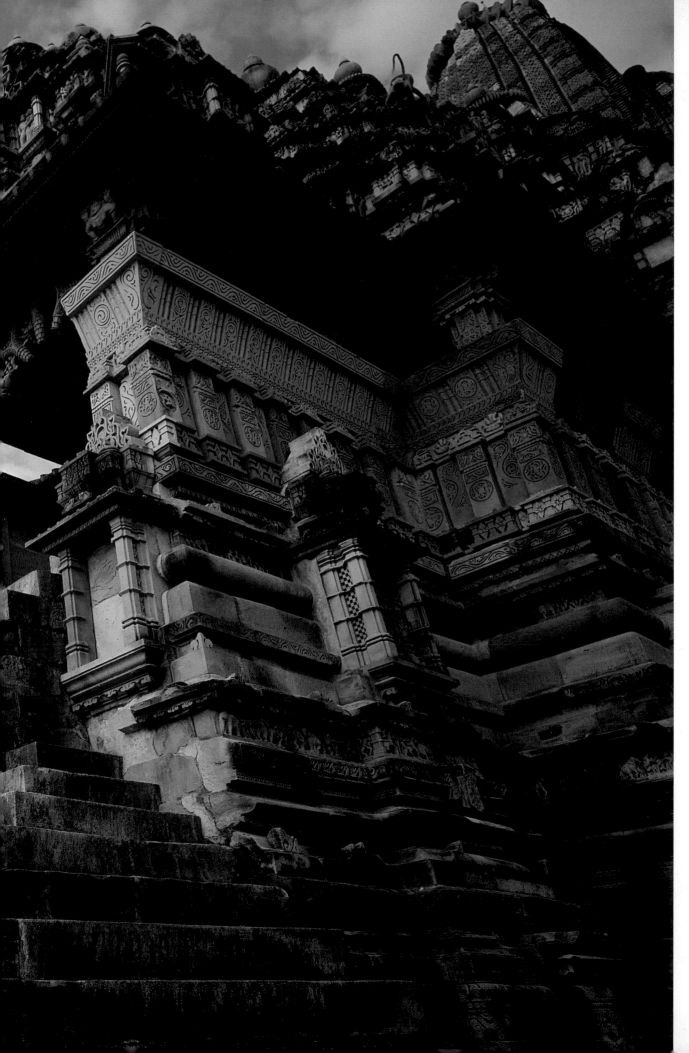

Left: Worshippers visiting one of the medieval Hindu temples of Khajuraho, south of Allahabad, where the Yamuna meets the Ganges.

The monsoon sparks a period of intense activity as the people capitalize on the favourable growing conditions. The landscape fills with workers planting rice, transferring the young plants from the nurseries into the larger paddy fields. The work is backbreaking, but for many people, it's their only source of income. The monsoon can, though, be infuriatingly fickle. Some years there is not enough rain, and the region is plagued by drought. In other years, there is too much, causing catastrophic floods that destroy homes and lives. In recent times, the meteorological data show that the swings are becoming more pronounced. Global warming appears to be playing havoc with a weather system on which millions of lives rely.

Below: The cremation ghats at Varanasi, on the Ganges – the most sacred place to be cremated and so reach nirvana. The ghats are owned by the Dom Raja, who collects gifts and huge fees from the families who perform the cremation ritual here.

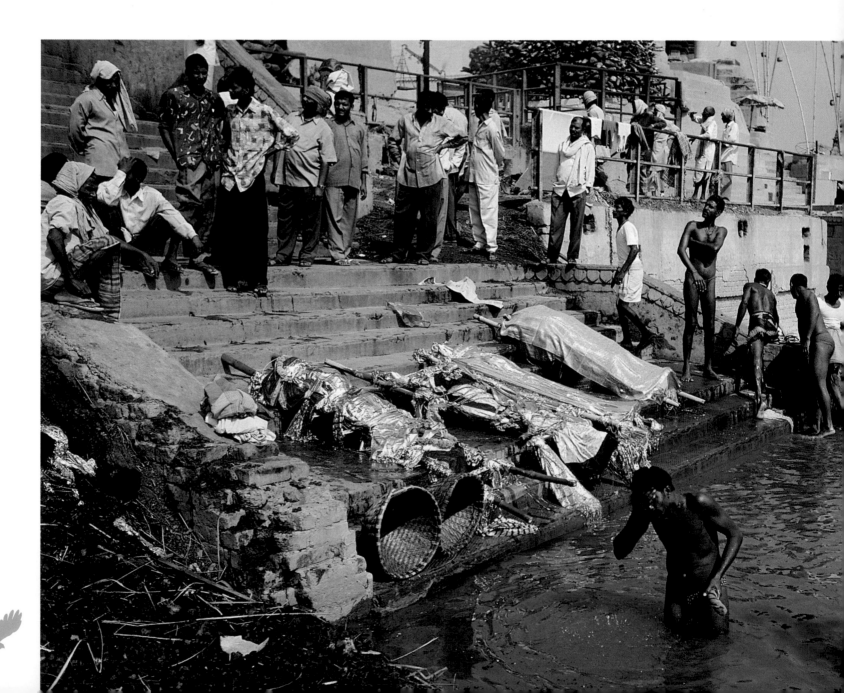

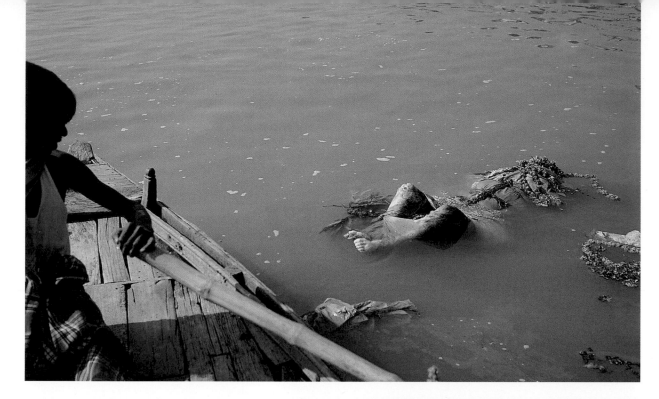

Left: A pure body. Holy men, pregnant women, children and those who have died of snakebite are not in need of purification by cremation and are placed directly into the Ganges.

Below: Preparing a relative for cremation.

Overleaf: The great sandbank opposite the ghats of Varanasi. During the monsoon, wrestlers use the damp sand as a practice arena.

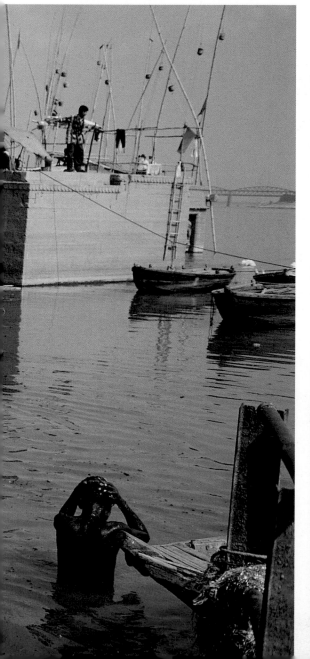

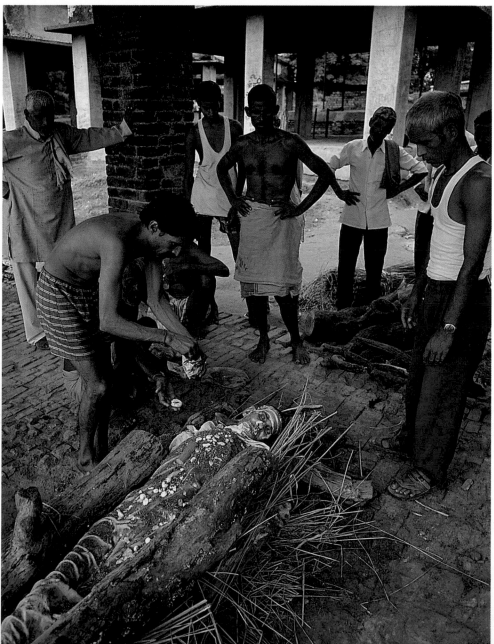

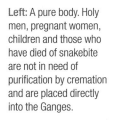

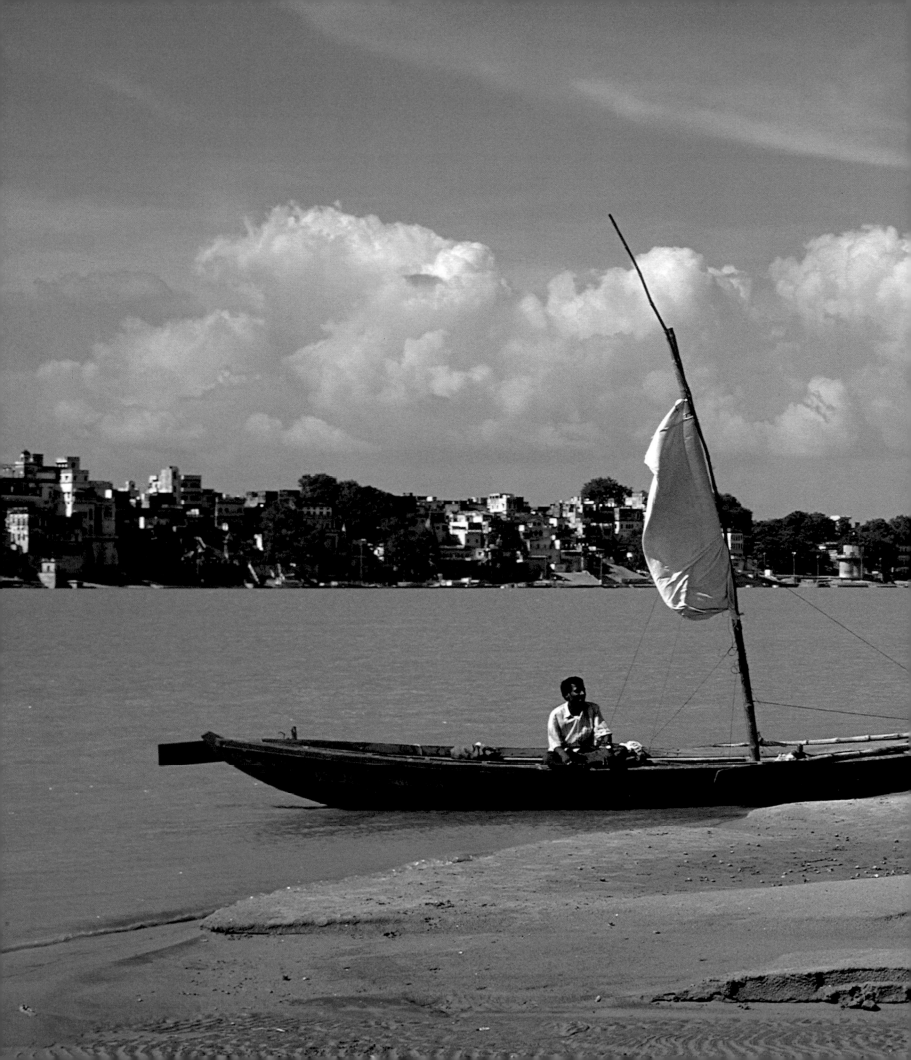

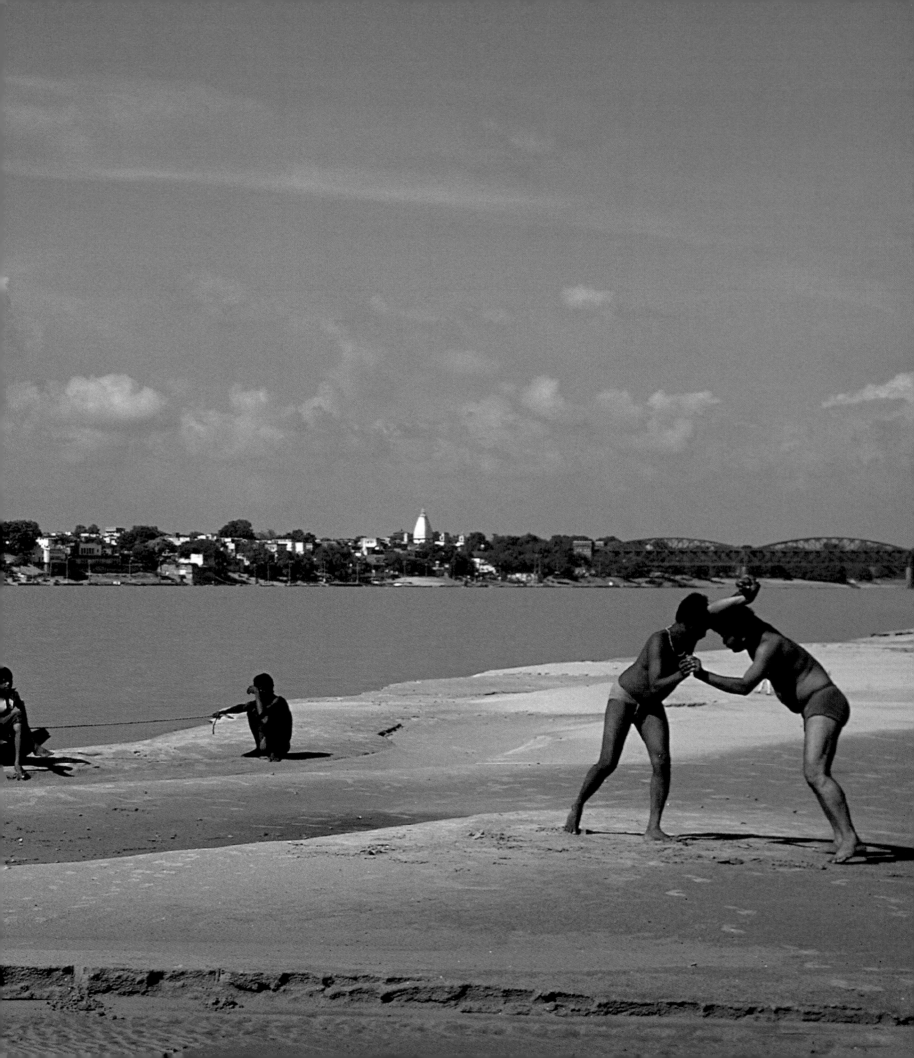

As the Ganges floodwaters recede, they leave behind their parting gift. The eroded Himalayan rock that coloured the river brown is deposited on the land as a thick layer of mineral-rich silt. Over millions of years, this annual dousing has built up an alluvium 5km (3 miles) deep, creating some of the richest soils in the world. This is the rice bowl of India, and archaeological evidence suggests that rice has been cultivated here for more than 7000 years. In many areas, paddy fields create a green sea that stretches as far as the eye can see.

Below: The river has a multitude of uses – here, laundrette and dryer.

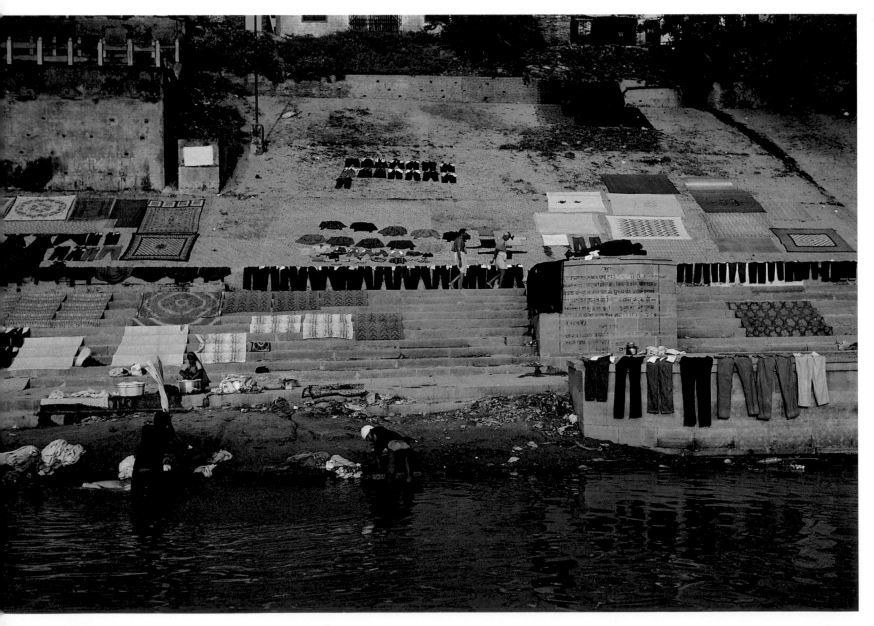

Jute, wheat, sugarcane, vegetables and a variety of fruit are also grown along the banks of the Ganges, and conditions are so ideal that farmers may harvest three crops in a year. The region is also famous for its mangoes, which are claimed to be the most delicious of all the varieties. Huge orchards line the riverbanks, and thousands of tons of fruit are harvested each year. In summer, the sweet flesh finds its way into almost every meal, and the fragrant aroma of ripe mangoes fills the air.

Below: River life – afternoon exercise beside the sacred water.

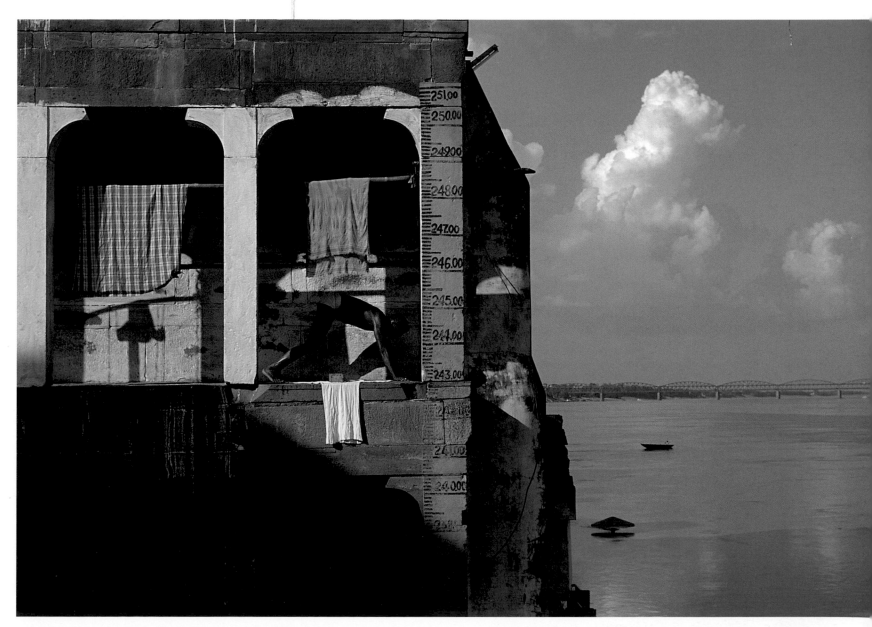

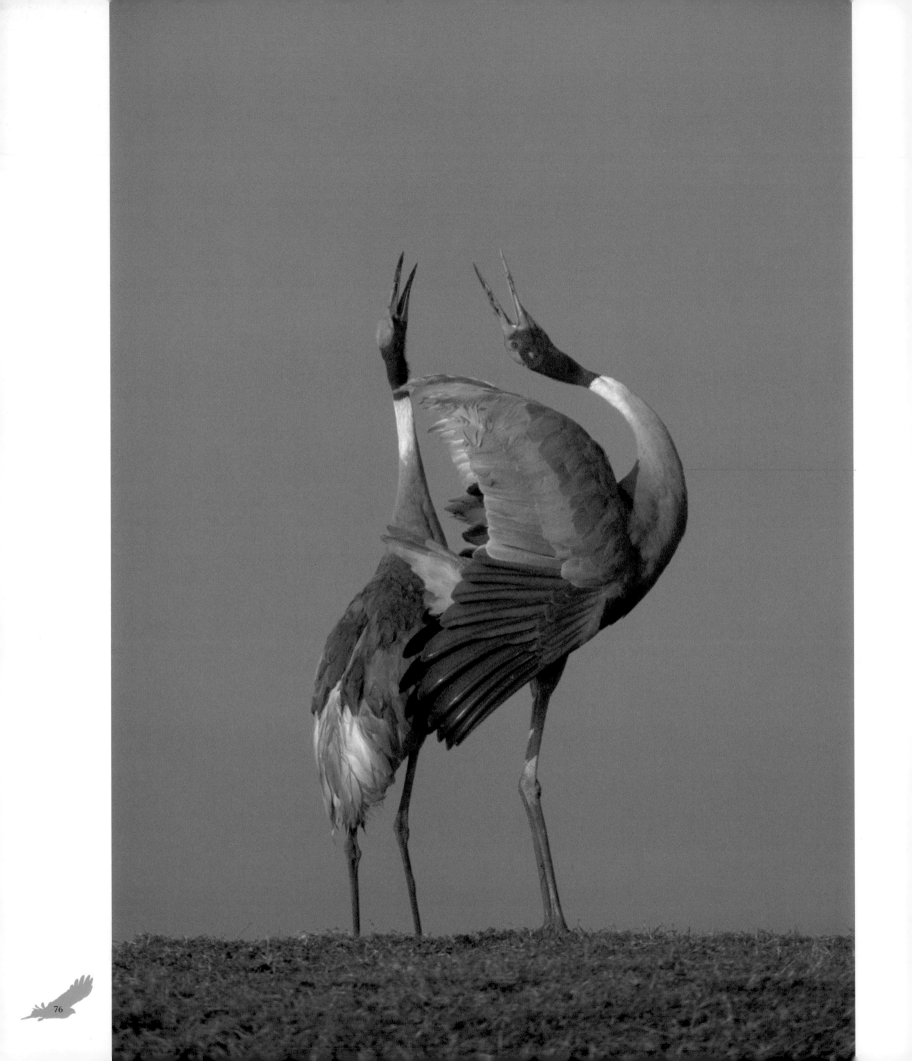

Though the Ganges basin has become the most intensively farmed area in the world, many wild animals survive in the rice paddies and fields. The most obvious are the world's tallest flying birds, the sarus cranes. They feed on amphibians and invertebrates, and paddy fields provide a habitat so attractive that, unlike most cranes, they never migrate to better feeding grounds. Sarus cranes pair for life, which has led them to be venerated as symbols of marital bliss and fertility. An elegant courtship dance helps strengthen their bonds. This involves a lot of synchronized bowing, jumping, pirouetting and the odd bit of dung-flinging, all accompanied by a cacophony of trumpeting calls that can be heard miles away. Dancing occurs throughout the year but peaks just before the monsoon, when the birds mate. The resulting young hatch after the monsoon during the time of plenty.

In some agricultural regions, though, overuse of pesticides is taking its toll, polluting the land and reducing the numbers of insects. This has a knock-on effect on the entire animal community, including the cranes.

Opposite: Pairing for life. Sarus cranes cement their bonds through synchronized dancing and trumpeting, which peak just before the monsoon.

Below: Ganges as playground. Though the river is one of the most polluted in India, people continue to swim in it, wash in it and drink its water.

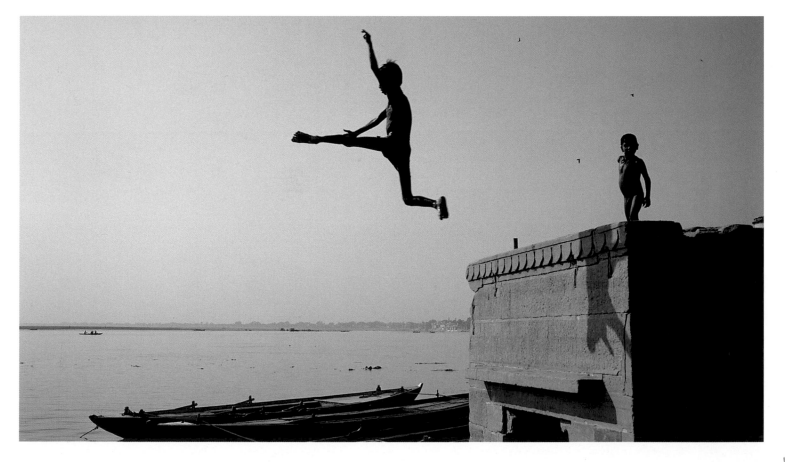

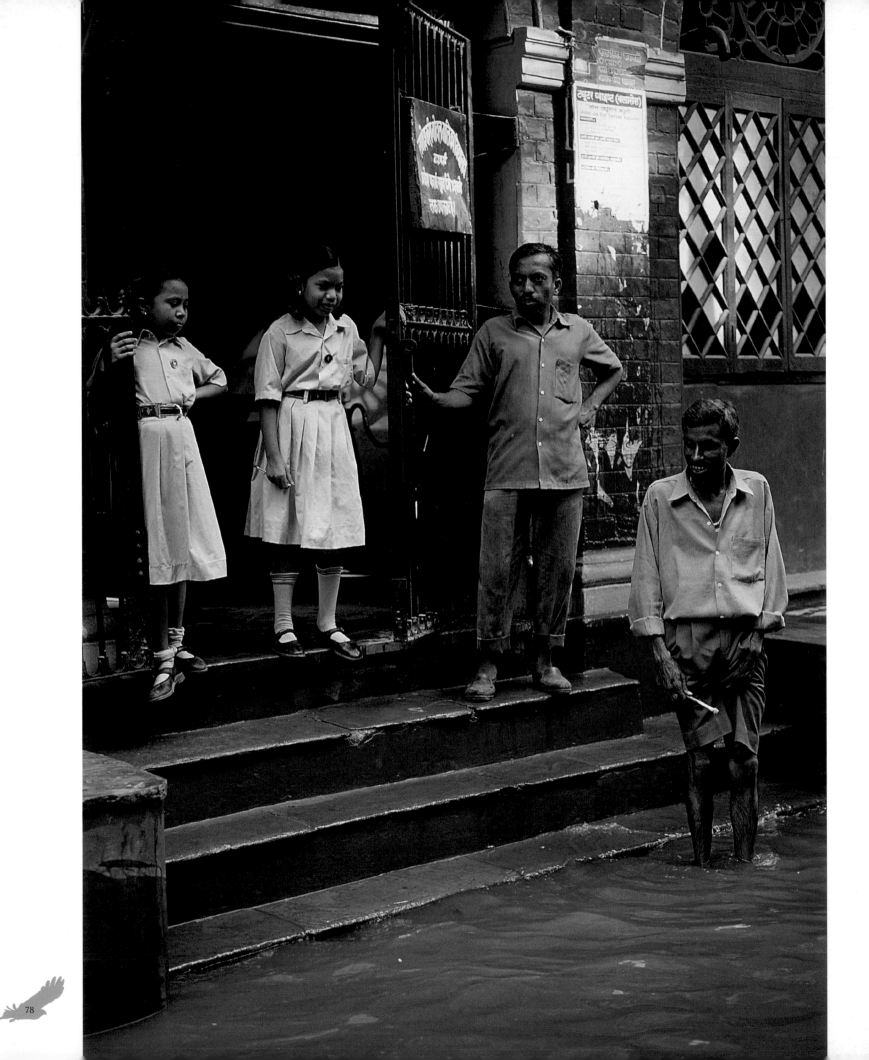

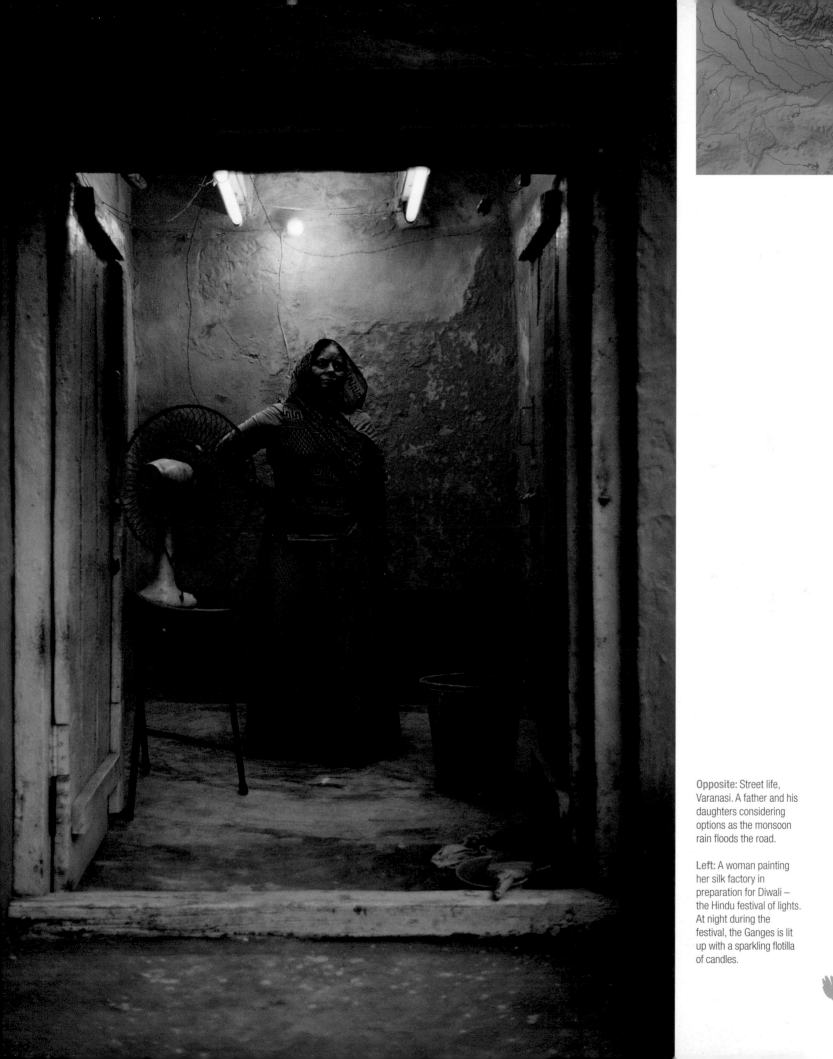

Opposite: Street life, Varanasi. A father and his daughters considering options as the monsoon rain floods the road.

Left: A woman painting her silk factory in preparation for Diwali – the Hindu festival of lights. At night during the festival, the Ganges is lit up with a sparkling flotilla of candles.

VARANASI AND THE REVOLUTION

By 1000 BC, the seeds of change had been planted. Thick forest still prevented large-scale colonization of the eastern Ganges, but in the upper reaches of the river, the agricultural boom was fuelling an urban revolution. As the towns and cities grew, so the cultures became more sophisticated, and over time, the early animist religions – which revered nature and, above all, the river that nurtured it – were incorporated into the elaborate religion of Hinduism. Water is the most divine symbol in Hinduism, and there is no water more sacred than that of the Ganges.

Above: A never-ending stream of people coming and going from the river as the light fades, grabbing a snack en route.

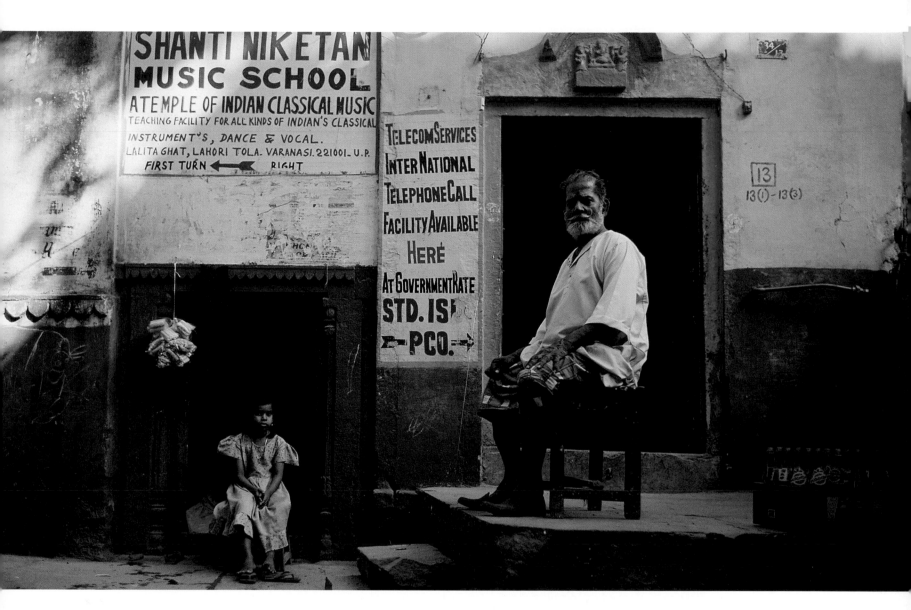

The ancient city of Varanasi, or Benares (to give it its older name), is considered the most holy Hindu site along the Ganges and perhaps in all of India. It is also one of the oldest cities in the world, dating back more than 6000 years. It lies about halfway along the Ganges, at the only place where the river turns to flow northwards back towards the Himalayas, which has given rise to the Hindu belief that it is the centre of the world. Every year, millions of pilgrims visit the city to bathe and wash away their sins. The bathing ghats face east along the banks of the Ganges so that, each morning, as the sun rises, its rays scatter over the water and illuminate the bathers in an exquisite pale golden light.

Above: Father and daughter talking in the warmth of early morning in a quiet back street.

Overleaf: A holy man at the Ramakrishna Mission – an ashram for the sick and homeless of Varanasi.

THE GREAT GANGETIC PLAIN

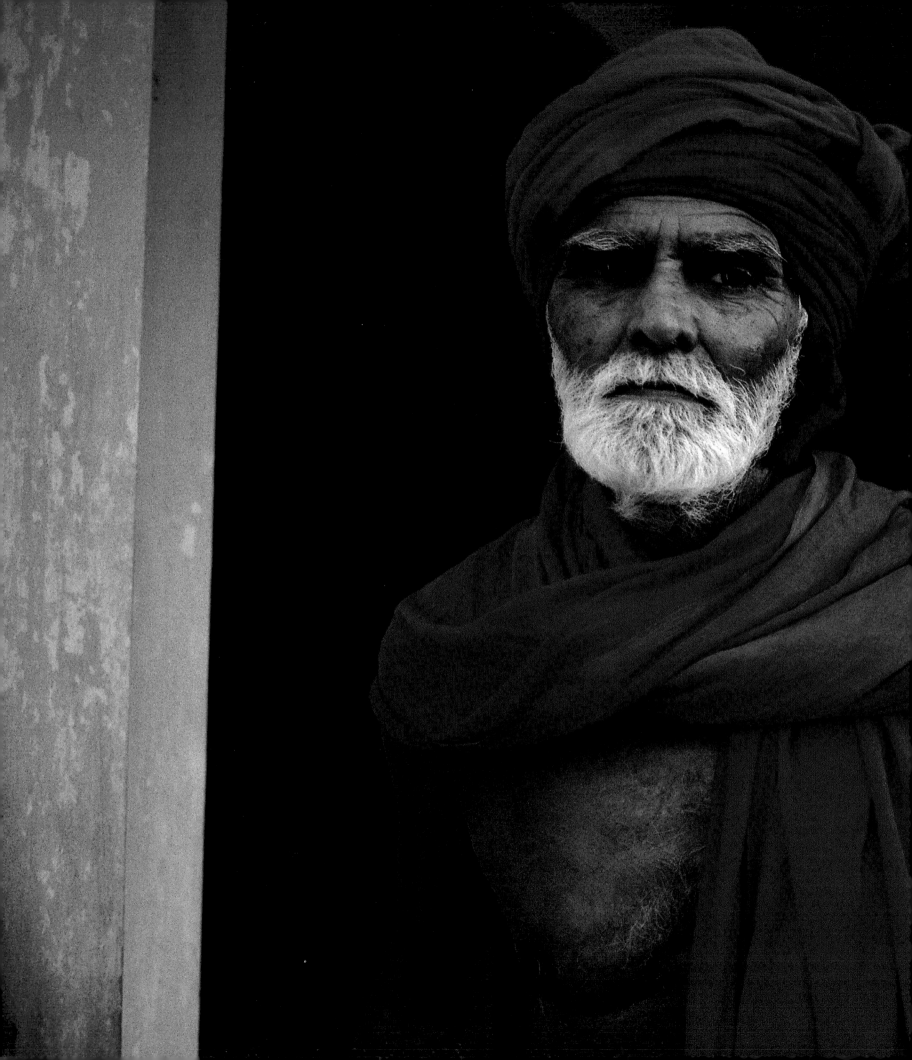

Right next to the bathing ghats are the famous burning ghats, where the dead are cremated. It is the wish of every pious Hindu to die at Varanasi, as to die here is to die that much closer to paradise. Cremation is so popular that the funeral pyres burn all day and all night. As many as 40,000 bodies are cremated here each year, and at least 10,000 tons of wood are brought in by boat to fuel the flames.

Varanasi vividly illustrates the contradictions that are so much part of India. Makeshift shacks and crumbling concrete buildings perch on top of ornate temples and palaces, discarded

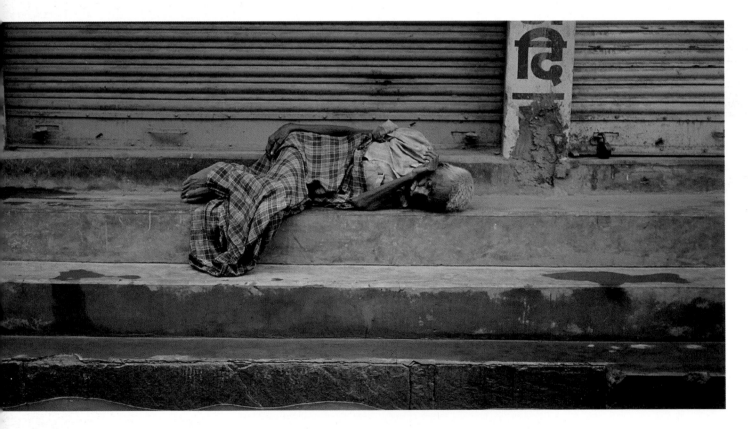

Left: Sleeping pilgrim. Some years, the monsoon rains are so severe that flooding of the streets in Varanasi brings normal life to a standstill.

Opposite: Washing a birdcage with monsoon street water. During heavy flooding, the drain covers may be lifted, and people have been known to vanish down the open drains while wading through the water.

Overleaf: Long view along the Varanasi ghats.

offerings and garlands of flowers decorate the endless piles of rubbish, and the perfume of incense mixes with the odour of decay. Beggars and feral animals scavenge on the excesses of rich Hindu pilgrims, and detritus and corpses drift along the most sacred of all rivers.

That Benares was already a city when Rome was merely a collection of huts illustrates just how long human civilization has been shaping the Ganges. Settlements and populations grew

THE GREAT GANGETIC PLAIN

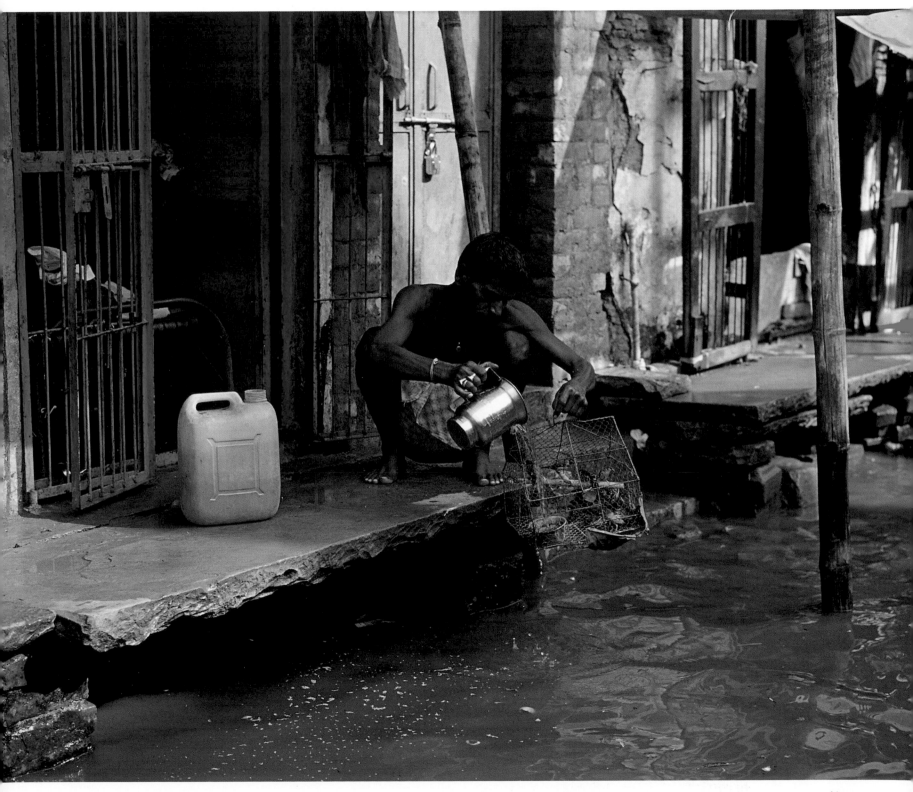

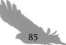

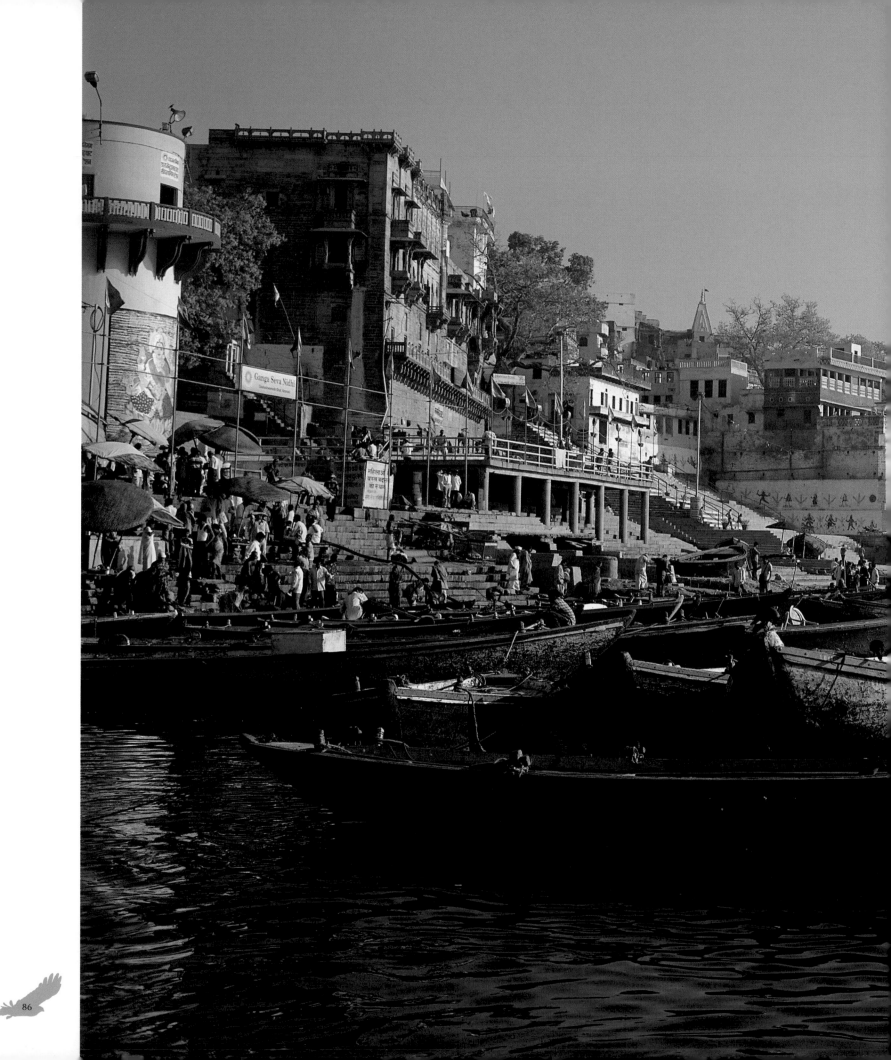

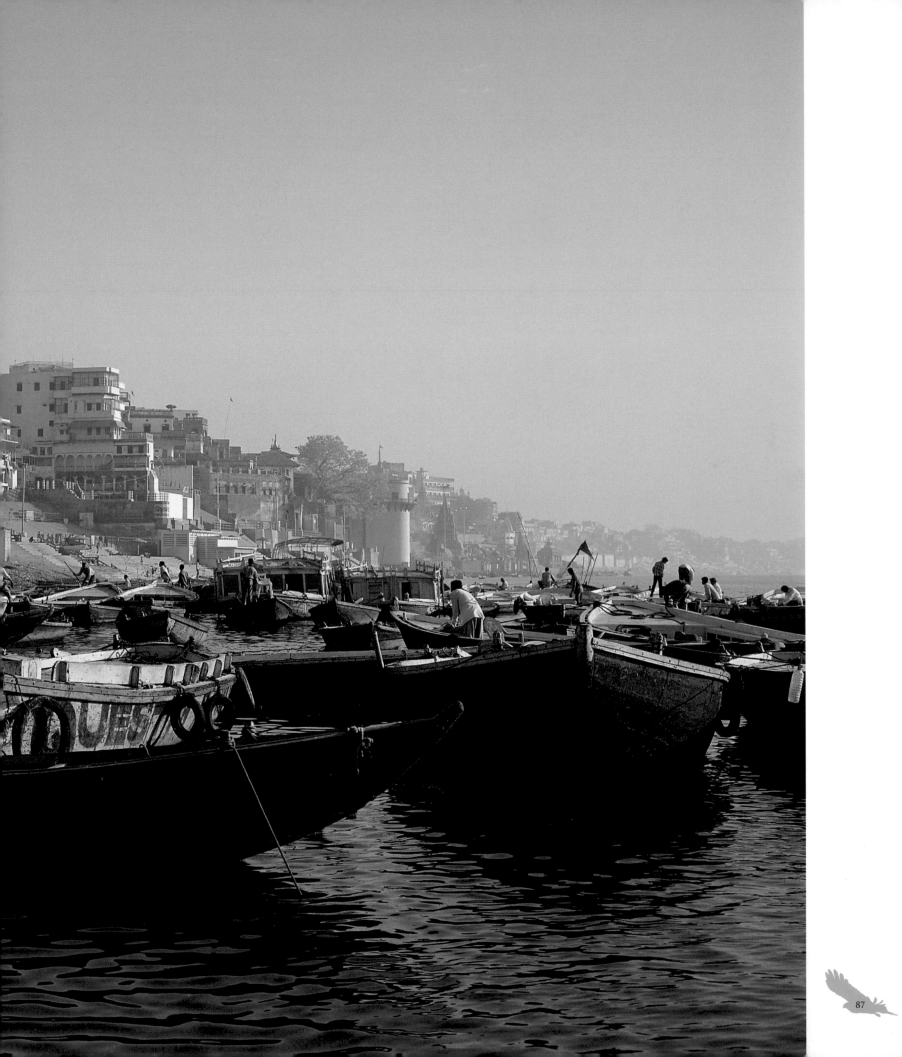

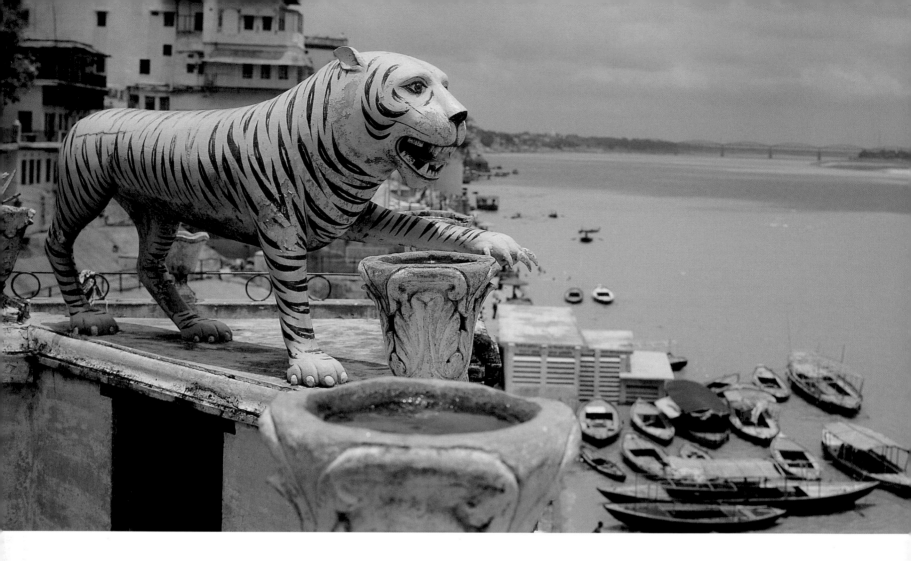

steadily through ancient and medieval times, and more and more land was cleared for agriculture. Yet there was still plenty of space for nature. The cultivated sites created little more than small islands in a vast sea of trees, and the rainforest regenerated fast. Indeed, the wilderness between the settlements could be so thick that the Ganges channel provided the only practical highway for communication and trade. Lions, tigers, cheetahs, buffaloes, rhinos and elephants could all be encountered just outside the city limits, and many other creatures lived in the urban areas.

THE HERITAGE OF ANIMISM

Even today, the people of the Gangetic Plain seem happy to share their streets with an array of wild animals. The animist origins of Hinduism have ensured nature a central role in religion and respect for all life forms from its devotees. Ganesh, the elephant god, and Hanuman, the monkey warrior, are perhaps the most famous of the animal deities, but almost endless varieties of other beasts are linked with gods or incorporated into the faith in one way or another. So many animals have been associated with Hinduism that different people can choose to concentrate their devotions on different animals – and in some cases, the choices are surprising.

Above: The view from the house of the Dom Raja. Tigers – representing power and strength but also destruction – are among many animals used in Hindu symbolism.

The large number of rats and mice in the towns and villages provides food for snakes such as cobras and vipers and brings these snakes into frequent contact with humans. About 20,000 people die from snake-bite in India each year, and a large proportion of the deaths occur on the Gangetic Plain. As most people cannot tell non-venomous from venomous species, they tend to kill any snake they encounter – but not everywhere.

In the Burdwan district of Bengal, close to the banks of the Ganges, lie five villages where the streets slither with an abnormally high density of cobras. The inhabitants consider them to be sacred animals that guard the village against evil, and it is believed that anyone who harms one will be cursed. The cobras are even allowed to slither in gardens and houses.

This tolerance seems to have its benefits. Cobras can be aggressive, but the snakes in the villages are remarkably docile, and there are claims that their poison has evolved to be less potent. Locals are regularly bitten when they inadvertently step on cobras, but excruciatingly painful and deadly

Below: Rooftop langurs. Throughout India, Hanuman langurs use roofs and walls as an urban jungle. They are offered food by some Hindus, especially on Tuesdays and Saturdays, which are known as Hanuman days.

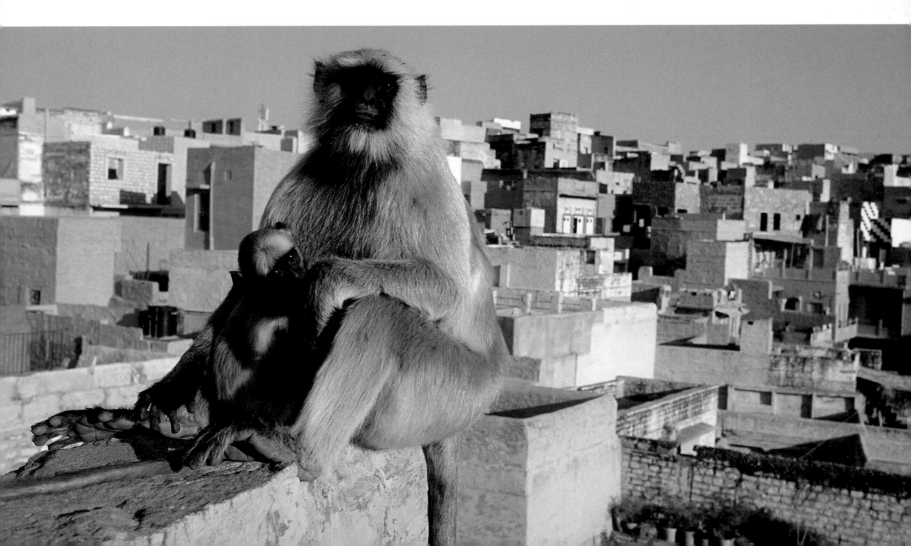

though the bites can be, the victims refuse to go to hospital or take antivenom. Instead they rely on faith-healing, bathe in their holy village pool, take no food for 24 hours and, most important, try not to succumb to the soporific effects of the neurotoxins. Though a cobra bite can be fatal, there is no record of anyone dying from one in these villages.

Sharing the streets with cobras might be exceptional, but throughout the Gangetic Plain, it is remarkable how accommodating people can be towards their wild neighbours. Even scavenging animals such as dogs with no religious status are allowed the run of the towns, and jackals, black kites, langurs and rhesus macaques are all commonly sighted in even the most built-up areas. Though food-stealing by troops of urban macaques is a nuisance that plagues almost every community along the Ganges, macaques are still generally accepted as part of the rich variety of life.

Below: A calf and a boy resting side by side. Cows are revered and allowed to roam free. Symbolic of abundance, they provide milk, fertilizer and fuel, and also plough and carry.

Opposite: Cobra-village life, Burdwan, Bengal. In five villages close to the Ganges, cobras are considered sacred and live alongside people. Any bites are treated through faith-healing, and there are no recorded fatalities.

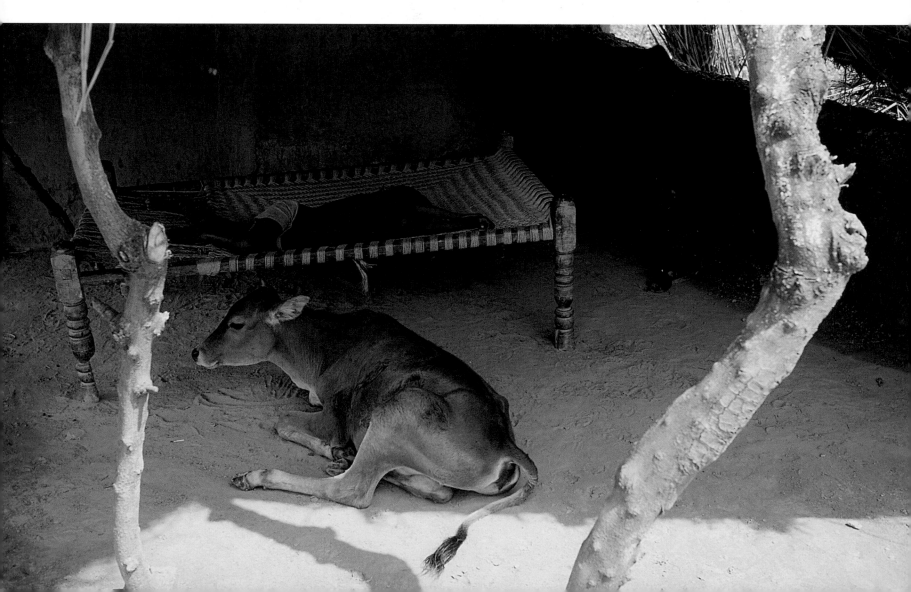

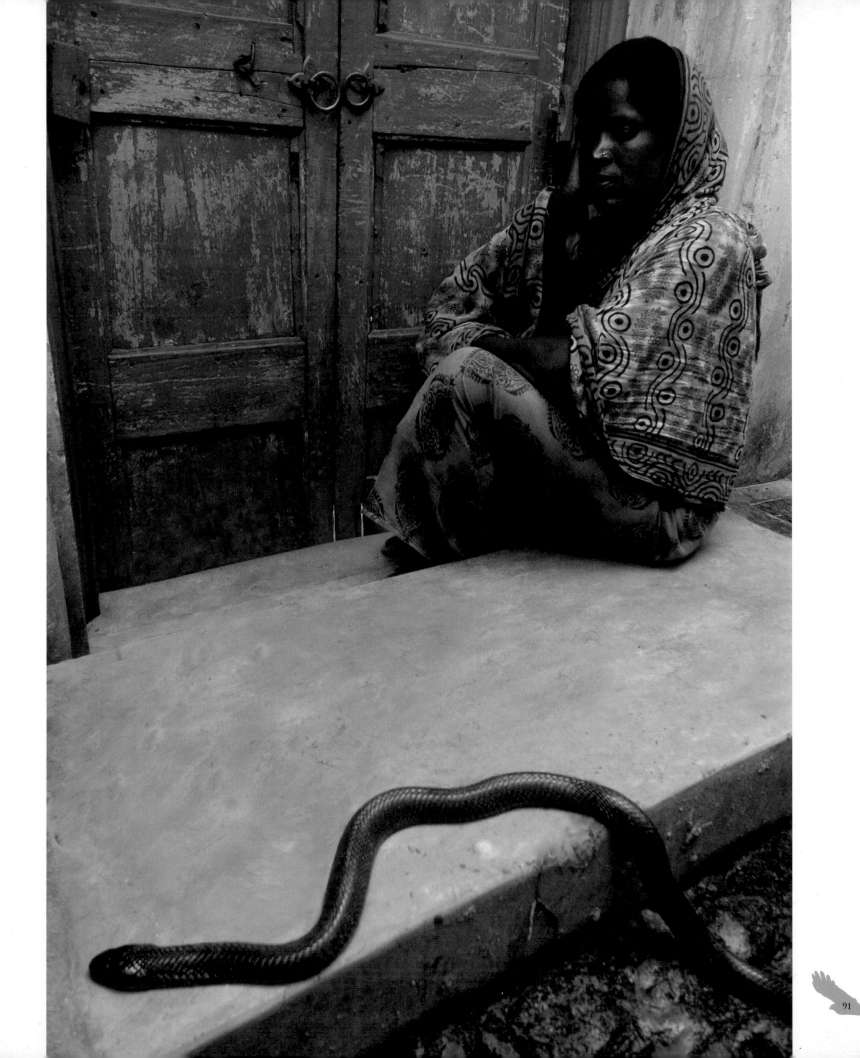

THE MOGUL REVOLUTION

The golden age of the Ganges – when man and beast shared the towns, fields and wilderness – lasted right into the sixteenth century. It was only in 1526, when the Mogul invaders began to make a serious bid for the control of northern India, that things really began to change. As well as introducing Islam to the region, the Moguls brought new ideas about science, art and technology, all of which would revolutionize life on the Gangetic Plain.

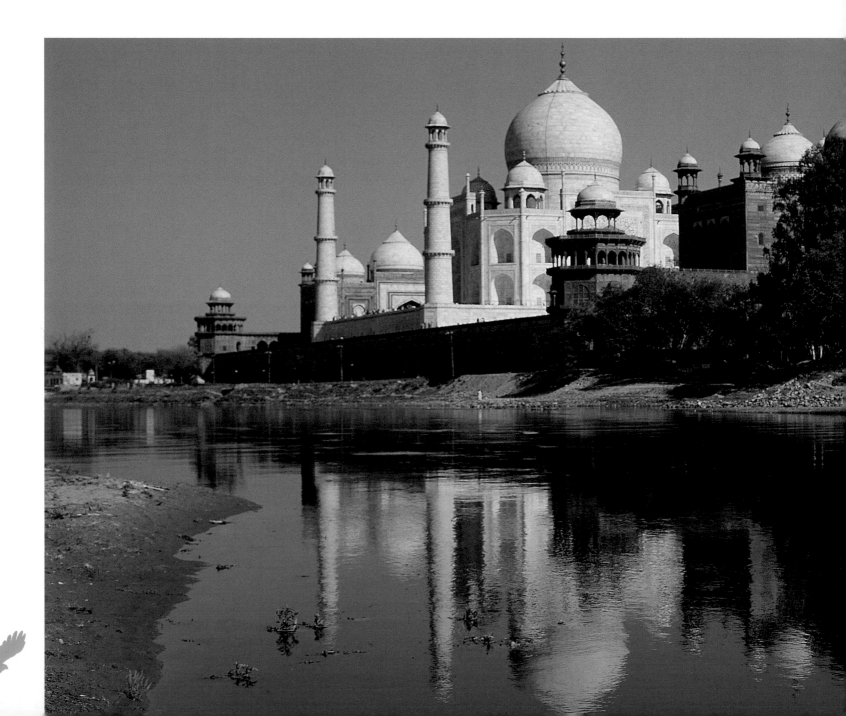

One of the Moguls' greatest and longest-lasting influences was on architecture. Mogul buildings are scattered throughout the region, but by far the most celebrated lies on the banks of the Yumana, another major tributary of the Ganges. The Taj Mahal of Agra is considered by many to be the most exquisite building ever built. It was completed in 1654 by Emperor Shah Jahan as a memorial to his wife. The building took 23 years and 22,000 labourers to build and was made from only the finest materials, including marble and 28 different precious and semi-precious stones. It is estimated to have cost the equivalent of $500 million (£275 million).

Left: The Taj Mahal – Mogul monument – seen from the opposite bank of the Yamuna river (tributary of the Ganges). The floral designs that cover its internal walls and its formal gardens are reminders of the Mogul invaders' more doministic attitude to nature.

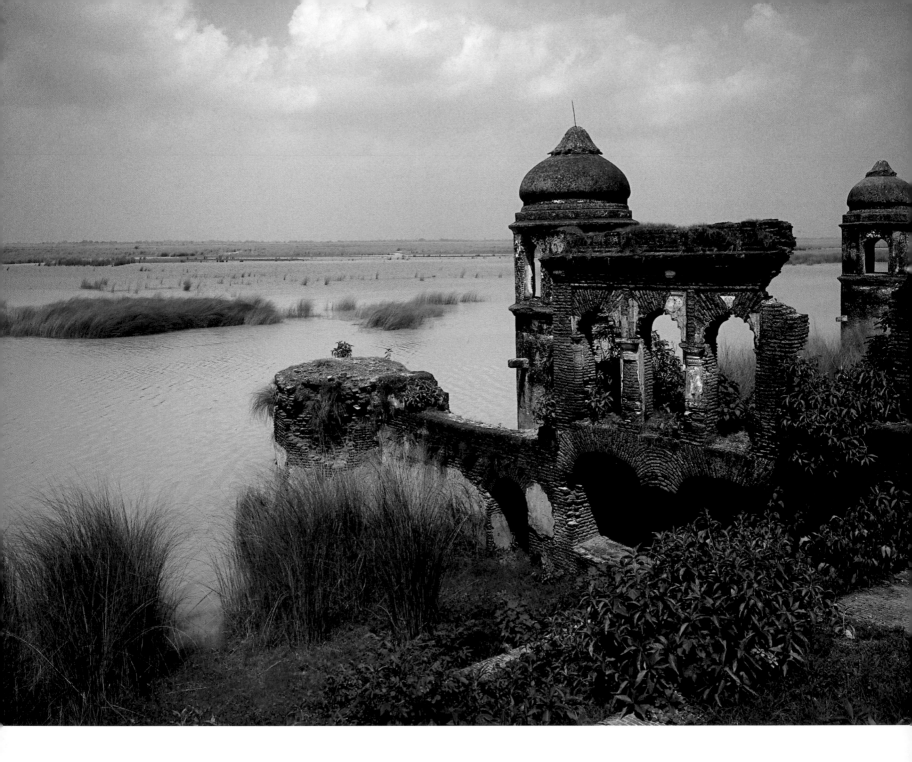

The intricate detail of the building, inspired by natural forms, and the beautiful gardens surrounding it show that the Moguls had a fascination with nature. But unlike the Hindus, they liked to control wildlife – both mentally and physically. They were great observers, recorders and painters of animals, and they loved to train plants, creating highly formal gardens, which they would stock with exotic beasts. Above all, they were passionate about hunting.

Hunting as a pastime had long been practised by the various rulers of the plains, but it was taken to a totally new level by the Moguls. Originating from the relatively barren Middle East, the Moguls were dazzled by the profusion of game in the Gangetic basin, and they began to hunt

Above: A Mogul ruin on the bank of the Ganges near Kanpur. The Mogul era of the sixteenth and seventeenth centuries introduced new irrigation systems and constructed canals that dramatically changed the Ganges.

on a massive scale. Kings embarked on hunts that lasted for months, and huge armies were sent out on foot to encircle animals so the king could move in for an easy kill. The Moguls likened killing wild beasts to slaying their enemies and believed that hunting was excellent training for combat. Success as a hunter was considered symbolic of strength and status, and there was competition among the royalty to bag the most prey. During a 12-year reign, one king, Jahangir, killed 17,000 animals, among them 87 tigers and lions, 889 nilgai and 1670 antelopes and gazelles. The Moguls also diversified the sport of hunting, introducing the use of muskets, using cheetahs to course deer and blackbuck and training falcons to hunt birds. The spoils from these trips fed the Moguls' appetite for wild meat, and a successful hunting trip would be celebrated by 30- or 40-course banquets.

The Moguls also changed the face of the Ganges more directly. They used their technological know-how to build canals and irrigation systems that helped to extend the waters of the Ganges to areas further away. Many of these canal routes form the basis of the modern Ganges canal network.

Influential though the Moguls were, just 200 years after their arrival, their empire was in decline. They left behind a land that had changed greatly, but compared to Europe, there were still enormous areas of wilderness left. It would be European colonialists, especially the British, who would thoroughly change the Gangetic Plain.

THE GREAT BRITISH CLEARANCE

Europeans came to India in search of opportunity and quickly appreciated the vast economic potential of the Ganges and its fertile floodplains. There are few places along the Ganges that are free of the Influence of the British Raj. Downstream from Varanasi is the city of Patna, which under rose to great prosperity and became the central hub of British operations in the Gangetic basin. It was where produce from all over the region was collected and processed, ready to be shipped around India and overseas. Today it is still possible to find old factories and warehouses from the times of the Raj dotted through the modern urban sprawl.

Overleaf: A young man looks over the holy Son river south of Varanasi. Where the Son meets the Ganges is the city of Patna, which became the centre of British operations in the Gangetic basin.

In the pursuit of maximum turnover, organisations such as the East India Company squeezed as much as they could out of the land and the labour force. Agricultural expansion and intensification led to the clearance of vast swathes of forest. Elephants were used to clear the jungle and bring out trees to supply the booming timber trade, providing props for the many mines and sleepers for the ever-expanding railway network, which needed 2000 trees for just one mile (1.6 km) of line. By the time the government realized the scale of clearance and tried to control the situation by putting limits on timber and by replanting areas, it was largely too little too late.

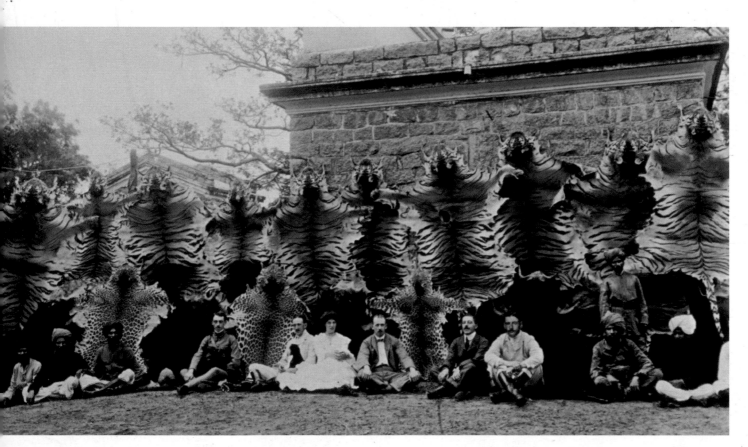

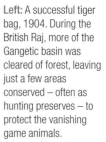

Left: A successful tiger bag, 1904. During the British Raj, more of the Gangetic basin was cleared of forest, leaving just a few areas conserved – often as hunting preserves – to protect the vanishing game animals.

Opposite: Young Bengal tiger. Today, the remnant, fragmented tiger population is protected but in rapid decline – the result of poaching to supply the Chinese medicine trade with bones.

Animals were shown even less mercy. The British put bounties on the heads of 'pests' and used propaganda to sway local opinion. The British and the maharajas also took up with gusto the hunting traditions establish by the Moguls and competed with each other to bag the most animals. Financial rewards also encouraged local people to join the hunt, and around 20,000 bounties were claimed each year on animals that included elephants, rhinos and buffaloes. But it was the large predators that were the most wanted. Tigers were regarded as savage and

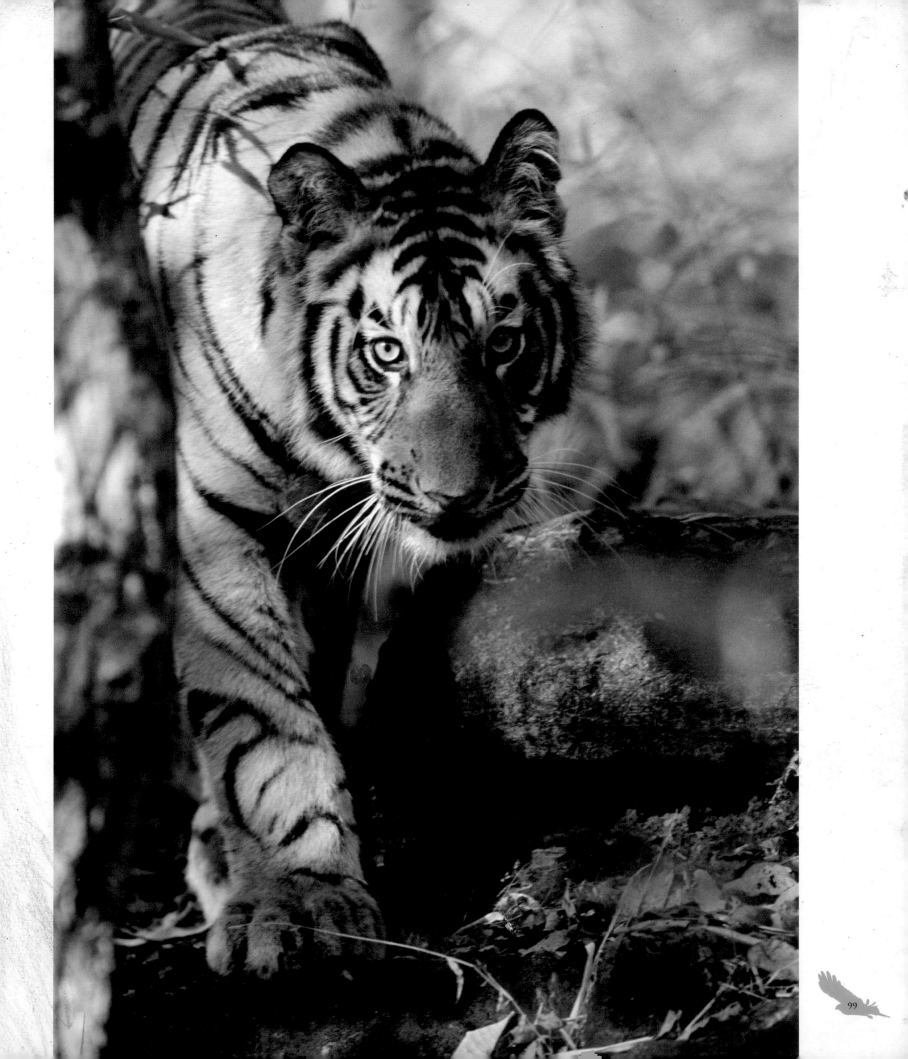

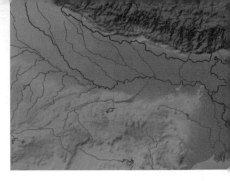

cunning, threatening both humans and livestock. Between 1875 and 1925, 80,000 tigers, 150,000 leopards and 200,000 wolves were on record as having been killed. In reality, the death toll must have been far higher.

Tiger numbers declined dramatically, but small populations were able to take refuge in island pockets of dense forest. The animals of the open plains were not so fortunate. Here the land was easier to clear and the exposed animals easier to shoot. The grey wolf, cheetah and Asiatic lion were all pushed to the brink of extinction. The bounty system had proved too effective.

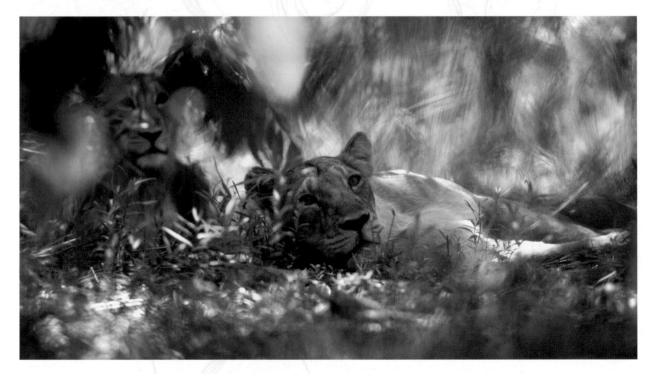

Left: Asiatic lions. Once found all over the Gangetic plain, the lions were wiped out mainly by hunting – being far easier to shoot than the tiger – save for a tiny population in the Gir Forest in Gujarat. Though there are now around 360 lions, the population has not spread naturally much beyond the Gir National Park and is still very vulnerable.

Opposite: Black kites circling over a municipal dump. This is one species to have benefited from the spread of humans. Being an opportunist, it has learnt to scavenge on household rubbish and carrion.

By the 1920s, bounties were being phased out. Forest reserves were established to protect the disappearing animals, though often simply to preserve the hunting grounds of the rich. Today, these parks are the strongholds of Indian wildlife. But for most of the Ganges region, the land was simply too valuable to be set aside for wildlife, and most of it had long since been cleared for farming.

India gained independence in 1947, and the British departed, leaving the floodplains dramatically changed and without many of the animals that had been common just a hundred

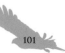

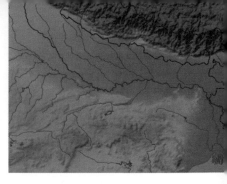

years earlier. But while the wildlife was declining, the human population was expanding faster than ever. Since Independence the number of people living on the Gangetic plains almost tripled to around half a billion. Today, the people can no longer rely on the natural resources. Wood is in very short supply, and collecting enough sticks to do the day's cooking has become a time-consuming chore. Many resort to alternative fuels, in particular, dung, and in most villages, the walls of buildings are lined with discs of cow dung drying in the sun.

Opposite: Dung cakes drying in the sun. With wood now in short supply, people must use alternative fuels – in particular, cow dung. Today, some power plants are also using dung, to generate bio-gas and producing fertilizer as a by-product.

TAMING THE WILD

The very early settlers not only domesticated plants but also tamed animals. Native species such as wild cattle (the now-extinct aurochs), jungle fowls, elephants and buffaloes were successfully domesticated, and others were introduced. Today, overwhelming numbers of zebu cows, buffaloes, goats, sheep, chickens and ducks are encountered in the villages and fields and, most scarily, on the roads. But the greatest concentration of domestic animals is to be found at the Sonpur mela.

Sonpur lies on the confluence of the Gandaki and the Ganges, about an hour from Patna. About half a million people flock here for the night of the first full moon in November to meet friends, relax, celebrate, pray and bathe in the river. There is an 'anything goes' atmosphere, and the mela is renowned in India for being a little wild. After a couple of nights, though, the crowds begin to thin, and the focus of the celebration turns to the serious business of buying and selling livestock.

Animals have been traded here since the fourth century BC, and today Sonpur is the largest cattle fair in Asia. Livestock traders come from all over the state of Bihar and further afield, buffaloes, horses and goats are sold in huge quantities, and on the black market, it is possible to purchase birds, monkeys and other wild animals. The trade in trained elephants at the fair is technically illegal, but around 70 seem to turn up each year to be illicitly sold. These elephants would have once been bought to be put to work, but with the increased use of machinery, the demand for working elephants has dwindled, and most are now kept simply as status symbols.

For the wild elephants of the Gangetic basin, the situation is no better. Their forest habitat is now too scarce and too degraded to support any large populations – a cruel twist of fate, given that their wild-caught ancestors would have been used to log those forests. The herds that

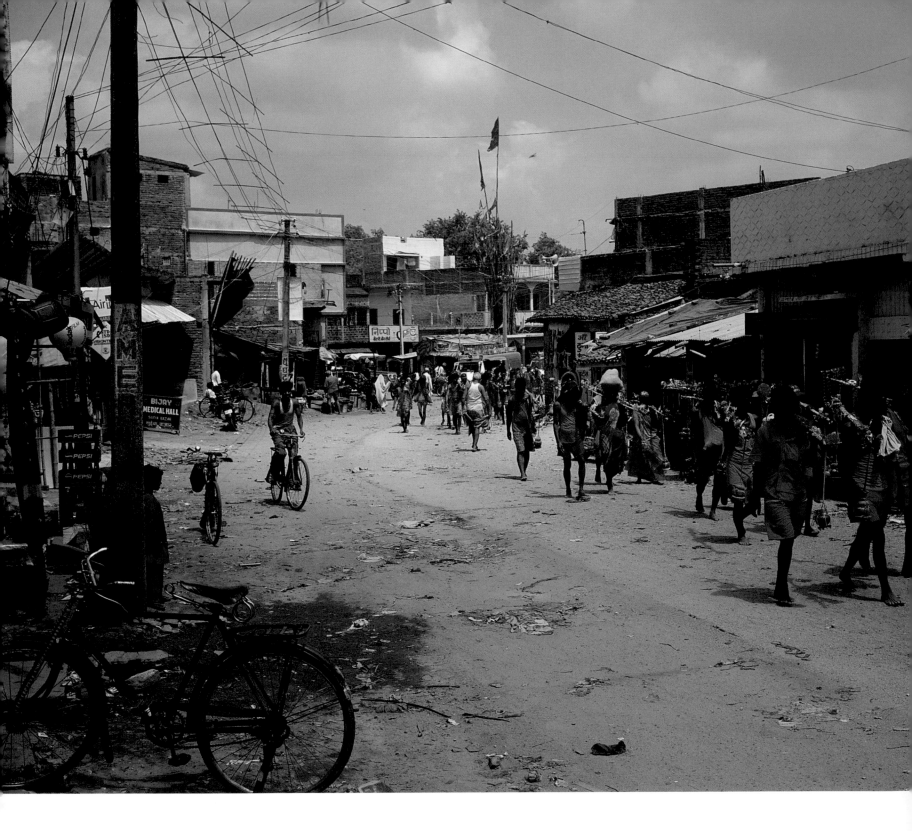

have survived in West and North Bengal must migrate over vast areas to find enough food – a migration that takes them through agricultural land and into direct conflict with humans. When they can't get enough food in the forests, the elephants sneak into the rice paddies and fields at night to feed on the crops. The villagers post night-watchmen in machans – treehouse-like lookouts. If a watchmen raises the alarm, the men arm themselves with flaming torches, spears, flashlights and firecrackers and set off into the fields. Chasing a large herd of stressed

Above: Barefoot pilgrims on the 105km (65-mile) trek from Sultanganj to Deogarh – 'abode of the gods'. They set out at the start of the monsoon and carry Ganges water to present to Shiva.

elephants in the dark is a highly risky business. Sometimes the elephants are scared off easily, at other times they stand their ground or even charge back, and occasionally people get killed. Even if a marauding herd is chased off, it usually moves on to other fields, only to be chased back later that night. The elephants can feel so persecuted that some seem to seek revenge, entering villages and actively attacking people. In Bengal alone, around 80 people a year are trampled by elephants.

Above: The cobra, mark of Shiva, adorns the water-carrying yokes. Ganges water from Sultanganj is considered particularly holy because of the river's unusual flow northwards at this point.

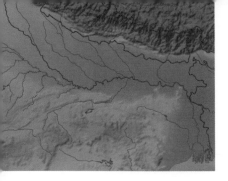

It is a huge problem with no obvious solution – the last remaining herds are protected by law and sanctity, and so killing them is not an option – and both the people and the elephants are becoming desperately frustrated. The battle between humans and elephants highlights the issues of the Ganges basin today. The area is so dominated by humans that there is little room for wildlife that cannot adapt to live in man-made environments. Pollution and irrigation are also taking their toll on the river and the animals that inhabit it.

Though the Ganges is among the most polluted of all rivers, the enigmatic Ganges river dolphin has managed to hang on. A flash of a fin breaking the water's surface is about as much of a glimpse of this rare and elusive animal that anyone gets. In evolutionary terms, it is possibly the most primitive of the dolphins alive today, and as it lives in such turbid water, little is known about its behaviour. In the murky depths, sight is useless, and so the dolphin has lost the focusing lenses in its eyes and is almost completely blind, relying instead on highly developed echolocation to navigate and hunt. It feeds on fish, crustaceans and cuttlefish, and like the gharial, it has a long, thin snout designed to snap shut with minimal water resistance.

Often the best places to see Ganges river dolphins are at the confluences of two rivers, where fish tend to gather in eddies created by the meeting currents. Though the dolphins are not thought to be social, it is possible to see a number of individuals feeding in these choice spots. Many populations, though, are isolated by dams along the Ganges and its tributaries. The dolphins are also affected by dredging and embankments, which cause the sediment to be deposited on the riverbed, reducing still further the areas they can survive in. Their presence is considered a sign of relatively healthy water, and though the species now probably numbers no more than 5000 and possibly fewer than 2000 individuals, its continued survival suggests that there is still hope for the future of the Ganges.

THE CITY OF 14 MILLION

As the river turns south towards the Bay of Bengal, it flows through the heart of the largest Indian city of all, Kolkata, or Calcutta. This huge metropolis was founded 300 years ago by the British and became the capital of the Raj. Its position towards the end of the Ganges and close to the sea rendered it the perfect centre for receiving, packaging and exporting the produce that arrived from the Gangetic basin. Today, Kolkata is still a major port and a bustling city, home to more than 14 million people. The urban sprawl stretches as far as the eye can see, and the roads are choked with endless queues of cars and yellow taxis. Apart from the decaying

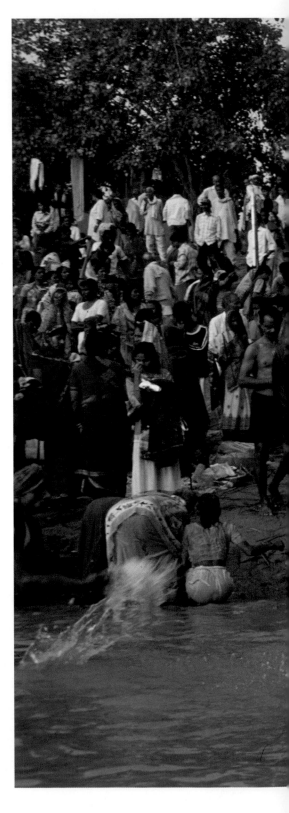

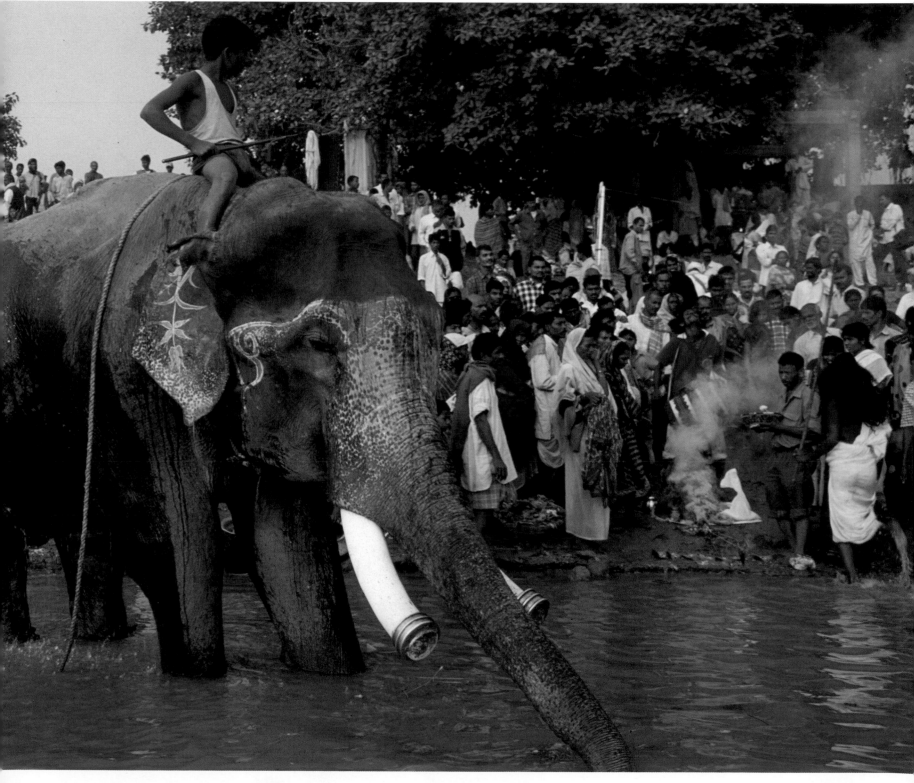

THE GREAT GANGETIC PLAIN

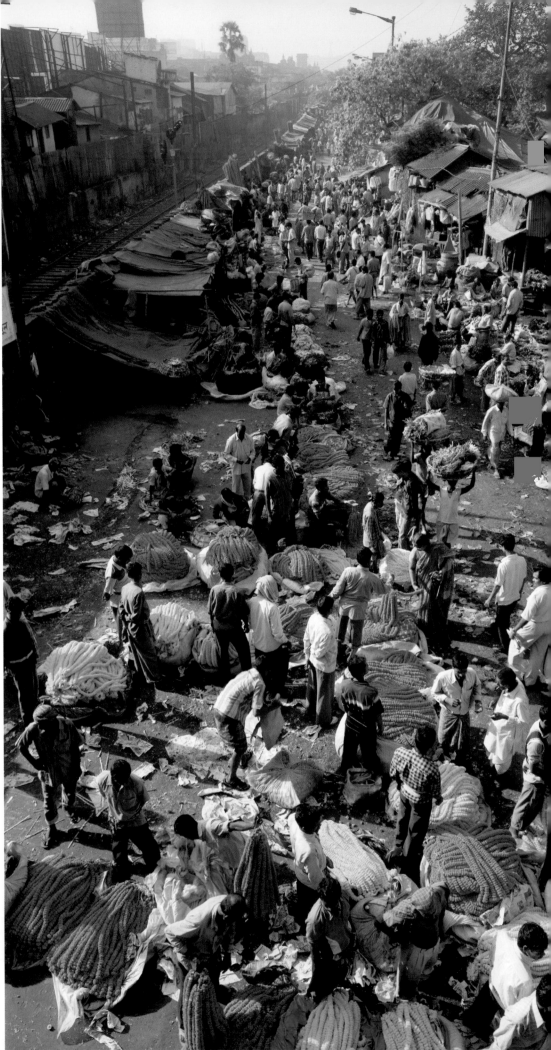

Above: Goats and a taxi crossing the Maidan (Hindi for field). Kolkata's huge city park is bounded on the west by the Hooghly river, which splits from the Ganges near Baharampur and runs south into the Bay of Bengal.

Right: The early morning flower market under the Howrah Bridge. The flowers, including the garlands of marigolds, are sold mainly for ceremonial purposes.

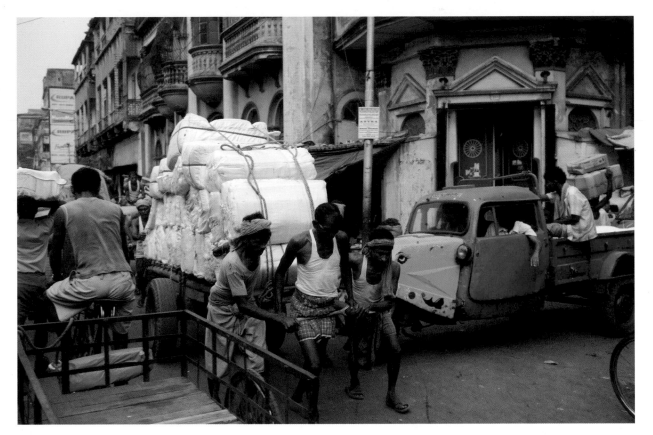

grandeur of old colonial buildings that still dominate much of the city centre, there is little left in this modern metropolis that bears testimony to the long history of the Ganges basin.

Kolkata is typical of twenty-first-century India. Technology and industry are shaping the country into one of the fastest-growing economies on Earth. Whether human or animal, those that can't adapt to the changes are pushed to the fringes of society, forced to make a living from what others discard. The usual animal scavengers and generalists such as kites and jackals can do well here, but this is no place for the exotic cast of animals that once inhabited the area.

It is inevitable that the people of Kolkata are becoming further and further separated from their natural heritage, but their lives will always be inextricably tied to the Ganges. Even today, most of their food is grown on her floodplains or caught in her waters, and the river remains central to their religion. Like all Hindus, the inhabitants of Kolkata continue to honour and worship Ganga Ma, and the Ganges continues to play a role in life's most important rituals of birth, initiation, marriage and death.

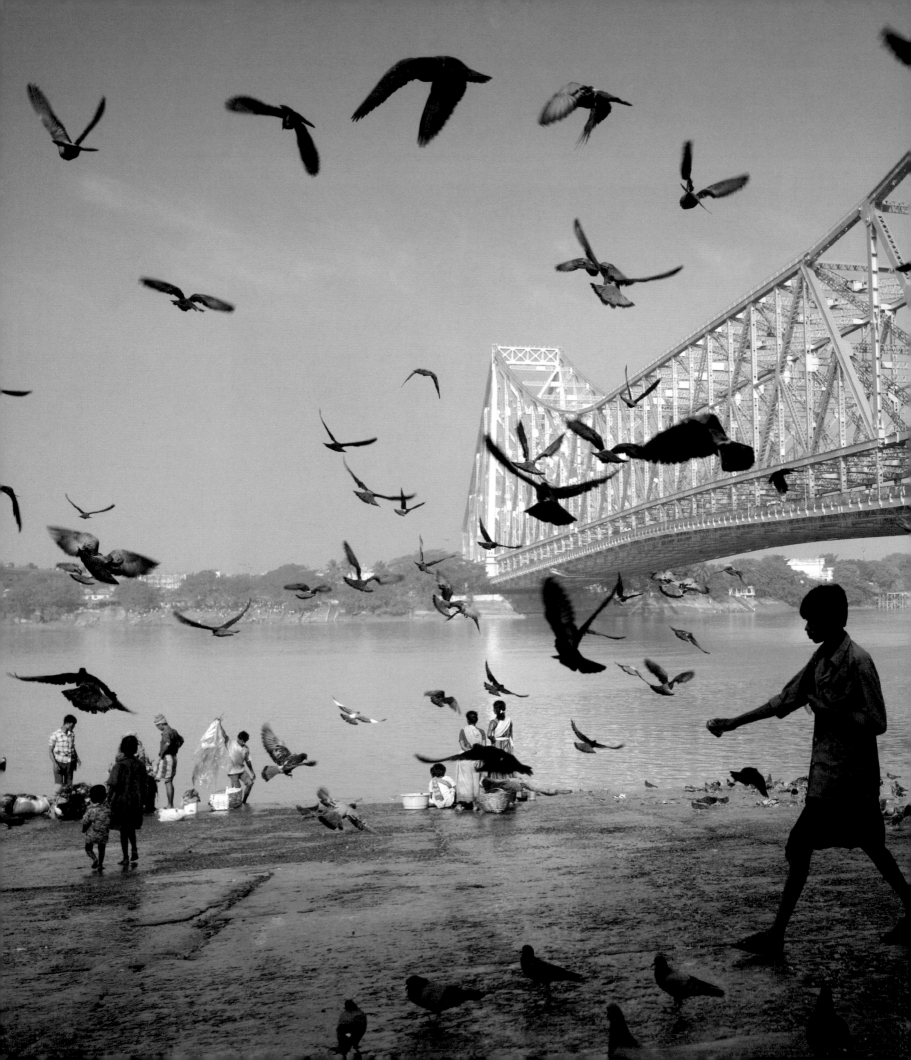

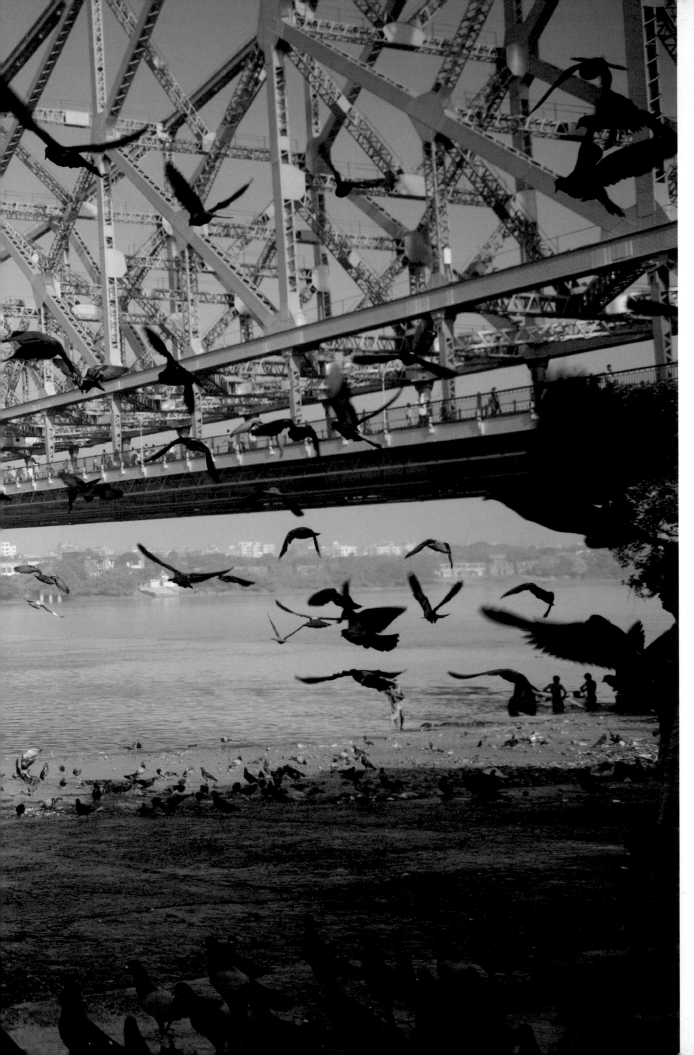

Left: Howrah Bridge, linking Kolkata with its industrial twin city Howrah. It is the world's busiest cantilever bridge, jammed in rush hour with cars, rickshaws and coolies and their carts.

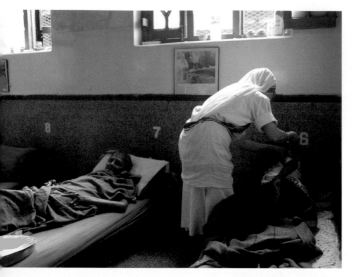

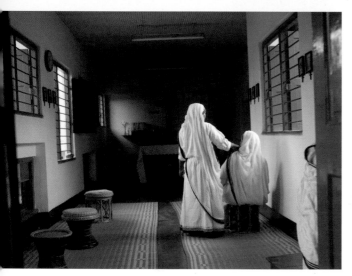

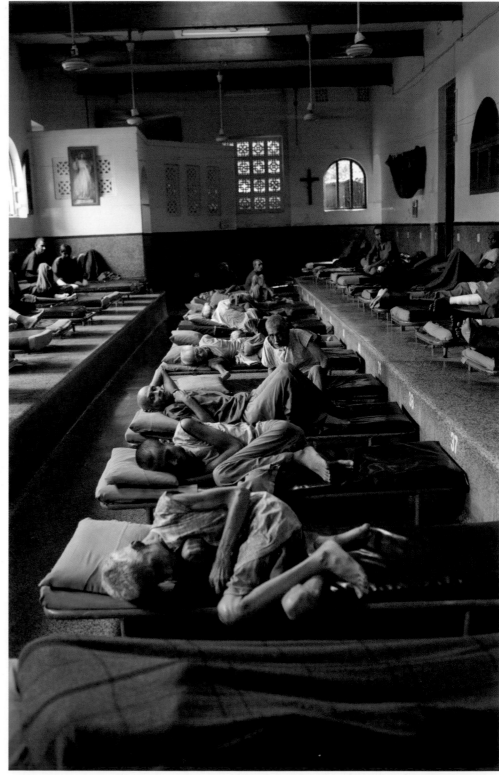

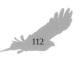

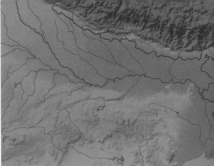

MEDICINE

Left and opposite:
Tending to the work of God at the Missionaries of Charity's hospice in Kalighat, Kolkata.

Founded in 1950 by Albanian Roman Catholic nun Mother Teresa, the converted Hindu temple is a free hospice for people 'unwanted, unloved, uncared for throughout society'. The Missionaries of Charity now operates worldwide.

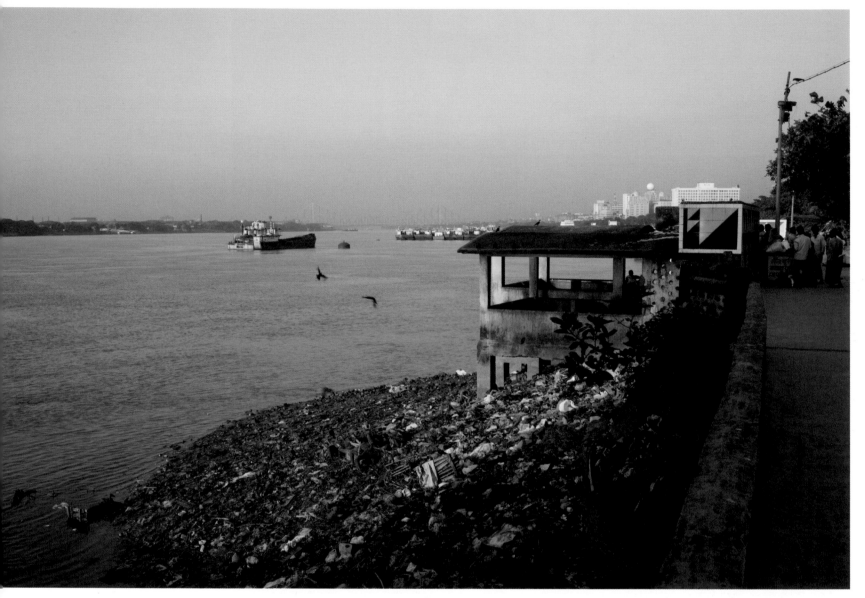

Like the Hindus who live and die by her banks, the Ganges itself has also been through many incarnations. The richest wilderness in India has been transformed into the most densely populated area in the world – all fuelled by the river and her gift of fertility. But this benevolence cannot be sustained for ever, and there is a limit to how much sin the Ganges can absolve. There is still space for people and wildlife to coexist, but human attitudes and actions must change if this is ever to be a reality.

Above: Ganges rubbish bank. Kolkata is trying hard to clean up the holy river, but with an expanding population, rubbish disposal is a growing problem for the city.

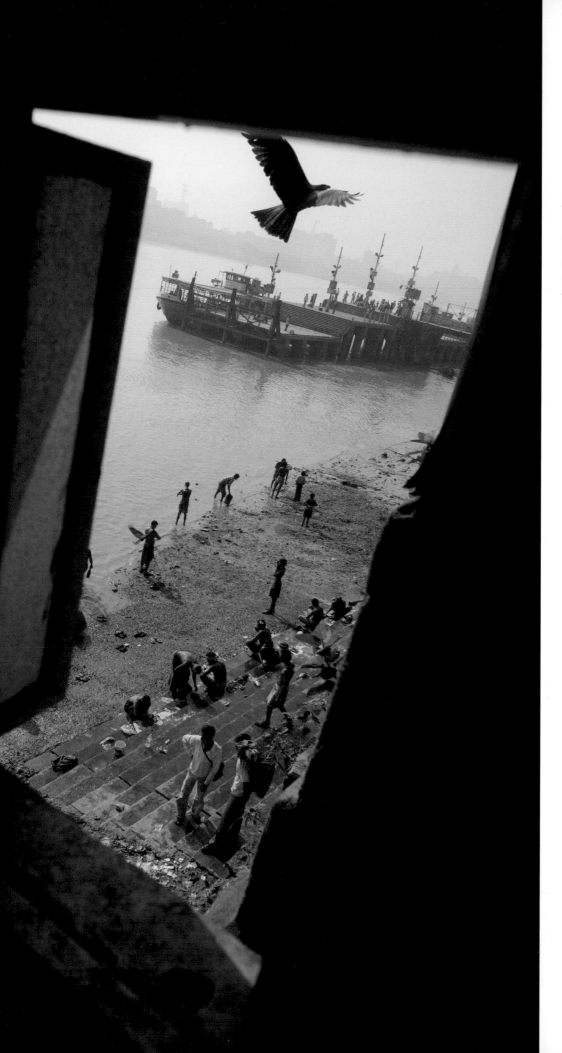

Left: Window on the river. Whatever the state of the Ganges, worshippers and bathers continue to immerse in her waters. Overhead hovers one of nature's cleaners – a black kite – on the lookout for scraps.

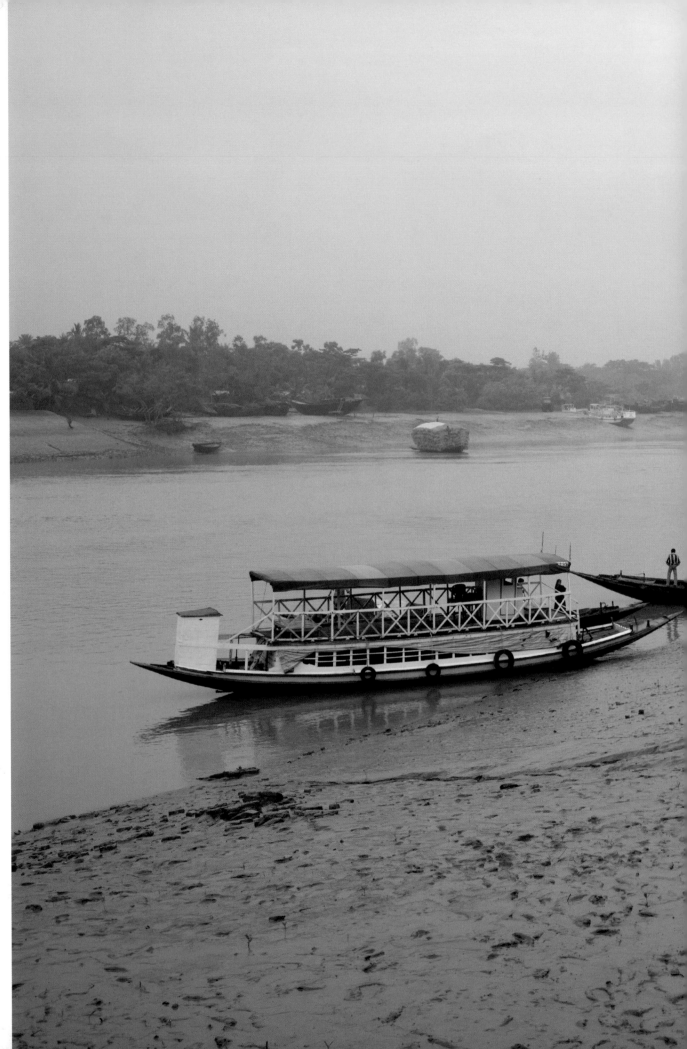

Right: Sonakhali –
embarkation point for
the long boat ride to
Sagar Island.

116

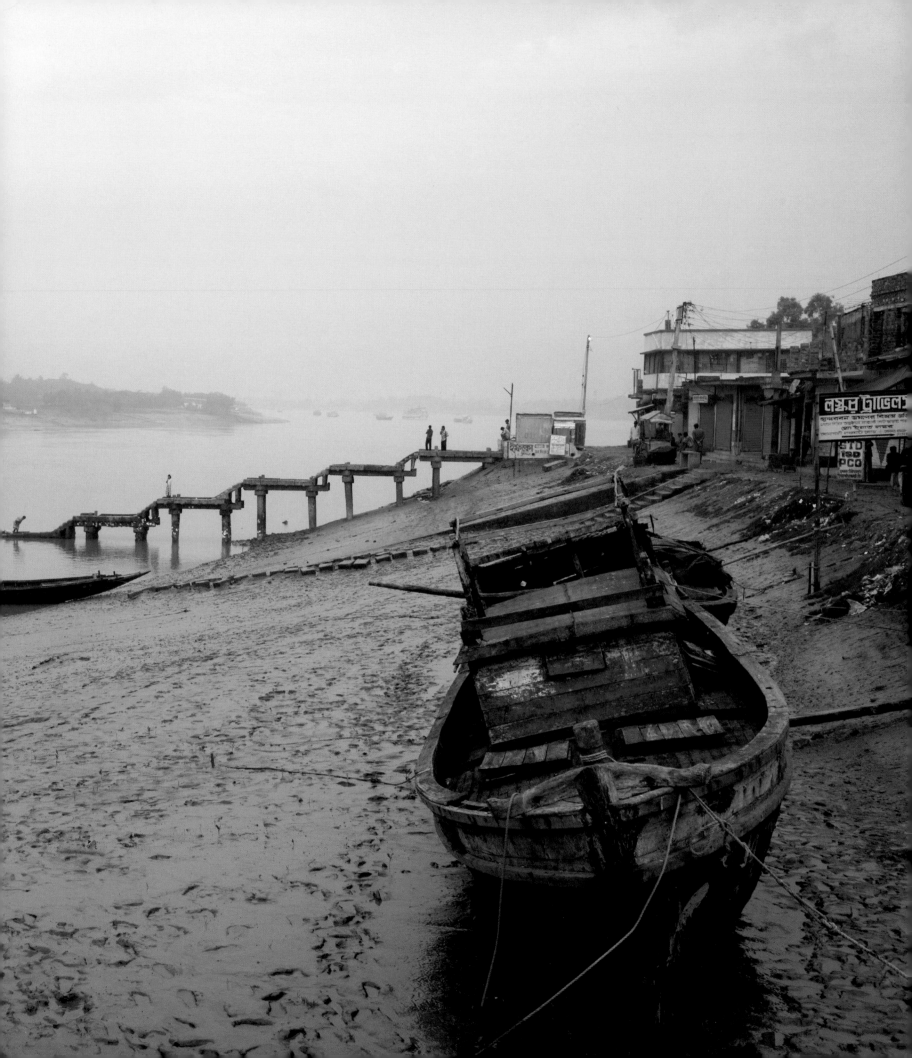

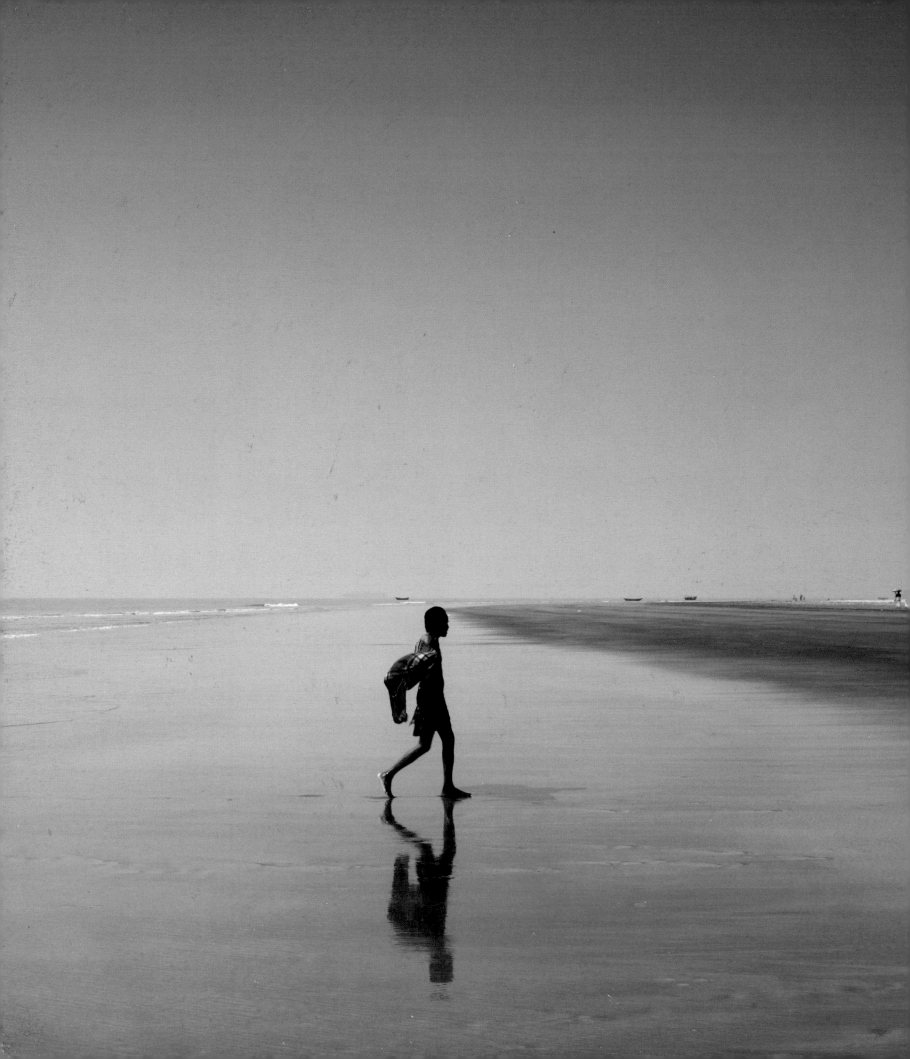

THE GREAT
DELTA

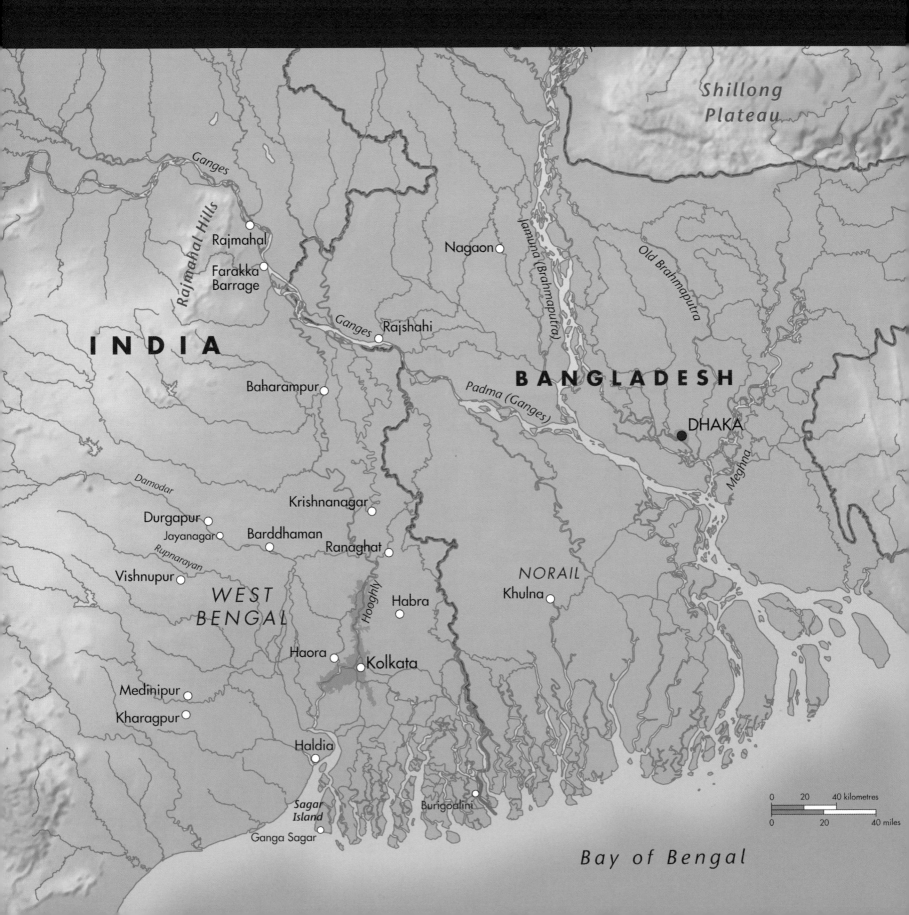

Shillong
Plateau

Ganges

INDIA

Rajmahal Hills

Rajmahal

Farakka
Barrage

Ganges

Rajshahi

Nagaon

Jamuna (Brahmaputra)

Old Brahmaputra

Baharampur

BANGLADESH

Padma (Ganges)

DHAKA

Meghna

Damodar

Krishnanagar

Durgapur

Jayanagar

Barddhaman

Rupnarayan

Ranaghat

NORAIL

Vishnupur

*WEST
BENGAL*

Hooghly

Habra

Khulna

Haora

Kolkata

Medinipur

Kharagpur

Haldia

*Sagar
Island*

Burigoalini

Ganga Sagar

0 20 40 kilometres

0 20 40 miles

Bay of Bengal

If the Ganges is a lock of Shiva's hair, then the delta is the frayed end of that lock – a great fan formed of the many channels into which the river divides before she finally dissolves into the sea. In this lower region, the mighty Ganges doubles in size when she is joined by her brother, the Brahmaputra, which has taken a journey of almost identical length along the northern side of the Himalayas. The moods of these great rivers completely dominate life in the delta region, subjecting the land to near-desert conditions one month and flooding of Biblical proportions the next.

Yet the life of the delta is rich and abundant. Not only does it support more than 200 million people, it is also the location for one of the world's great wildernesses: the Sundarbans, home to what may be the planet's largest remaining population of tigers. All of this life is ultimately made possible by the waters that flow through the land and the precious gift they bring.

Above: Early-morning mist lifting over one of the many channels into which the great river divides as she nears the end of her journey.

Previous page: The long beach on Sagar Island. More than a million pilgrims make the annual trip to Sagar for the Ganga Sagar mela.

GLORIOUS MUD

Bengal is made of mud. From the Rajmahal hills in the west to the Chittagong highlands in the east, and from the Shillong plateau in the north, south to the Bay of Bengal – an area of around 200,000 sq km (77,220 square miles) – there is no rock. The chimneys of brickworks dot the landscape, feeding a building industry that has evolved almost entirely without the use of stone. This vast plain, comprising most of the Indian state of West Bengal and almost the entire country of Bangladesh, consists of a thick layer of sediments carried down over the millennia by the Ganges and Brahmaputra. The great weight of mud, in places up to 5km (3 miles) deep, has pushed down the underlying bedrock, ironing out any bumps, to leave the countryside flat for as far as the eye can see.

The Ganges and Brahmaputra between them carry more sediment than any other river system – twice as much as the Amazon, four times as much as the Nile. In peak flood season, 13 million tonnes a day are carried to the delta. Most of it continues out into the Bay of Bengal, but a large percentage is dropped where the river slows over the plains.

THE SHIFTING WATERS

The delta may be flat, but it is a dynamic landscape. The rivers constantly change their course as they drop their sediments. Between the Indian border with Bangladesh and its meeting with the Brahmaputra, the riverbed of the Ganges has risen in places by 7 metres (23 feet) over the past few decades. The deposited mud first forms sandbars and eventually new riverbanks or entire river islands. These islands, or chars, can be kilometres long and home to communities of hundreds or even thousands of people.

The people of the chars are some of the poorest in the delta, for though their land is often very fertile, their existence is a precarious one. From one year to the next, there is no knowing whether the land they are farming will be growing or disappearing – while the river is depositing land in one part of its channel, it is eroding it in another.

Riverbank erosion can happen with extraordinary speed, especially during the monsoon – 400 metres (1312 feet) of riverbank have been known to be swept away in a year, with devastating consequences for the people living there. In Bangladesh alone, a million people are affected by riverbank erosion every year, often having to dismantle their houses and pack their belongings at

Opposite: A mangrove-fringed riverbank at low tide, built from the Himalayan sediment that the Ganges carries with her to the delta.

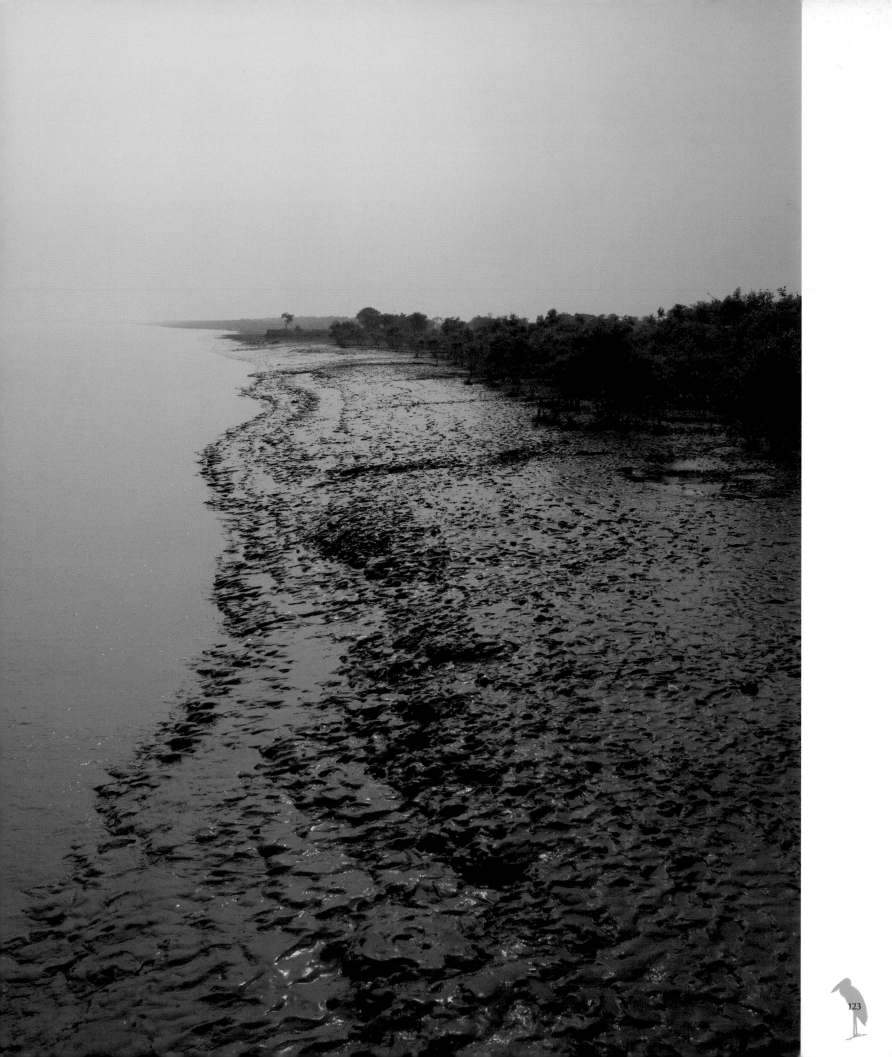

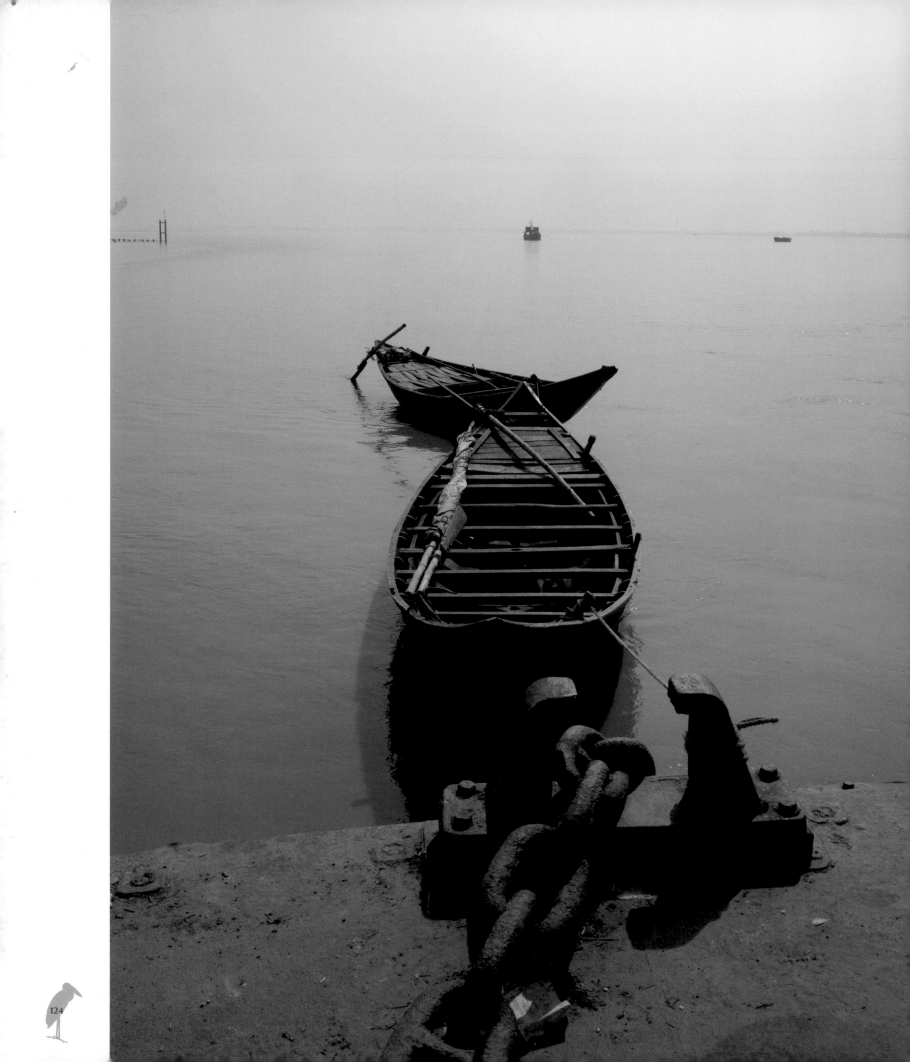

short notice as an episode of erosion begins. The people made homeless in this way must find land to rent or else set up home on a newly emerging char hovering just above the waterline.

The main channel of the Ganges has moved east by several hundred kilometres over the past couple of hundred years, probably due to seismic movement as well as siltation. In the seventeenth century, when the British first established a trading post at what is now Kolkata, they did so on what was then the main outlet of the Ganges to the sea: the Hooghly. Since at least 1770, however, the Hooghly has been slowly silting up as the Ganges has shifted course, forging a new main channel, known locally as the Padma, east and south into what is now Bangladesh.

Opposite: River transport. Many river-island communities are well established, but the people must be ready to leave at a moment's notice if erosion strikes.

Below: Ferry journey. Crossing the river in its lower reaches is like travelling across a vast inland sea.

In 1975, the Indian Government built the Farakka Barrage to divert water from the Padma into the Hooghly in an effort to keep the river navigable and so keep Kolkata's port alive. The Bangladeshis blame the Farakka Barrage for both a lack of water during the dry season and increased flooding in the wet. They claim that, beyond the barrage, the river's flow is slowed, causing it to drop more sediment, thus raising the riverbed and making it more likely that the river will break its banks during the rainy season. Bangladesh's argument seems a strong one, though the Indian Government would disagree. Whatever the truth of the matter, additional flooding is something a country like Bangladesh could do without.

WATERLAND

To travel through Bangladesh is to experience a country where the boundaries between land and water are blurred. Water is everywhere: in rice paddies, village ponds and the hundreds of rivers that cut through the land, all of which are offshoots or tributaries of the Ganges and Brahmaputra. Through the combined watersheds of these great rivers, Bangladesh drains an area 14 times its own size – as if all the rivers of western Europe flowed through England. Eighty per cent of the rain that feeds those rivers falls during the three months of the monsoon. Small wonder that, in the minds of many people, Bangladesh is synonymous with flooding.

Above and opposite: Mud boys – diving for coins thrown into the river by pilgrims awaiting the ferry to Sagar Island.

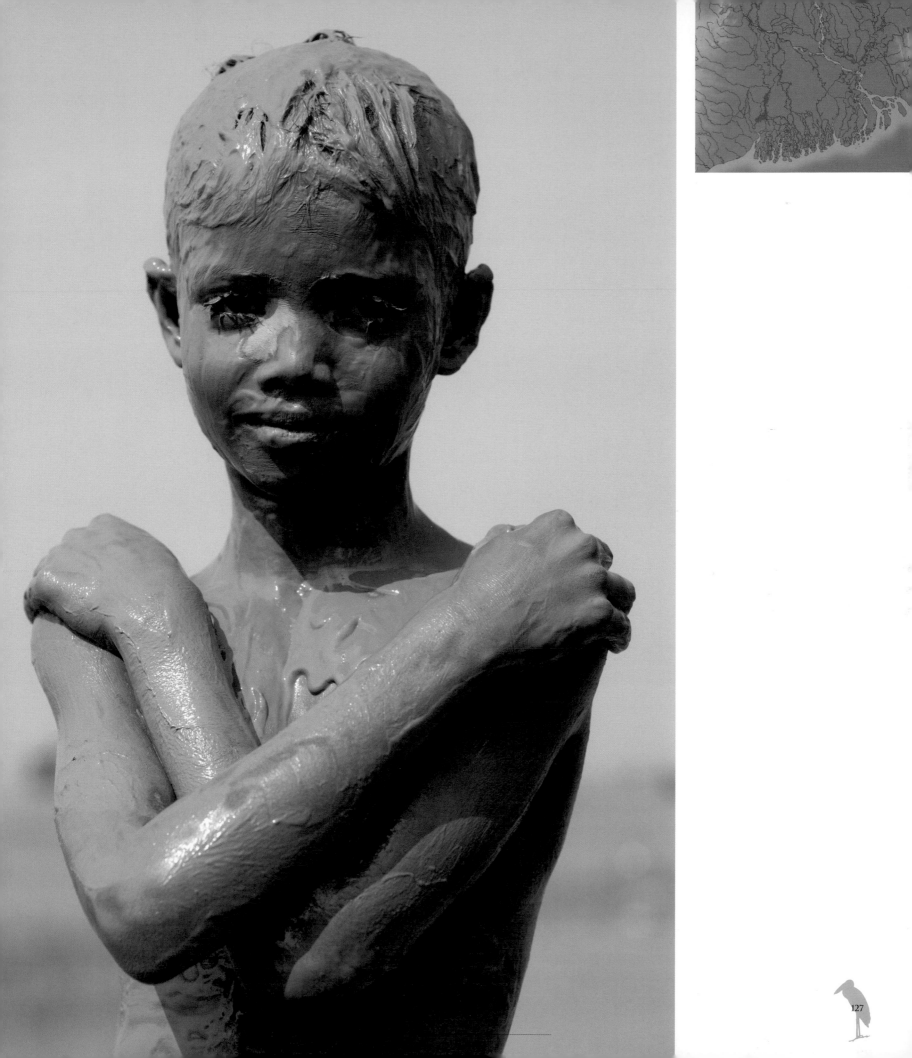

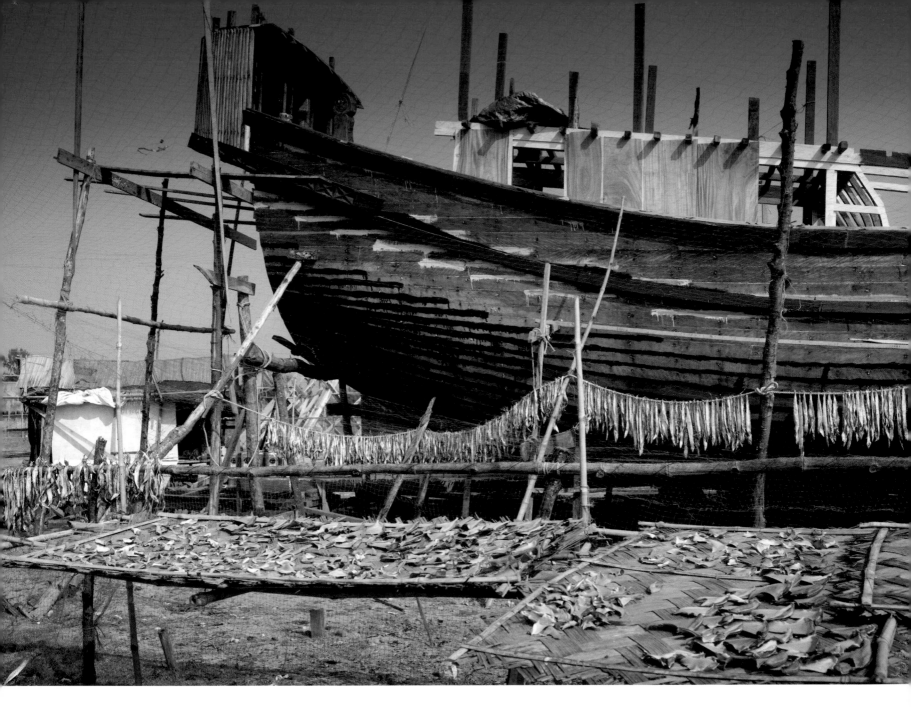

At the end of the dry season, in late April, when no rain has fallen in Bangladesh for seven months, and the beds of many of the rivers are dustbowls, even the flow of the great Ganges is so weak that a man can pull a boat upstream against it. Bee-eaters and kingfishers nest in the 6-metre-high (20-foot) riverbanks exposed by the falling water. The farmers, harvesting their last meagre crop of dry-season rice, pray for rain but know they should be careful what they wish for.

When the rains begin, the flow on the main channels of the rivers can, in the space of a few weeks, increase 200-fold to nearly a billion litres a second. The rivers can rise by up to 8 metres (26 feet), breaking their banks and spreading out to transform the countryside into a waterscape. Even in a weak monsoon year, 30 per cent of Bangladesh floods. In heavy rainfall years, 70 per cent of the country can lie under water.

Above: Boat-building from the proceeds of the shark-fin trade. The hundreds of drying fins – destined for China – are cut mainly from the small bamboo sharks that swim into the mangroves to lay their eggs.

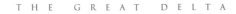

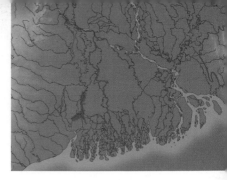

But the impression given by the western media about flooding in Bangladesh can be misleading. The floods are occasionally catastrophic, leading to great loss of life, but this is uncommon and usually associated with cyclones powering in from the Bay of Bengal, pushing storm surges in front of them. Moderate floods are a part of life for most Bangladeshis. Indeed, they are often welcomed as they replenish the water table as well as leaving behind fertile new topsoil.

Left: Deer crossing. Like most Sundarbans animals, chital are capable swimmers and cope with tidal waters and the monsoon floods, as do the people.

The frequency of *severe* flooding, however, does seem to have increased in Bangladesh over the second half of the twentieth century. This may be caused partly by dams upstream, but other factors are also involved. Rising sea-levels have the effect of lessening the gradient of the river, causing water to 'pile up'. Farming practices in Bangladesh and forest clearance upstream in the Himalayas might also be exacerbating the floods by causing a significant loss of topsoil, which ends up raising the level of the riverbeds, leaving less room for the water.

There are broadly two schools of thought on how best to tackle the problem of increased flooding. The first has involved the construction of many kilometres of tall embankments along the rivers, a solution that is also being used to tackle the problems of riverbank erosion in the worst affected areas.

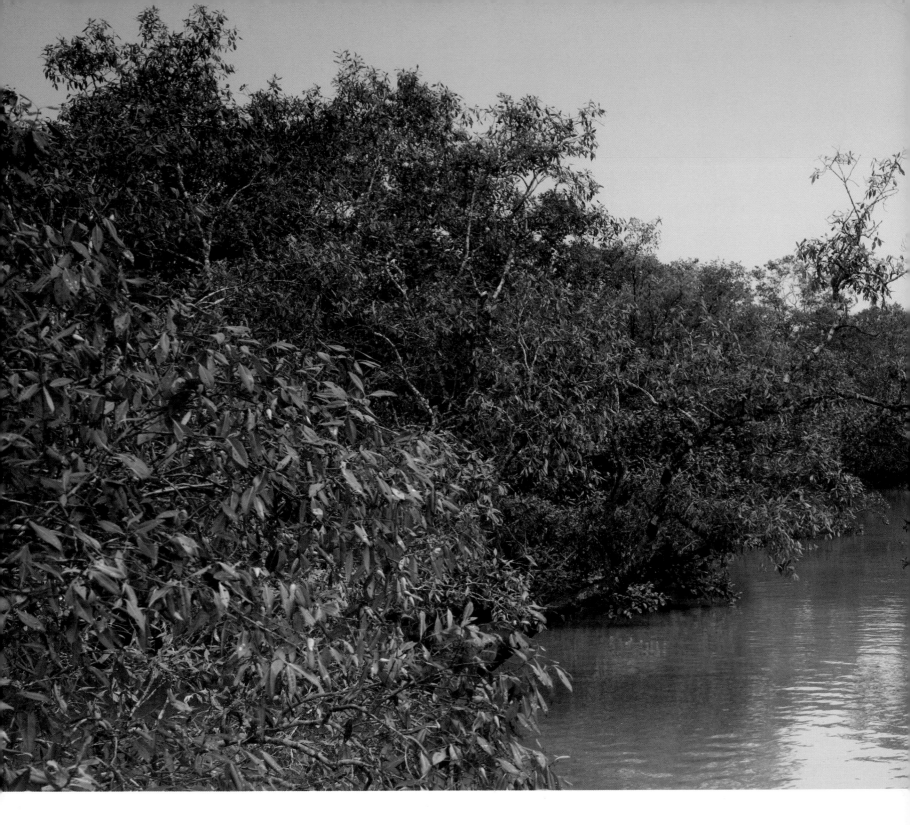

Under this system the countryside is divided into huge 'compartments', which can be flooded
in a controlled way at times of very high water. Embankment building is, however, increasingly
seen as an ineffective option. It is cripplingly expensive for a poor country such as Bangladesh
to maintain and, ironically, may also be leading to greater flooding, as the riverbeds are raised
by increasing amounts of sediment being deposited on them instead of the surrounding land.
The alternative to building embankments is to allow the land to flood naturally from time to time,

Above: Mangrove
highway. The Sundarbans
comprises the world's
largest mangrove forest,
with at least 35 species of
mangrove tree.

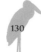

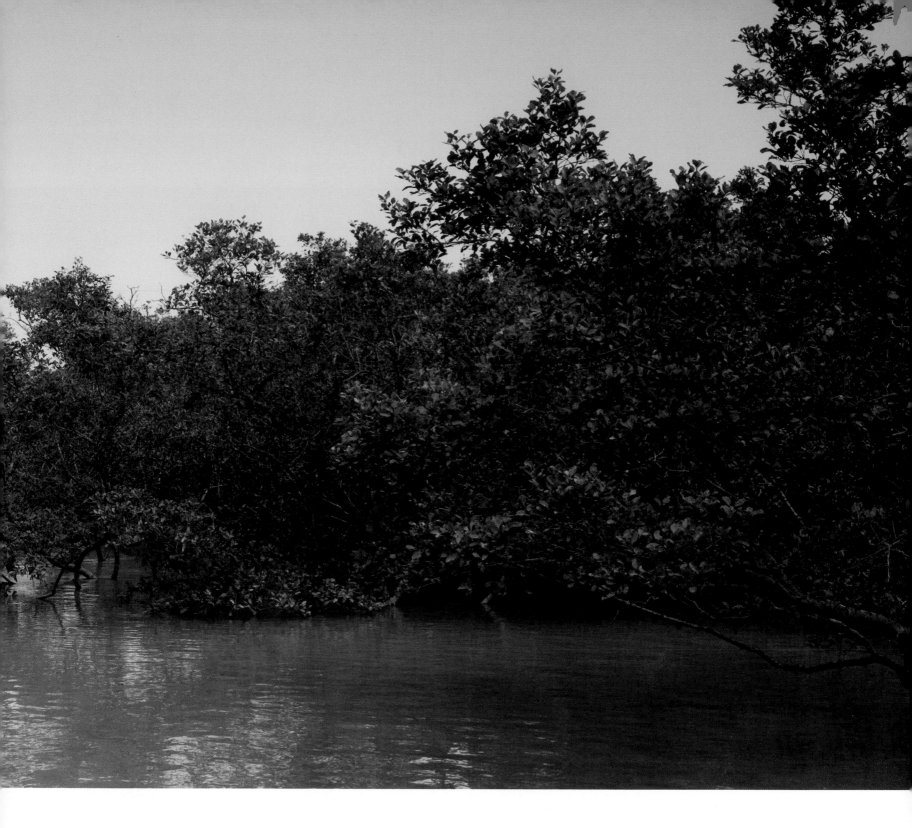

while working to maintain and improve the natural drainage, through techniques such as dredging. This approach requires effective early-warning systems and safe areas for the people to get to in case of extreme flooding, but it has the huge advantage of allowing periodic replenishment of the topsoil by the fertile river sediments. Bangladesh, formed by sediment from the rivers that drain it, will eventually be wiped out by the rising sea should the rivers be prevented from depositing their mud on the land.

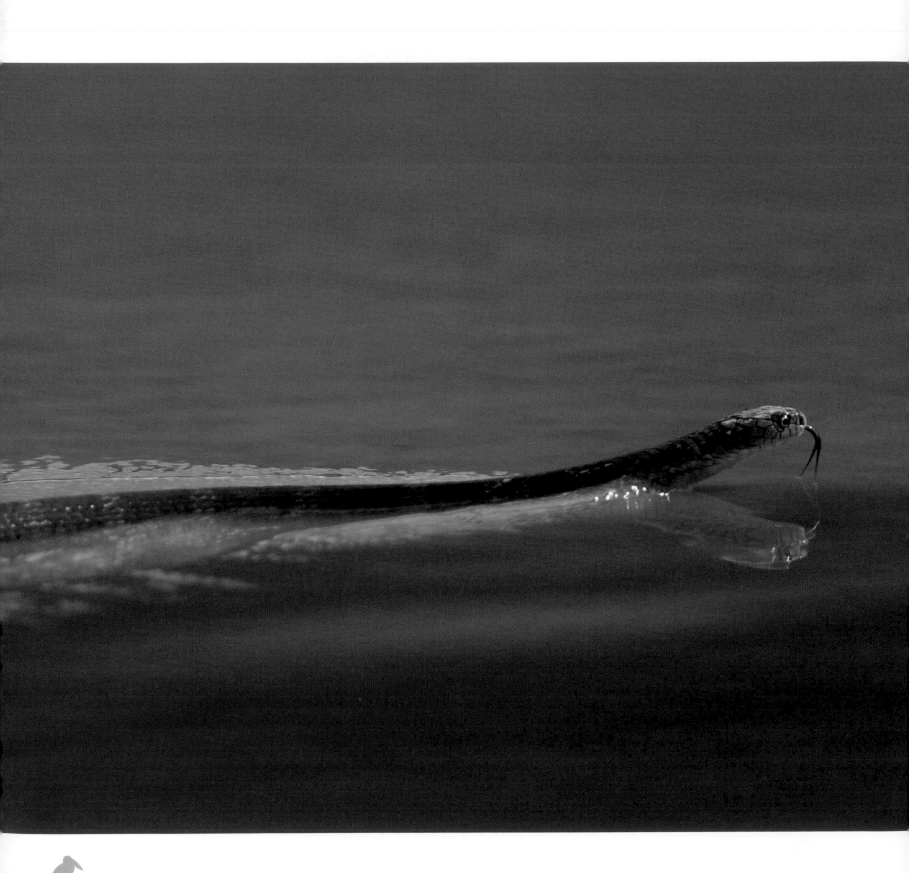

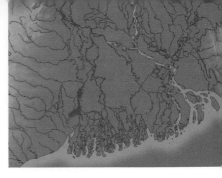

SNAILS AND SNAKES – LIFE IN A RICE PADDY

No Bengali meal is complete without rice. So fundamental is the crop to the culture that, in Bengali 'to eat a meal' literally means 'to eat rice'. A huge percentage of the delta's area is given over to rice cultivation. In many areas, excessive use of pesticides has created a virtual monoculture. Now, however, more and more farmers are starting to realize that they can make greater profits from farming organically, and where they do farm without pesticides, the biodiversity is much higher. The paddies support many of the same animals that would have inhabited the original great natural wetlands. Frogs, snails, crabs, herons and egrets abound, but perhaps one of the most welcomed sights in the artificial wetlands of Bengal is the annual arrival of the openbill stork in the village of Jayanagar.

Opposite: King cobra – a snake-eating snake and not normally a danger to humans. Most people are bitten by snakes during the monsoon, especially in paddy fields, when floods result in more frequent accidental contact.

Below: Rare sighting – a Ganges river dolphin leaping. The Sundarbans is one of the endangered dolphin's last refuges.

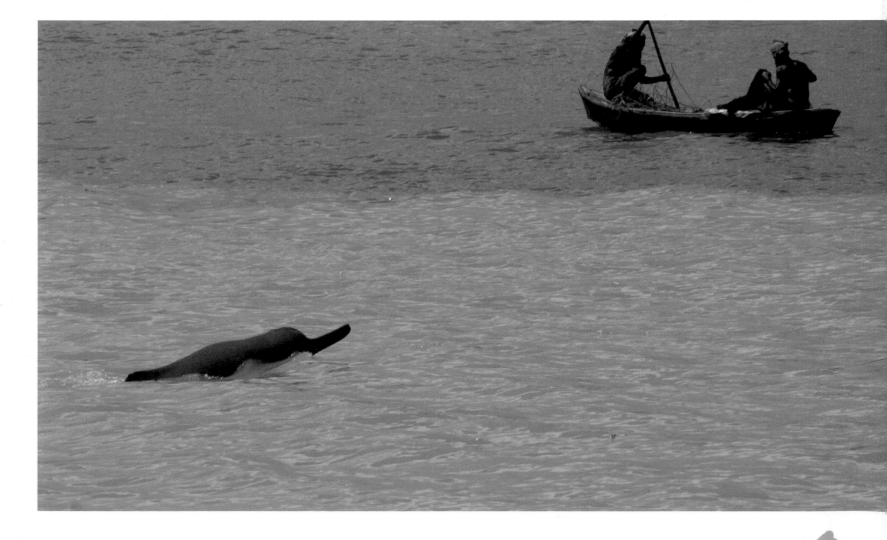

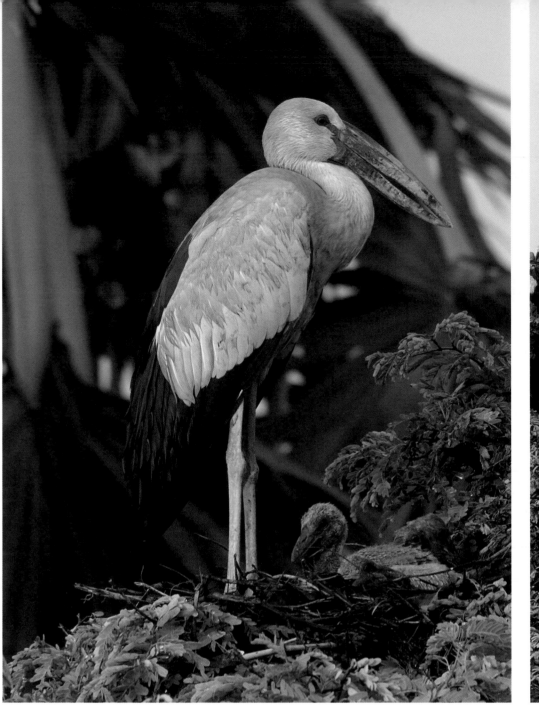

A distant hum – growing to a cacophonous clacking of beaks and beating of heavy wings – alerts you to the village before you can see it. About 8000 storks come to Jayanagar every year to breed, outnumbering the human inhabitants by nearly three to one. The birds' enormous nests deck the tamarind and mango trees around the village ponds like overelaborate Christmas decorations. An openbill's beak, as the name suggests, is joined only at the base and tip – a specialized adaptation for deftly removing snails from their shells. The storks hunt for snails and other small animals in the rice paddies around the village. Each pair raises two to four chicks – the parents returning periodically during the day to regurgitate food for their offspring. The noise of the young begging for food and the adults fighting for personal space provides a constant soundtrack to village life.

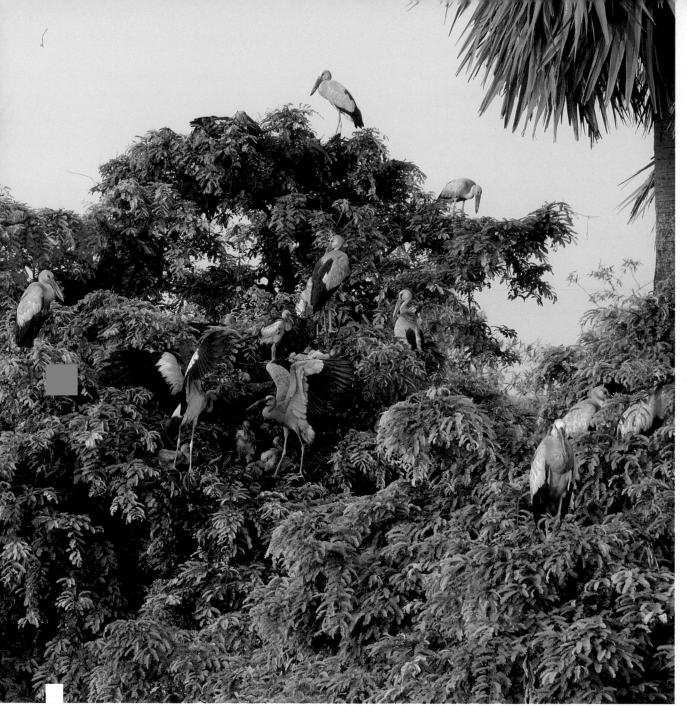

Left: The openbill storks of Jayanagar. The villagers protect the colony, believing that the birds – which feed on snails and other creatures in the rice paddies – keep the land productive.

There is little obvious gain for the villagers from the presence of the storks, apart from a small amount of guano, the smell of which hangs heavy in the air. Nevertheless, the villagers go to great lengths to look after the birds. Chicks that fall out of nests are hand-reared using snails collected from the fields, and anyone found to have wilfully damaged a stork or nest is fined. The reason the villagers give for protecting the storks is that they believe their land will become unproductive if the birds stop coming. The surrounding countryside would certainly be a lot less diverse if the villagers stopped their conservation efforts.

Snakes are also tolerated. During the rainy season, many are driven out of their hiding holes by the rising waters and gravitate towards the shrinking areas of dry ground – frequently, the raised

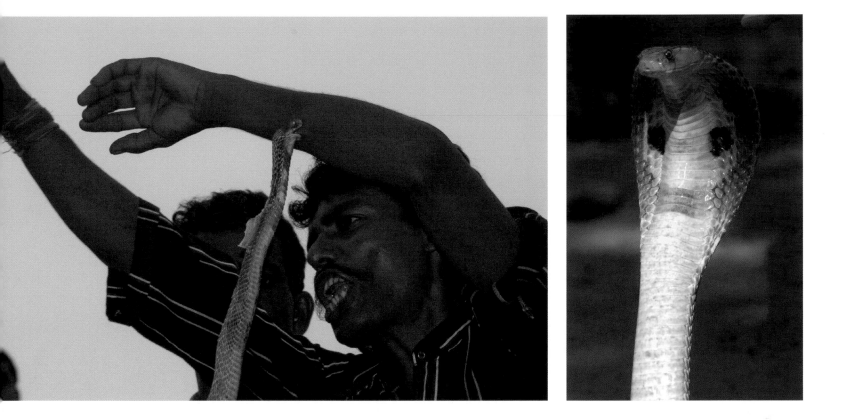

boundaries between rice paddies. The majority of India's 20,000 annual death toll from snakebite occurs during the monsoon. In typical Indian fashion, though, many Hindus choose not to persecute the snakes but to worship them. In Bengal, the festival of Manasa, the snake goddess, is held at the peak of the monsoon. On the fifth day of the waxing moon in the wettest month, known as Shravan, thousands of people throng the streets of the ancient town of Vishnupur to witness snake charmers perform feats with cobras, kraits, vipers and a range of non-venomous snakes. Snakes, presumably drained of their venom, are 'charmed' from their baskets, wrapped around bodies and hung by their fangs from ear lobes, tongues and limbs for the amusement of the crowds. The Manasa festival has evolved into more of a circus than an act of devotion, but the root of the festival remains a celebration of snakes as symbols of fertility – an association they carry because of their relation with the arrival of the monsoon.

The stork village of Jayanagar and the snake festival of Vishnupur both demonstrate that, even though humans are by far the dominant animals in most of the region, the people of the delta retain a relationship with nature. To see the most extreme example of this relationship, though, you have to travel over the border to the Norail district of Bangladesh.

Above: 'Charmed' cobra in warning pose – star of Vishnupur's festival of the snake goddess Manasa.

Above left: Drawing blood and crowds. Snakes used for the shows are likely to have been drained of their venom beforehand.

Opposite: Fascination of the snake baskets.

FISHING WITH OTTERS

On cool, damp, misty mornings, on one of the many branches of the Ganges in its lower reaches, the cries of fishermen mingle with the shrill calls of otters, signalling the most extraordinary collaboration between humans and wild animals in the whole of the delta.

The people of Norail don't know how long their ancestors have been fishing in this way, but the system they have developed is sophisticated. Every night, the village men head out onto the river. Each boat carries four fishermen, two adult otters and a handful of juvenile animals. When they have reached a good spot, the men push out a rectangular net from the side of the boat, supported by three bamboo poles. The adult otters, wearing harnesses attached by ropes to sticks, are released into the water at each end of the boat, along with the unharnessed youngsters.

Left: Trained fisher. The rope is not so much to keep the otter captive as to relay signals to it under water, so that it knows when the net is set and when to drive the fish into it.

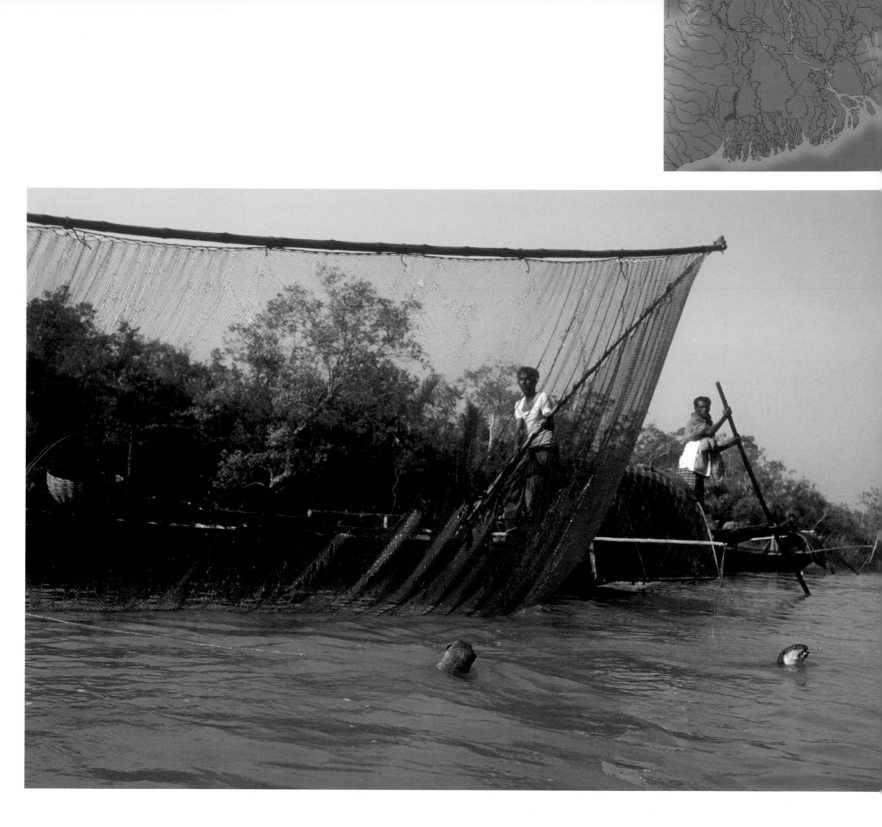

When the net is set, the fishermen signal to the otters by pulling on the sticks with their feet. The otters dive into the river and chase all the fish they can find into the net. It's a very efficient system, and in the course of a night, the fisher-otters can catch as much as their boats can carry. It's good for the otters, too, as the fishermen make sure their charges are well fed even in the dry season, when many wild otters struggle to find enough to eat. Presumably, this is why the otters don't chew through their rope harnesses, which they wear all the time.

Above: Fishing partners. A boat carries two trained adult otters and a number of trainee youngsters. In a fishing session, the otters can round up as much fish as a boat can carry.

Young otters learn the technique by observation. Up to about eight months of age, there is no need to harness them, since they won't go far from their parents. Once trained and used to the harness, the youngsters are sold – a good animal may fetch as much as $100. Fishermen rarely catch new otters from the wild, such is the effort involved in training them. Instead, they breed from the otters they already have, taking care to avoid inbreeding by finding unrelated mates from neighbouring villages.

Most otter fishermen don't venture far from their village homes, but a brave few set out on missions lasting several weeks, downriver into the great wilderness of the Sundarbans.

THE BEAUTIFUL FOREST

The Sundarbans is a truly great wilderness. It is the largest mangrove forest in the world, ten times the size of the next largest area of mangrove. A journey by boat from one side to the other through its maze of more than 400 waterways would take several days, along channels that can be more than a kilometre across. There are more than twice as many species of mangrove found in the 10,000 sq km (3860 square miles) of the Sundarbans as are found anywhere else, and many of them reach an impressive size. The largest, the keora, can grow to more than 20 metres (65 feet) tall and 3 metres (10 feet) in girth. To travel down a stretch of keora-lined creek – the branches of the great trees reaching down to the water like giant weeping willows, sunlight glinting off the wings of kingfishers flitting across the water in front of you – is a magical experience. The origin of the name Sundarbans is unclear, but many people believe it is derived simply from 'ban', meaning forest, and 'sundar' meaning beautiful – an appropriate name.

The Sundarbans owes its uniqueness to the constant influx of fertile mud from Mother Ganges, providing the fuel for the ecosystem, and the salty, tidal conditions brought on by the proximity of the sea, which create an environment where only a few plant species, principally the specialized mangrove trees, can survive. Mangroves possess glands in their leaves to excrete excess salt, while their most distinctive feature, the stalagmite-like roots known as pneumatophores, serve to anchor the plant against the push and pull of the tides and, by projecting above the dense, oxygenless mud, allow the roots to breathe. Different species of mangrove (35 in all) dominate in different regions, depending on the degree of salinity.

Thanks to the Ganges mud, the forest is very productive. The mangroves and the 300 or so other plant species in the Sundarbans support an impressive animal biodiversity. More than

Above: Mangrove jewel – brown-winged kingfisher, one of many Sundarbans kingfisher species. The impenetrable nature of the mangrove swamp and the danger posed by tigers help preserve the area for its wild inhabitants.

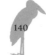

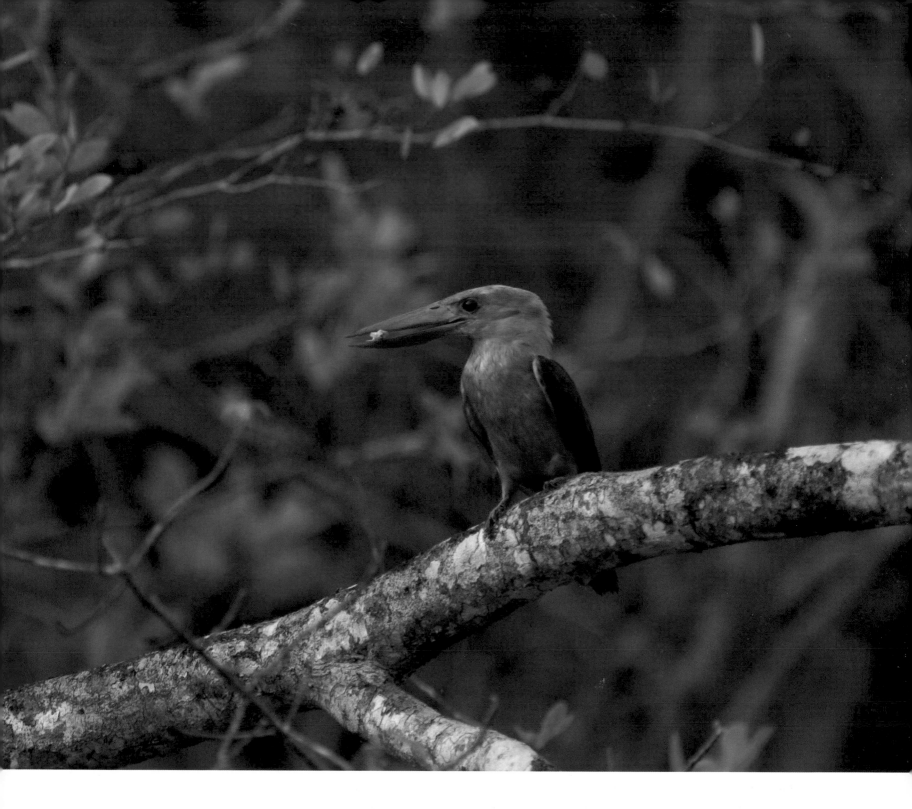

300 species of birds, about 50 species of mammals and a similar number of reptiles inhabit the 200 or so islands, and the rich waters support about 400 species of fish – more than are found in the whole of Europe.

Very few people live permanently in the Sundarbans, but millions of people from Bangladesh and India depend on the forest. The people who venture in do so to collect firewood or to fish, but a few adventurous villagers come in search of the Sundarbans' most valuable product: honey.

LIQUID GOLD

Every April, in the remote forest station of Burigoalini in the northwest corner of the Bangladeshi Sundarbans, boats gather for the start of an extraordinary race. The first of the month is the start of the honey-collecting season in the forest, and the boats compete to get to the best spots first.

At the sound of a gunshot, fired by a forest-department guard, the boats set off on their quest. Rowed by a crew of six to ten men, the boats head deep into the forest. A shajoni, a wise older man, is in charge of guiding each boat to the best places. The larger ones take a longer journey, crossing into the Indian Sundarbans, where they say the pickings are richer.

Above: Honey harvest. The collectors go deep into the forest by boat. Using smoke to fool the bees into fleeing the 'forest fire', the men slice off honey-laden chunks of hive, traditionally leaving some behind for the bees.

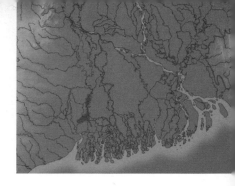

The men seek the hives of the giant Asian honeybee. This is the largest honeybee in the world and the architect of the largest hives – up to 2 metres (6.5 feet) across and 30kg (66 pounds) in weight. The bees begin hive construction in January or February, coinciding with the start of the flowering season of the mangroves. By April, the hives have reached their full size and are packed with honey.

When the honey-collectors, or mowalis, arrive at a favourable spot, they spread out to comb the forest, looking deep into the densest thickets, where the bees usually build their hives, suspended from horizontal branches. The shajoni remains on the boat, periodically blowing a cow's horn to help the searchers orientate themselves.

Walking too close to a hive can be a very painful or even a potentially lethal experience. Not only are these honeybees the largest in the world, they are also among the most aggressive. Even at a distance of 20 metres (66 feet), a sudden movement can spark an attack by a swarm of thousands. But the mowalis know the bees' Achilles heel. They quickly make torches of dried grass and set light to them. Then, with only clouds of smoke and cloths wrapped around their heads for protection, they approach the hive. The smoke triggers the bees to behave as if the forest was on fire – they leave the hive and do not attack the honey-gatherers.

In the eerie surroundings of a cloud of pacified bees, the mowalis work quickly, slicing off chunks of the hive, dripping with golden honey, into a waiting basket. Good mowalis attempt to manage the honey harvest sustainably, always leaving as much as possible of the section of the hive that contains no honey.

A good hive can yield 20kg (44 pounds) of honey. Over a 10-week season, even a small boat might expect to collect 150kg (332 pounds), worth up to $3 a kilo in the markets of Dhaka, where the Sundarbans honey is a highly prized delicacy. But many honey-gatherers pay for the honey with their lives. Searching through the deepest pockets of forest entails the high risk of walking right into the resting place of the Sundarbans' most famous resident: the Bengal tiger. Many attacks go unrecorded, but it is thought that an average of about 10 honey-gatherers are killed every year by tigers – about 10 per cent of people attacked by tigers in the Sundarbans every year.

Above: Giant honeybee workers on their giant hive. The combs – the largest in the world – are built to coincide with the flowering of the mangroves. Workers air-condition the double-sided comb by fanning their wings.

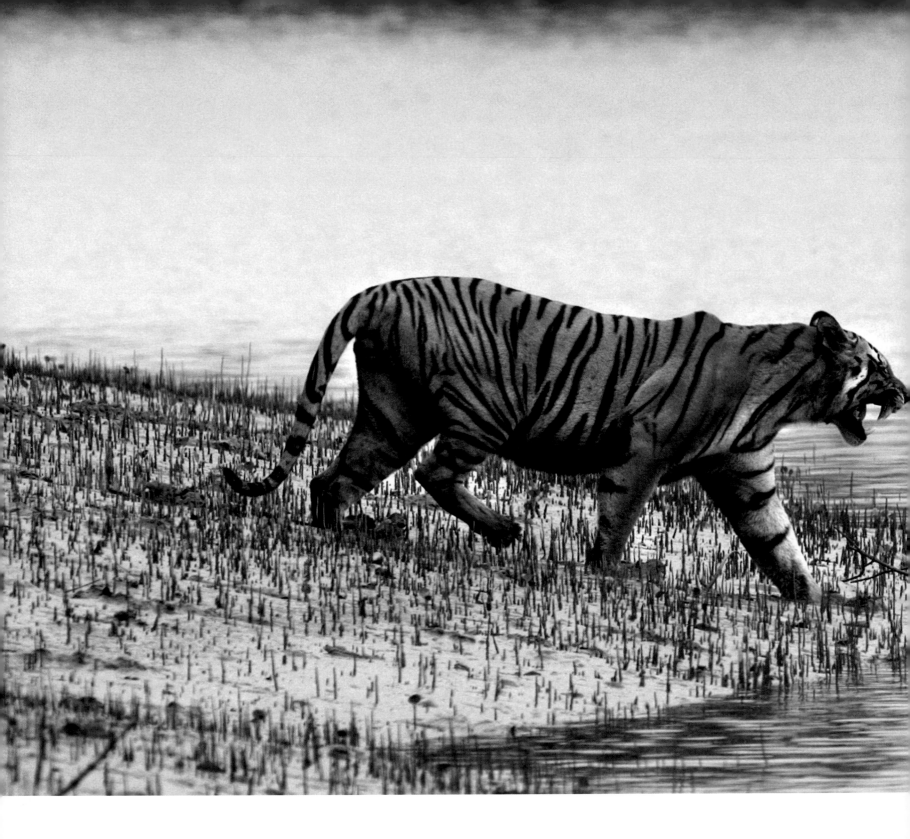

THE TIGER'S KINGDOM

Why so many people are killed by tigers in the Sundarbans, compared to other areas where tigers are found, is one of the questions that the Sundarbans Tiger Project hopes to address. Fieldwork started in 2005, with the principal aims being long-term conservation of the tigers and alleviation of the man-eating problem.

THE GREAT DELTA

The project's biggest difficulty from the outset has been the lack of basic knowledge about the behaviour of these tigers. The impenetrability of the mangrove forest makes tracking them almost impossible, and few detailed studies have been carried out. The ecology of the tigers of the Sundarbans is, however, intriguingly different. No other mangrove forests are home to tigers. Nowhere else are they the only large predators – with no leopards, bears, wolves or wild dogs (dholes) to compete with – and nowhere else do they have no very large animal prey. Here

Overleaf: Chital – prey of the tiger. Large herds live in the forest, providing plentiful food for tigers and so helping to maintain one of the last large tiger populations in the world.

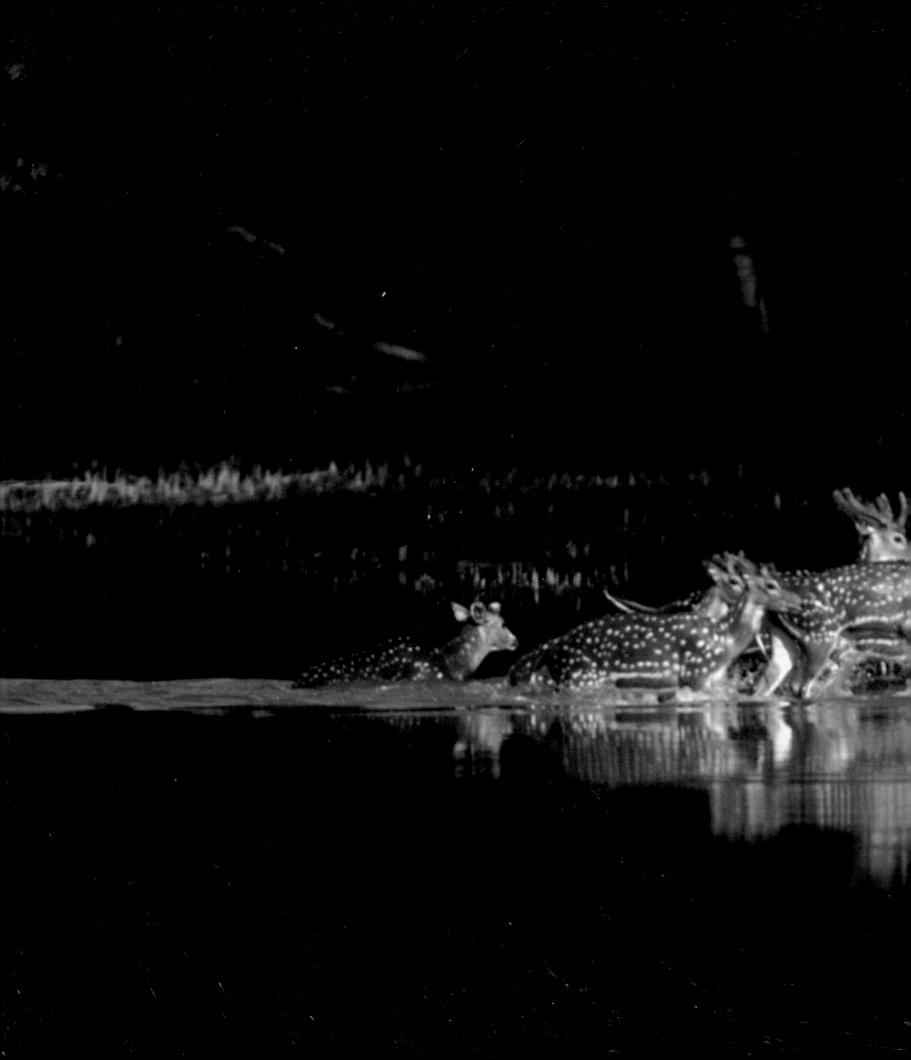

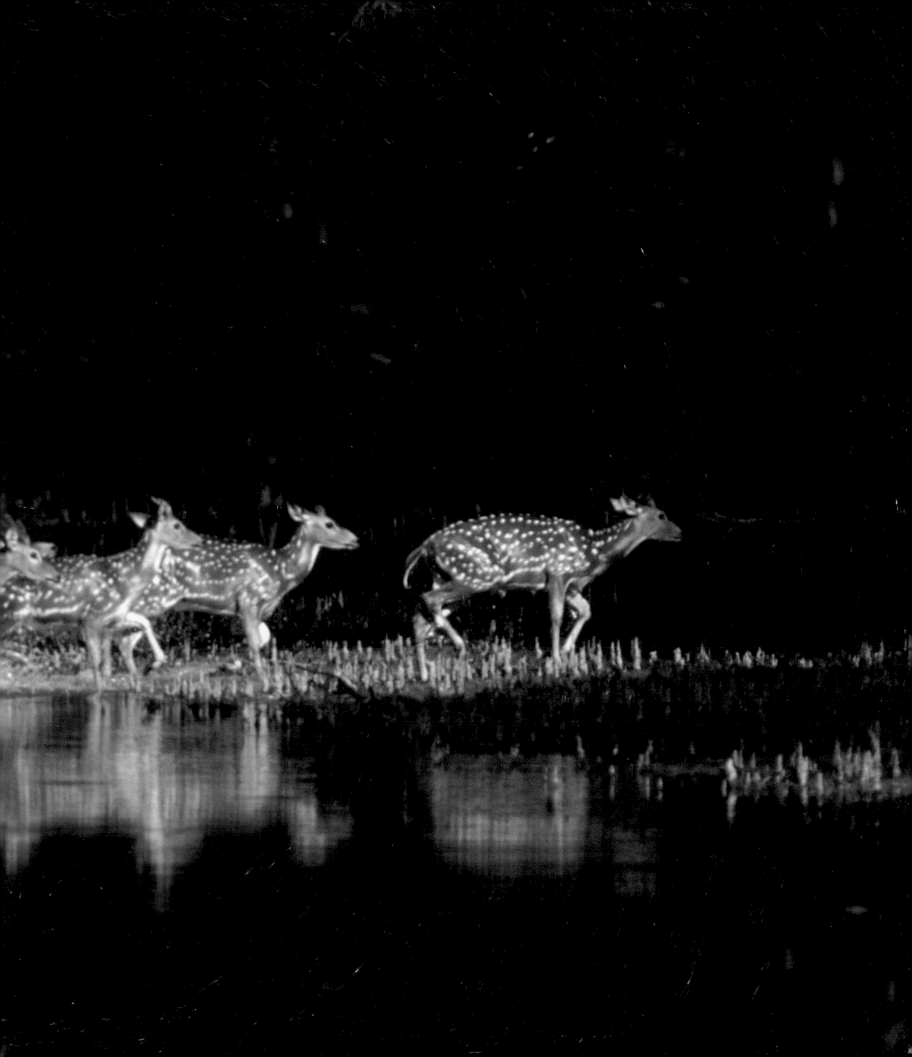

their main prey is chital, or spotted deer – a medium-sized species for a predator that needs an average of 5kg (11 pounds) of meat a day.

Typically, female tigers try to defend exclusive territories large enough to provide food for themselves and any cubs they might have. Male territories are generally much larger – with each male trying to forge one that overlaps those of several females. Whether the Sundarbans' tigers do likewise has long been a matter of conjecture. Most of what is known about the population until recently has been gleaned from observations of tracks, scats and other signs alongside the waterways. Until recently, nobody even had any accurate idea of how many tigers there were in the forest, though it has long been believed that it might be home to a big population. To try to fill this knowledge gap, the Sundarbans Tiger Project has radio-collared a number of the animals.

Putting radio collars on tigers is difficult and dangerous, especially in the Sundarbans. Elsewhere, tigers can be approached and darted from the back of an elephant. In a swamp, this is out of the question. Instead the tigers have to be caught in snares, concealed around bait placed where a lot of tiger signs have been seen. (An unsnared animal would run away on being darted and might be lost in the undergrowth, which would endanger it: once under anaesthetic, a tiger's vital signs have to be monitored all the time.) Snares are designed and rigorously tested to make sure they don't harm the tigers and are checked regularly so that no animal is held for long.

Frequently, tigers will sense there is something not right about the bait and avoid it. Even more frequently, they will come to the bait but somehow manage to avoid the snares. This is the situation that a tiger scientist dreads: on approaching a bait to check if he has caught a tiger, he finds instead an unsnared animal that doesn't want to be disturbed while eating its dinner. If a tiger is caught in a snare, it is anaesthetized with a tranquillizer dart before being sexed, weighed and measured and having its age and general condition assessed. The fitting of the radio-collar is the last part of the process. Each collar weighs 1.1–1.5kg (2.5–3 pounds), about 1 per cent of a tiger's body weight, and doesn't appear to affect a tiger's well-being in any way. It is designed to give out a signal for six months, during which time the tiger's precise movements can be monitored. After that, the collar automatically falls off.

So far, two tigresses have been collared, with further collarings planned. Like all tigers, these females have been found to be mostly nocturnal and solitary. Intriguingly, though, the home ranges of the two tigresses are among the smallest ever recorded. That suggests that the density of prey is very high, as supported by the team's observations that the forest is teeming

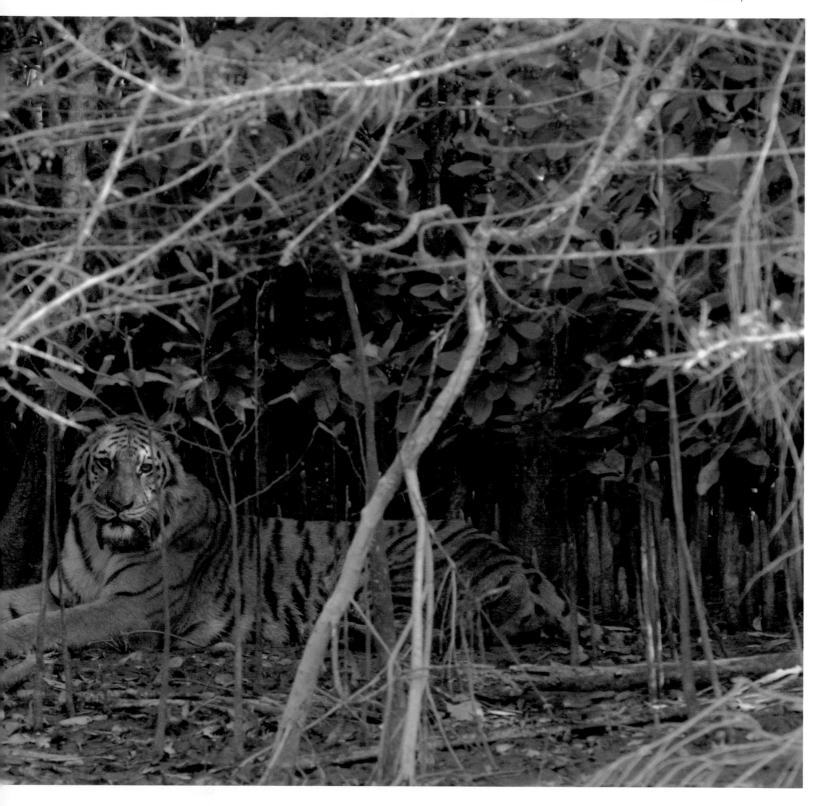

THE GREAT DELTA

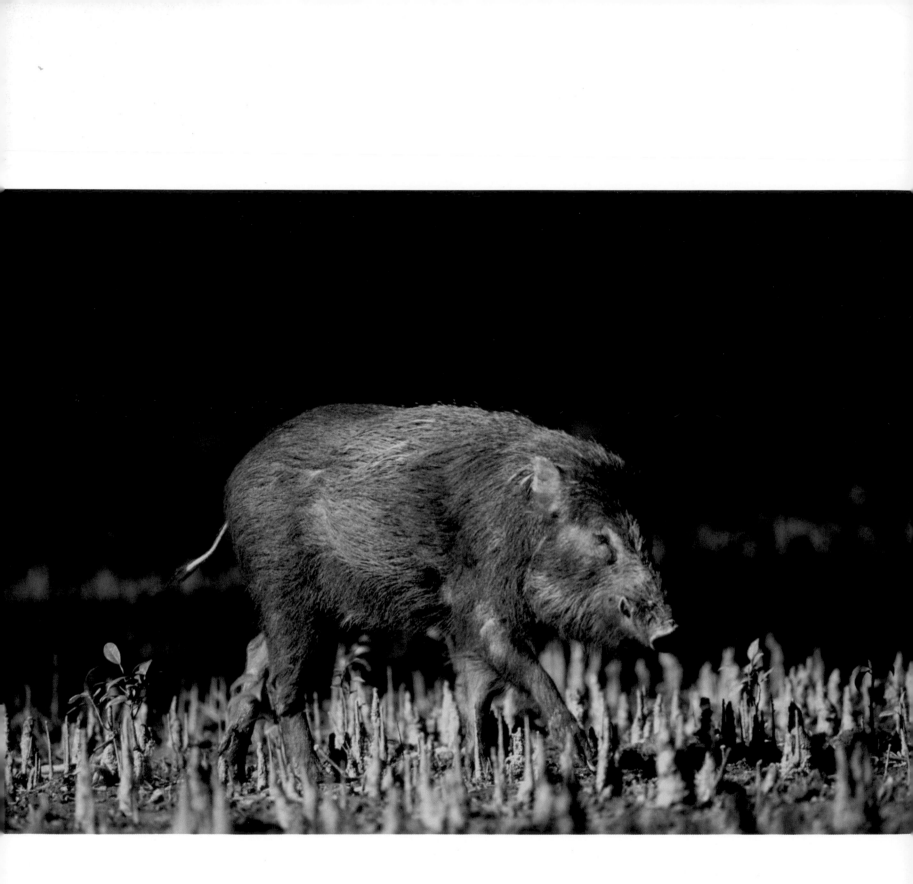

with deer and wild boar, feeding on the mangrove leaves and fruits. These initial findings suggest that the Sundarbans may support between 300 and 600 tigers, which could make it the largest tiger population in the world. But can these cats continue to exist alongside people without conflict in an increasingly crowded world?

OF CATS AND MEN

The activities that bring people into the forest put them at the greatest risk of tiger attack. Honey-gatherers and woodcutters walk into the depths of the forest, while fishermen frequently moor overnight at the forest edge, sleeping exposed at a time when tigers are most active.

People have experimented with a range of innovative means to avoid attack. In the Indian half of the forest, one technique is for people to wear masks on the backs of their heads, which supposedly deters a tiger from its favoured mode of attack – the surprise pounce from behind. A novel method, being pioneered by Monirul Khan of Jahangirnagar University in Bangladesh, is to train dogs to sniff out tigers and use them as early warning systems on entering the forest. Another option is warning people about areas that might be particularly dangerous: the radio-collar findings suggest that tigers may select a type of thorn scrub to lie up in during the heat of the day. In the future, it might also be possible to place relatively cheap radio-collars on tigers living near areas frequented by people, which could alert locals to a tiger's whereabouts.

It is not unknown for tigers to be poisoned or even beaten to death if they are suspected of killing someone or entering a village too often. Surprisingly, though, such events are rare, and the attitude of people towards the tiger is not as negative as might be expected. Hindus entering the Sunderbans believe that Bonbibi, goddess of the forest, will protect them, while Muslims ask Allah for protection – though many hedge their bets with an offering to Bonbibi as well. The majority of these people believe that, if they are taken by a tiger, it is the will of their particular god.

Perhaps the most enlightened attitude towards tigers is epitomized by the view of Alam. Born and brought up in a village on the boundary of the Sundarbans, Alam is one of a team of young Bangladeshis being trained by the Sundarbans Tiger Project in the techniques of tiger monitoring. In April 2006, Alam's older brother was killed by a tiger while gathering wood. Not surprisingly, this tragedy has left Alam with mixed feelings about tigers, but he still believes passionately in the work that he is doing to conserve them. His reasons have little to do with a belief that the tiger simply should be saved come what may. He believes in saving the tigers for the good of the future livelihoods of the people using the forest. It is fear of the tiger, reasons Alam, that prevents even more people coming into the Sundarbans to exploit its resources. If more people were to come, then the forest would rapidly be cleared and the waters emptied of fish, with disastrous consequences for the people of Alam's village and the countless other people who rely on this extraordinarily rich habitat.

Opposite: Mangrove scavanger and tiger snack. Wild boar thrive in the Sundarbans, feeding on anything from mangrove fruits and leaves to the rotting carcasses of fish, crabs and the like left by the tidal floods.

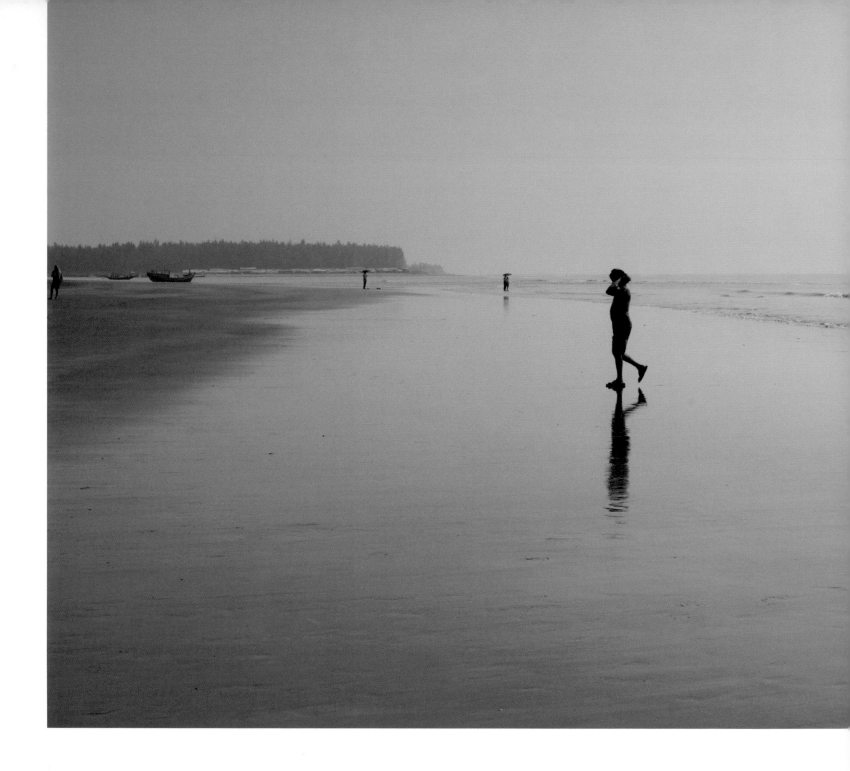

AGAINST THE TIDE

So what are the biggest threats to the Sundarbans and its precious wildlife? The diversion of a large part of the Ganges dry-season flow to provide irrigation water for agriculture is one issue. This has both increased salinity levels and affected fish-migration patterns. That there is excessive fishing in its waterways is also beyond doubt, and the many boats piled high with freshly cut mangrove are testament to the fact that too much of the forest is probably being cleared for firewood and to expland farms. Shrimp fry are being collected at unsustainable levels for shrimp farms. Comparatively little tiger poaching has so far been reported, but it is

Left: Ganges end – the beach at Sagar. The end of the island is also a possibility. The projected rise in sea level – an outcome of global warming – is gradually inundating the lower regions of the delta.

certain that the poaching threat will increase as tigers continue to disappear from the other protected areas of the subcontinent. The biggest threat to the tigers and other wildlife of this wilderness, however, comes mainly from the highly industrialized countries of the developed world. Sea-level rise has in the past decade entirely swamped four major islands in the Sundarbans. Sagar Island, the largest in the Sundarbans, has lost more than 30 sq km (11.5 square miles) in that period, and it is possible that rising seas resulting from global warming could wipe out 1000 sq km (386 square miles) of the Sundarbans over the next century. Even the massive yearly influx of mud from Ma Ganga cannot keep pace with the sea rising over the land of the Ganges delta.

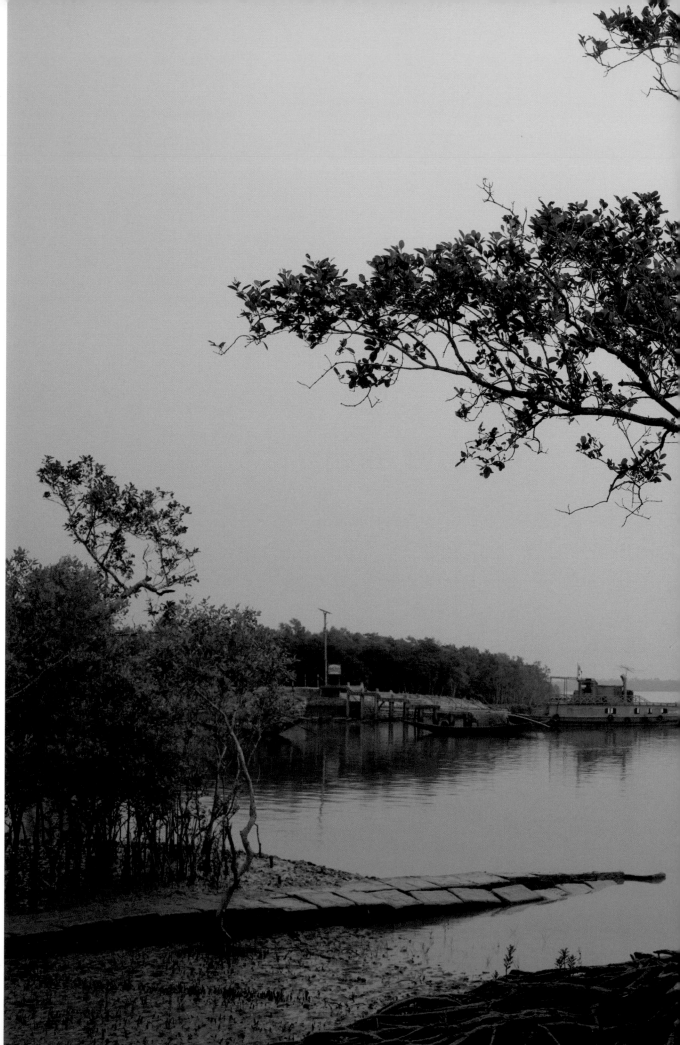

Right: Island settlement. Mangrove roots help to hold mud in place. Villages that don't clear their mangroves are less at risk of erosion.

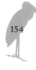

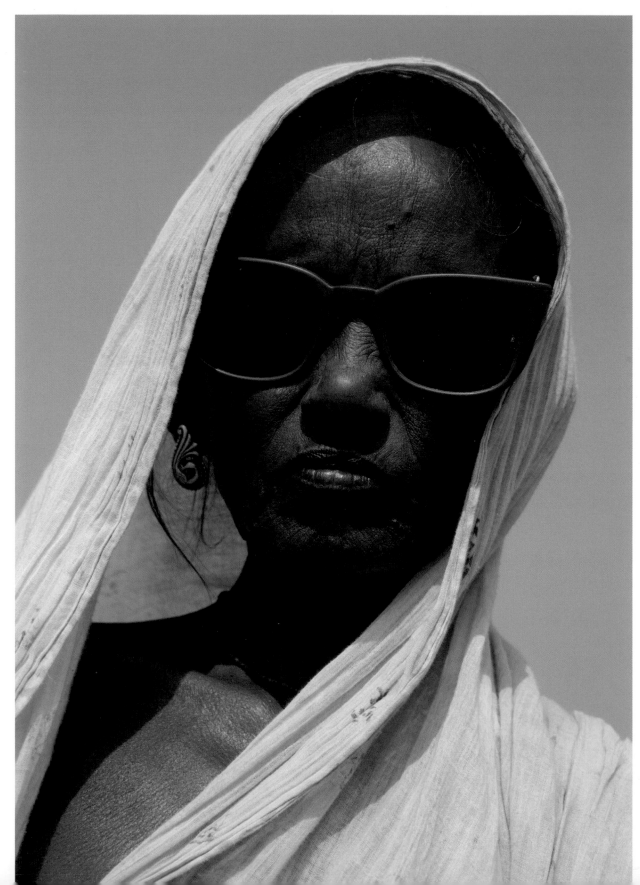

156

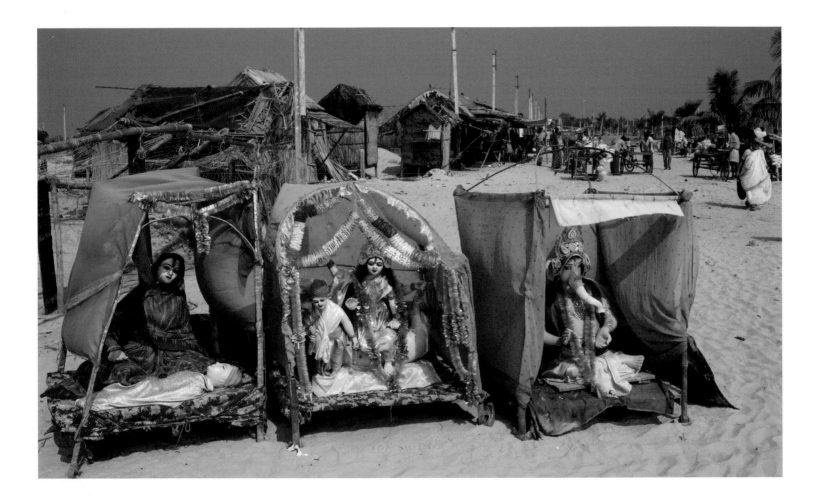

THE END OF THE RIVER

Sagar Island is the last landfall before the Ganges meets the sea. Centuries ago, this island was thickly forested with mangroves – a part of the Sundarbans forest that it adjoins. Now Sagar is densely inhabited. It is also the site of the Kapil Muni temple, one of the most sacred sites of Hinduism. In Hindu mythology, Kapil Muni was the sage who turned to ash the 60,000 sons of King Sagar. In so doing, he effectively brought the Ganges into being, since Ganga was called down to Earth to wash away the ashes and so liberate the souls of the sons.

The original ancient temple has been lost to the rising sea, but every January, the new temple is the focus for up to half a million pilgrims, who make the journey for the annual Sagar mela. For the pilgrims, a dip in the waters of the Ganges at the Kapil Muni temple at sunrise on the auspicious day of Makar Sankranti washes away all accumulated sins.

Above: Beach gods, Sagar Island. The deities on display include Ganesh (right) and Saraswati, goddess of wisdom (centre).

Opposite: Ancient practises in a modern world. A pilgrim at the Kapil Muni temple, Sagar.

In its long journey from the mountains, the Ganges receives a great volume of refuse and effluent. The point where it reaches the sea and delivers the filth it has washed from the land seems a good place also to cleanse human souls. It might also seem a good place to end the story of the Ganges, but the journey isn't quite finished yet.

The Ganges does not end at Sagar Island. Satellite photos show a great fan of silty water pushing far out to sea. The true end of the river was probably discovered by nineteenth-century explorers measuring the depth of the Bay of Bengal. Across a finger of ocean 200km (124 miles) long but just 5km (3 miles) wide, the seabed suddenly dropped away, from a mere 50 metres (164 feet) to a depth beyond the capabilities of the available instruments, a

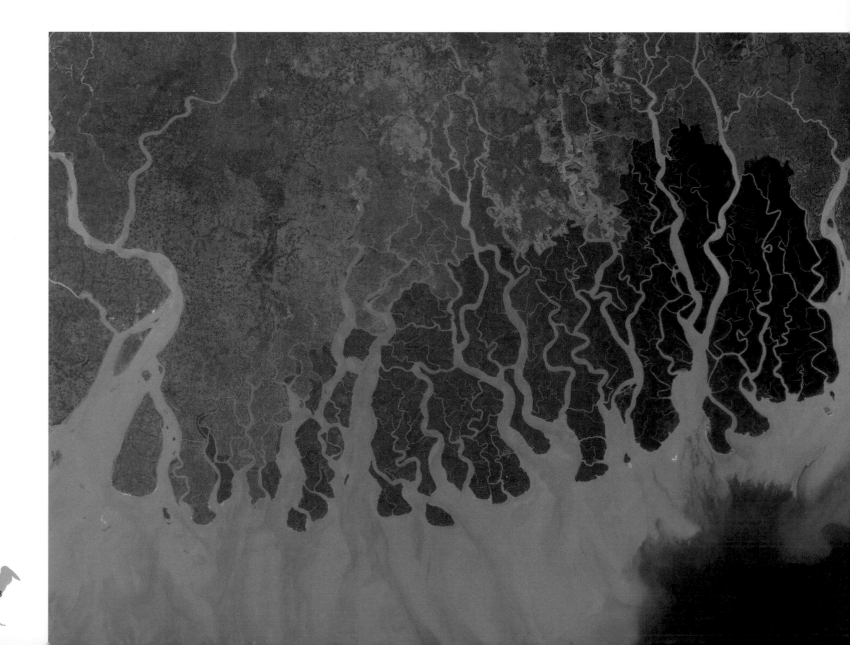

measurement the sailors recorded simply as No Ground. These men had discovered a great undersea canyon, now known simply as the Swatch of No Ground. The sediments of the Ganges tumble into this great chasm, channelling the mud far out into the depths of the ocean, where it fans out across the sea floor for 3000km (1860 miles).

At the Swatch, the Ganges sediments mix with the oceanic waters to create an incredibly rich fishing ground. These waters have recently been discovered to support resident schools of dolphins and whales, perhaps even including the blue whale, the largest animal on Earth. Fifty kilometres (31 miles) from the nearest land, as her waters finally disperse into the ocean, Ma Ganges continues to fulfil her celestial destiny as the giver of life.

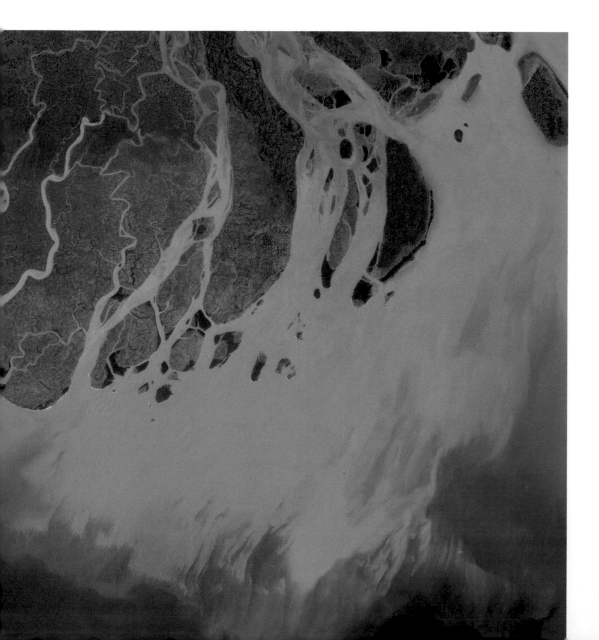

Left: Where the Himalayas meet the sea. A satellite picture of the world's largest delta reveals the extent to which the great river system continues into the sea. It carries with it more than a billion tons of sediment a year, which nurture a vast, rich fishing ground offshore.

Overleaf: The last view – the Ganges becomes sea.

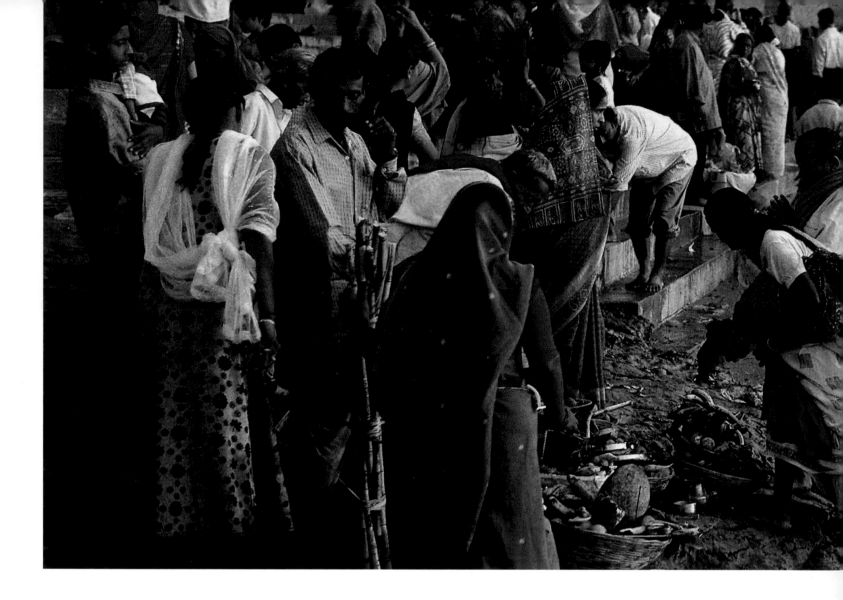

BIBLIOGRAPHY

CHAPTER 1

Alter, Stephen, *Sacred Waters: A pilgrimage to the many sources of the Ganga* (Penguin, 2001).

Bradnock, Robert and Roma, *Indian Himalaya Handbook* (Footprint Guides, 2001).

Corbett, Jim, *The Man-eating Leopard of Rudraprayag* (first published 1947).

Fonia, K.S., *The Valley of Flowers* (Lancers Books, 1996, Delhi).

Pavan, Aldo, *The Ganges: Along sacred waters* (Thames & Hudson, 2005).

Saith, S. and Dilwali, A., *Garhwal and Kumaon* (Guide Book Company, 1993, Hong Kong).

Sharma, K.P., *Garhwal & Kumaon: A trekker's and visitor's guide* (Cicerone Press, 1998).

Smythe, Frank S., *The Valley of Flowers* (first published 1939).

Valdiya, K.S., *Himalaya Emergence and Evolution* (Universities Press, 2001, Hyderabad).

Young, Emma, 'Himalayan Forests Are Quietly Vanishing' (*New Scientist,* 18 May 2006).

CHAPTER 2

Eck, Diana L., *Benares: City of light* (Alfred A.Knopf, 1982).

Darian, Steven G., *Ganges in Myth and History* (Motilal Banarsidass Publishers, 1978).

Gurung, K.K. and Singh, R., *Field Guide to the Mammals of the Indian Subcontinent* (Poyser, 1998).

MacKenzie, John M., *The Empire of Nature: Hunting conservation and British imperialism* (Manchester University Press, 1988).

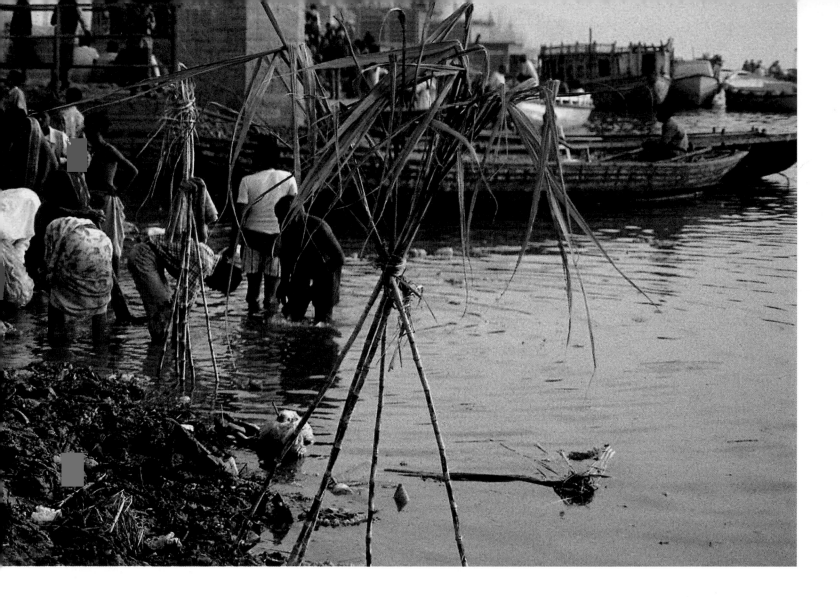

Rangarajan, Mahesh, *India's Wildlife History: An introduction* (Permanent Black, 2001).

Thapar, Valmik, *Land of the Tiger: A natural history of the Indian subcontinent* (BBC Books, 1997).

CHAPTER 3

Buchmann, Stephen, *Letters from the Hive: An intimate history of bees, honey and humankind* (Bantam Books, 2005).

Burge, R., Seidensticker, J., Christie, S. and Jackson, P., *Riding the Tiger: Tiger conservation in human-dominated landscapes* (Cambridge University Press,1999).

Campbell, Bruce, and Lack, Elizabeth, *A Dictionary of Birds* (Harrell Books, 1985).

Chowdhury, B.R. and Vyas, P., *The Sundarbans: A pictorial field guide* (Rupa and Co, 2005).

Environment and GIS Support Project, *Riverine Chars in Bangladesh: Environmental dynamics and management issues* (University Press Ltd, 2000, Dhaka).

Hofer, T. and Messerli, B., *Floods in Bangladesh: History, dynamics and rethinking the role of the Himalayas* (United Nations University, 2006).

McAdam, Marika, *Lonely Planet: Bangladesh* (Lonely Planet Publications, 2004).

Mitra, A., Banerjee, K., and Bhattacharyya, D.P., *Ecological Profile of the Sundarbans: Pelagic primary producer community* (WWF India).

Thomas, Frederic C., *To the Mouths of the Ganges: An ecological and cultural journey* (East Bridge, 2004).

PICTURE CREDITS

ALL PHOTOGRAPHS BY JON NICHOLSON, WITH THE EXCEPTION OF THE FOLLOWING WILDLIFE IMAGES

27 (top) Ian McCarthy; **28** Eric Dragesco; **29** Ian McCarthy; **30** Ian McCarthy; **34** Roger Tidman; **36** Gertrud & Helmut Denzau; **37** John Brown; **38** Ashish & Shanthi Chandola/naturepl.com; **41** Otto Pfister/NHPA; **46** Gertrud & Helmut Denzau; **47** Gertrud & Helmut Denzau; **48-9** Gertrud & Helmut Denzau; **50** John Brown; **53** Francois Savigny/naturepl.com; **55** Pete Oxford/naturepl.com; **56** Gertrud & Helmut Denzau; **57** Torsten Brehm/naturepl.com; **62** Jean-Pierre Zwaenepoel; **63** Gertrud & Helmut Denzau; **64** Jean-Pierre Zwaenepoel; **76** Jean-Pierre Zwaenepoel/naturepl.com; **89** Jean-Pierre Zwaenepoel; **91** Tom Hugh-Jones;

98 Toby Sinclair/naturepl.com; **99** Francois Savigny/naturepl.com; **100** John Aitchison; **101** Gertrud & Helmut Denzau; **102** Gertrud & Helmut Denzau; **107** Tom Hugh-Jones; **119** Elisabeth & Rubaiyat Fahrni Mansur; **129** Gertrud & Helmut Denzau; **132** Gertrud & Helmut Denzau; **133** Elisabeth & Rubaiyat Fahrni Mansur; **134-5** Simon Williams; **136-7** Simon Williams; **138-9** Elisabeth & Rubaiyat Fahrni Mansur; **141** Elisabeth & Rubaiyat Fahrni Mansur; **142-3** Elisabeth & Rubaiyat Fahrni Mansur; **144-5** Nikhil Devasar; **146-7** Gertrud & Helmut Denzau; **149** Elisabeth & Rubaiyat Fahrni Mansur; **150** Gertrud & Helmut Denzau; **158-9** BBC/BDH.

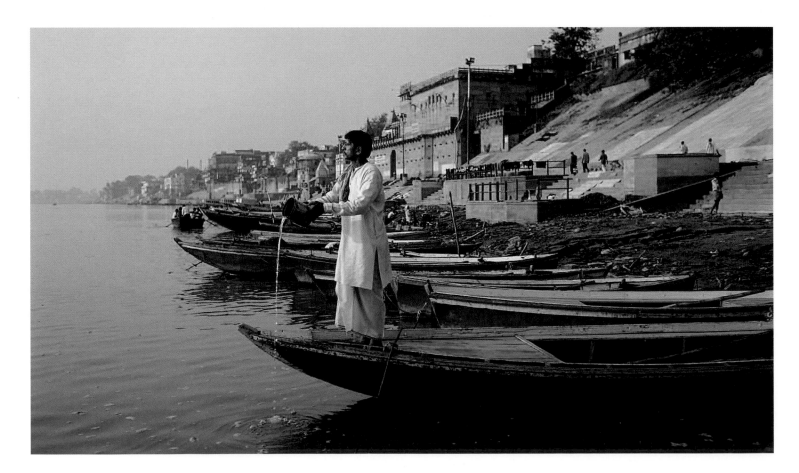

INDEX

Page numbers in *italic* refer to the illustrations